KU-018-444

Thinking Photography

Edited by
VICTOR BURGIN

Selection, editorial matter, Introduction © Victor Burgin 1982

All rights reserved. No reproduction, copy or transmission of
this publication may be made without written permission.

No paragraph of this publication may be reproduced, copied or
transmitted save with written permission or in accordance with
the provisions of the Copyright, Designs and Patents Act 1988,
or under the terms of any licence permitting limited copying
issued by the Copyright Licensing Agency, 90 Tottenham Court
Road, London W1P 9HE.

Any person who does any unauthorised act in relation to this
publication may be liable to criminal prosecution and civil
claims for damages.

First published 1982 by
MACMILLAN PRESS LTD
Houndmills, Basingstoke, Hampshire RG21 6XS
and London
Companies and representatives
throughout the world

ISBN 0–333–27195–5

A catalogue record for this book is available
from the British Library.

This book is printed on paper suitable for recycling and
made from fully managed and sustained forest sources.

6
00

Printed in Hong Kong

Series Standing Order
If you would like to receive future titles in this series as they are published,
you can make use of our standing order facility. To place a standing order
please contact your bookseller or, in case of difficulty, write to us at the
address below with your name and address and the name of the series.
Please state with which title you wish to begin your standing order.
(If you live outside the United Kingdom we may not have the rights
for your area, in which case we will forward your order to the publisher
concerned).

Customer Services Department, Macmillan Distribution Ltd,
Houndmills, Basingstoke, Hampshire, RG21 6XS, England

Communications and Culture

UN VERSI

'7 O. | ⁻

In the age of satellite transmission and digital storage, postmodern art works and global art sales, all that is clear amid the confusion of voices is that old cultural assumptions no longer hold. The difficult distinctions now are not only those between high and low cultures but also those between state and market, national and multinational cultures. We can no longer assume clear boundaries between the various media themselves, as entertainment corporations absorb all forms of communication. We can't even refer confidently to specific publics or audiences or markets any more. Cultural consumption now means ever-shifting networks of taste, activity and enjoyment that are not easily correlated with the usual social categories of race or class, age or gender.

The new constituencies for cultural goods are also new constituencies for cultural theory. More than ever before it is possible now for new voices to be heard, for readers to be addressed in new ways, mobilised for new sorts of interest. Our purpose in short, is to develop the **Communications and Culture** series beyond the position cultural theory has currently reached in the academy. Mass culture and subculture, semiotics and psychoanalysis, reception and deconstruction, the familiar terms of communications and culture studies will be used as stepping stones to what is necessary: a reconstruction of popular culture as a public sphere. To this end we will be commissioning multi-disciplinary work on the most pressing issues of cultural policy and practice, namely, *cultural value, cultural politics* and *cultural identity*. These are not issues of interest only to the theorist. They concern the everyday lives of us all.

Rosalind Brunt • Simon Frith • Stuart Hall • Angela McRobbie

26 0102097 0

COMMUNICATIONS AND CULTURE

Series Editors ROSALIND BRUNT, SIMON FRITH, STUART HALL,
ANGELA McROBBIE
Founding Editor PAUL WALTON

Steven Best and Douglas Kellner POSTMODERN THEORY:
 CRITICAL INTERROGATIONS
Roy Boyne and Ali Rattansi (eds) POSTMODERNISM AND SOCIETY
Victor Burgin (ed.) THINKING PHOTOGRAPHY
Victor Burgin THE END OF ART THEORY: CRITICISM AND
 POSTMODERNITY
Sean Cubitt VIDEOGRAPHY: VIDEO MEDIA AS ART AND
 CULTURE
Lidia Curti FEMALE STORIES, FEMALE BODIES: NARRATIVE,
 IDENTITY AND REPRESENTATION
James Donald (ed.) PSYCHOANALYSIS AND CULTURAL THEORY:
 THRESHOLDS
Peter M. Lewis and Jerry Booth THE INVISIBLE MEDIUM: PUBLIC,
 COMMERCIAL AND COMMUNITY RADIO
John Tagg THE BURDEN OF REPRESENTATION
John Tagg GROUNDS OF DISPUTE: ART HISTORY, CULTURAL
 POLITICS AND THE DISCURSIVE FIELD
Janet Wolff THE SOCIAL PRODUCTION OF ART (2nd edition)

Contents

List of Illustrations

Acknowledgements

The essays collected in this book were first published as follows, and the editor and publishers wish to thank those who have kindly given permission for the use of copyright material:

'The Author as Producer' as 'Der Autor als Produzent' in *Versuche über Brecht* © Suhrkamp Verlag, 1966, translated by Anna Bostock as *Understanding Brecht* © New Left Books, 1973, and in *Reflections* © Harcourt Brace Jovanovich Inc., 1978; 'Critique of the Image' as Part One of 'Articulations of Cinematic Code' in *Cinemantics*, no. 1, 1970, © Umberto Eco; 'Photographic Practice and Art Theory' in *Studio International*, vol. 190, no. 976, 1975; 'On the Invention of Photographic Meaning' in *Artforum*, vol. XIII, no. 5, 1975, © California Artforum Inc.; 'The Currency of the Photograph' in *Screen Education*, no. 28, 1978, © The Society for Education in Film and Television; 'Looking at Photographs' in *Screen Education*, no. 24, 1977, © The Society for Education in Film and Television; 'Making Strange: The Shattered Mirror' appears for the first time; 'Photography, Phantasy, Function' in *Screen*, vol. 21, no. 1, 1980, © The Society for Education in Film and Television.

The editor and publishers wish to acknowledge the following photographic sources:

The Estate of Diane Arbus; Arts Council of Great Britain; Victor Burgin; Central Press; Lee Friedlander; Imperial War Museum; International Museum of Photography; Library of Congress; Museum of Modern Art, Oxford; Dr Juliane Roh; Royal Photographic Society of Great Britain; Rosalinde Sartorti; University of Maryland Library, Baltimore County.

Every effort has been made to trace all the copyright holders but if any have been inadvertently overlooked the publishers will be pleased to make the necessary arrangement at the first opportunity.

Special thanks to Anne Williams for picture research
and editorial assistance

Introduction

Victor Burgin

The essays in this book are contributions towards photography theory. I say 'towards' rather than 'to' as the theory does not yet exist; nevertheless, as these essays indicate, some of its components may already be identified. The articles collected here are diverse in approach, the present state of underdevelopment of photography theory precludes a more homogeneous collection, but they share in common the project of developing a materialist analysis of photography – one which does not rely on that mixture of the biographical and the ineffable with which so many writers on photography defend their most fiercely held opinions. In introducing the essays I shall discuss three related topics. First, the idea of 'photography theory' as distinct from the more familiar 'criticism'. Second, a contemporary debate in cultural studies against the background of which the articles will, today, be 'positioned'. Finally, that other intellectual bearing relevant here – the relation of the essays to a history of theories of art since the inception of photography. Obviously, a consideration of any one of these topics could itself fill a book, and I apologise in advance for the necessarily cursory way I must summarise them within the confines of this introduction.

I

The expression 'photography theory', outside of a strictly technological application, may need some explanation. What I am proposing as the *object* of theory is not restricted to photography considered as a set of techniques (although, certainly, technique is

to be accounted for within the theory); it is, rather, photography considered as a practice of *signification*. By 'practice' here is meant work on specific materials, within a specific social and historical context, and for specific purposes. The emphasis on 'signification' derives from the fact that the primary feature of photography, considered as an omnipresence in everyday social life, is its contribution to the production and dissemination of *meaning*. To argue that the specificity of the object to be constituted in photography theory is semiotic is not to restrict the theory to the categories of 'classic' semiotics. Although semiotics is necessary to the proposed theory, it is not (nor would it ever claim to be) sufficient to account for the complex articulations of the moments of institution, text, distribution and consumption of photography. Confronted as it is with such heterogeneity, it is clear that photography theory must be 'inter-disciplinary'; there can, however, be no question of simply *juxtaposing* one pre-existing discipline with another.

For example, at the moment perhaps the least developed aspect of the emerging theory is the sociological component. Photography is most commonly encountered in sociological texts as 'evidence', the sociologist operating with the common-sense intuition of photography as a 'window on the world'. This type of sociological encounter with photography is quite simply irrelevant to the project of photography theory, which must take into account the determinations exerted by the means of representation upon that which is represented. More pertinent is the sociological description of photographic institutions. Here again, however, the criterion of relevance applies: a description of, say, the hierarchical structures of command governing the photographer in the advertising industry would be less relevant to the theory than a description of the discourses by which the institution inducts its functionaries, irrespective of rank, into a common belief system, constituting them *as* 'advertising people'. Certainly, we may expect structures of decision-making to be imbricated within beliefs, but it is the beliefs which are the 'sharp end' of that which *informs* the social effects of advertising. (Nor is this to suggest that advertisers' beliefs are simply 'communicated' to their audiences.)

Photography theory is not exempt from the call made upon any theory to identify observable systematic regularities in its object which will support general propositions about the object. This is already to establish that theory may be *taught*, and certainly the

elaboration of photography theory constitutes an intervention, at least in principle, in the field of education. In speaking of photographic education we should distinguish between two quite different pedagogic practices. In the first, a vocational training is given for some particular branch of industry and/or commerce – as when a school trains people to become advertising photographers. In this type of course academic studies will tend to be *pragmatic* – their content being determined by its practical bearing on the specific form of photography being taught. In the second type of course no particular vocational training is imposed; the student is asked, rather, to consider photography in its totality as a general cultural phenomenon, and to develop his or her own ideas as to what direction to pursue. Academic studies in the context of this latter type of course are presented as *heuristic* – aiming to provide the student with a wide range of facts, and a number of critical tools, in the interests of developing an informed capacity for independent thought. Contrary to their declared intent, the majority of those courses whose concern is with photography as *art* belong in the first category rather than the second. They offer a vocational training for that branch of the culture industry whose products are photographic exhibitions and books. The academic content of such courses tends overwhelmingly to take the form of an uncritical initiation into the dominant beliefs and values prevailing in the art institution as a whole. On such courses 'criticism' and 'history' stand in place of theory.

Photography criticism, as it is most commonly practised, is evaluative and normative. In its most characteristic form it consists of an account of the personal thoughts and feelings of the critic in confronting the work of a photographer, with the aim of persuading the reader to share these thoughts and feelings. Free reference is made to the biography, psychology and character of the photographer in question, and even to the critic him/herself. The 'arguments' advanced in criticism are rarely *arguments*, properly speaking, but rather *assertions* of opinions and assumptions paraded as if their authority was unquestionable. The dominant discourse of such criticism is an uneasy and contradictory amalgam of Romantic, Realist and Modernist aesthetic theories. The 'history of photography' predominantly supports such criticism in that it is produced within the same ideological framework. In such 'history' the unargued conventional assumptions to be found in 'criticism' are pro-

jected into the past from whence they are reflected inverted in status – no longer mere assumptions, they have become the indisputable 'facts' of history.

I have described the *dominant* mode of history and criticism of photography, in which the main concern is for reputations and objects, and in which the objects inherit the reputations to become commodities: a history and criticism to suit the saleroom. Neither history nor criticism are, *a priori*, committed to this course, and there are indications in the essays which follow of alternative approaches to history and criticism. Such alternative approaches reject the tendency to confine discussion of photography to some narrowly technicist and/or aesthetic realm of ideas; they aim, rather, to understand photography not only as a practice in its own right but also in its relation to society as a whole. This holistic project has traditionally been that of Marxist cultural theory, which of late has become increasingly engaged with precisely that topic of the production of meaning with which I began. As all the essays in this book are extensively informed by Marxist ideas, it is appropriate that I provide at least a rough sketch of the current state of the debate in Marxist cultural studies.

II

The majority of the articles collected here have been written since 1975. Their common concern is with the topic of 'representation', over recent years increasingly a subject of analysis and debate. A precondition for the recent emergence of this topic in the general field of cultural studies has been the break with a long-standing Marxist tradition in which cultural phenomena were theorised as 'superstructures' determined by contradictions in the economic 'base'. To this general superstructure belong, in Marx's words, 'the legal, political, religious, aesthetic or philosophic – in short ideological forms'. 'Ideology' here is the name given to the complex of values and beliefs which together organise the heterogeneous and contradictory elements of class society towards common goals, concealing from them the exploitative nature of their class relations – ideology is a *false consciousness* of these relations. Through a historical-materialist analysis of society the analyst may see through ideological appearances to the real forms behind them. After the revolutionary transformation of the mode of economic production,

the very cause itself of the distorting ideologies will have been removed, and all men and women will see reality as it really is.

The simplicity of the above scenario derives rather more from some of Marx's followers than from Marx himself. Other Marxist commentators, from Engels onwards, have contested the notion that the ideological is so *simply* determined by the economic. In recent years, the most influential such contestation has come from Louis Althusser, most notably in his essay 'Ideology and Ideological State Apparatuses: Notes Towards an Investigation', which was published in France in 1970 and in England the following year. Althusser conceives of all possible modes of production as necessarily structured in terms of three 'instances': the economic, the political and the ideological. To each of these instances correspond forms of practice which are complexly articulated together to produce a 'society effect', and yet which each remain 'relatively autonomous'. In 'Ideology and Ideological State Apparatuses', Althusser sets out to theorise the operation of ideology. 'Ideological State Apparatuses' (ISAs) are postulated as non-coercive institutions whose function is to secure *by consent* the necessary 'reproduction of the relations of production'. According to Althusser, the key ISAs are the family and the schools – amongst others he cites is 'the cultural ISA (Literature, the Arts, sports, etc.)'. The conception of control by consent through the ISAs, with its attendant emphasis on the necessity for ideological struggle within and across a complex variety of institutions, is a significant departure from a Marxist-Leninist tradition which pictures a ruling class exercising control over society through its privileged access to overtly repressive state agencies, such as the police and the army. Althusser does not reject this picture, but he includes it within a larger one. For Althusser, 'the ideological State Apparatuses may be not only the *stake*, but also the *site* of class struggle'.

For Althusser, ideology is not 'false consciousness' – a set of illusions which will be dispelled after the revolution – it is inseparable from the practical social activities and relations of everyday life and therefore a necessary condition of any society whatsoever, including communist societies. Ideology is 'a system (with its own logic and rigour) of representations (images, myths, ideas or concepts, depending on the case) endowed with a historical existence and role within a given society' which acts on men and women 'by a process that escapes them'. Althusser rejects a 'humanist' account

apply to bhabha

of the individual – a *free* subject possessed of an irreducible human 'essence' (which in Marxist humanism is presented as 'alienated' under capitalism). He also rejects an 'empiricist' account of the way the individual acquires knowledge – in *experience*, the world simply presenting itself, via the senses, 'for what it is'. For Althusser, both the subject and its experiences are *constituted* in representations: the ISAs offer 'pictures' of subjectivity in which the subject 'mis-recognises' itself, as if the pictures were mirrors.

For the past ten years, Althusser's essay has remained at the centre of debates in Marxist cultural studies, engendering the present polarisation of positions between those who always thought he had gone too far and those who now feel he did not go far enough. A variety of terms have been used to label the respective factions, at the time of writing 'culturalist' and 'post-Althusserian' seem most favoured. 'Culturalism' in Britain dates from the emergence, in the late 1950s, of the 'New Left'. New Left historians and literary critics revived a concern with 'culture' defined in terms of the 'whole way of life' of a social class. This concern set itself against a prevailing orthodoxy, derived from Matthew Arnold (by way of F. R. Leavis and I. A. Richards), in which culture was conceived of as a domain of civilising values preserved and passed down by an intellectual elite – a conception which repressed all consideration of the cultural production of the dominated class. The New Left concern with culture also went against that mechanistic version of Marxism in which cultural considerations were marginal-ised, or elided, as the superstructural epiphenomena of the economic base.

The major culturalist texts include Richard Hoggart's *The Uses of Literacy* (1957), Raymond Williams's *Culture and Society* (1958) and *The Long Revolution* (1961), and Edward Thompson's *The Making of the English Working Class* (1963). The preferred method of culturalism, as Richard Johnson has described it, is

> experiential, even autobiographical: witness Hoggart's personal-ised memories and childhood vision, Williams's deeply autobiog-raphical way of approaching larger questions, even Thompson's personalised polemic and deeply political historical partisanship. These styles went along with a popular, democratic, anti-elitist politics that centralised personal feelings and moral choices.

It is in fact essentially on the grounds of a moral choice that

culturalists have rejected 'Althusserianism'. The culturalist attack
on Althusser is at base a *defence* of the humanism and empiricism
which Althusser refuses, a defence of the integrity of the (oppres-
sed) class subject and the authenticity of his or her experience.
Against what it would characterise as bloodless abstractions, cul-
turalism opts for the vitality of lived convictions. We might note,
however, that, very often, much of the indignation has been pro-
voked by nothing more offensive than a category error: the rejec-
tion of *humanism* (a philosophical doctrine) has been understood as
a callous assault on *humans* (people, or more heinously, *the people*).

If culturalist attacks on Althusser have tended to be moral rather
than theoretical in inspiration, 'post-Althusserian' criticism has
made up the deficiency. The three major objections have been to
Althusser's account of the constitution of the subject, to the 'func-
tionalism' of his description of the ISAs, and to the equivocalness of
the idea of 'relative autonomy'. Althusser describes the human
subject as being in an *imaginary* relationship to its conditions of
existence, and it is clear than in using the term he is alluding to
Jacques Lacan's work in psychoanalytic theory. The subject Althus-
ser describes, however, is incompatible with the subject as de-
scribed either by Lacan or by Freud: there is no place in Althusser's
schema for the action of the *unconscious*; in a Lacanian perspective,
there is no allowance made in Althusser's theory for the constitu-
tion of the subject in *language*, or for the relation of language to
ideology. In the absence of such considerations, it is argued, we are
left with a picture of the subject as a coherent, uncontradictory, site
for the inscription of 'misrecognitions', which is not after all so very
different from the subject of 'false consciousness' that Althusser
sets out to reject.

Althusser's account of the operation of the ISAs fares no better
than does his version of the subject they 'interpellate'. Simply,
Althusser's restriction of ideology to a work of reproduction of the
relations of production – the stable, repetitive, work of any ISA
whatsoever – effectively elides the *differences* between the institu-
tions he names as ISAs, and the specificities of forms within them.
Not only is such a view reductionist but, in implying that reproduc-
tion is *guaranteed* by the ISAs, it undermines, or negates, the very
possibility of that 'struggle in and for ideology' which Althusser
would recommend. Finally, objection to the notion of the 'relative
autonomy' of the ideological has been presented as a matter of *logic*.

Colin MacCabe, for example, remarks: '"Relative autonomy" is an oxymoron: either the ideological is autonomous and then the struggles on its terrain are not to be explained or justified in terms of politics, or it is not autonomous and then it is exhaustively explained by a consideration of the reality of political struggle.'

Although the culturalist defence of humanism and empiricism has contributed most emotional heat to the debate over Althusser, it is the question of the autonomy of ideology that has most theoretical significance for Marxist analysts of culture. The Marxist project in cultural studies is to explain cultural production in general, and individual cultural forms in particular, in terms of the broader social formation to which they belong. This project has been assumed, not only in vulgar 'economism', but also in more sophisticated analyses (not excepting those of Althusser himself), to entail explanations which must ultimately devolve upon the economic. Although, however, Althusser allows the economic determinacy 'in the last instance', he also comments that, 'the lonely hour of the last instance never comes'.

What is here in danger of being lost to Marxist analysts, at the very least in respect of a theory of ideology, is Marxism itself. In a particularly influential critique of Althusser's theory of ideology, Paul Hirst has in fact rejected the specifically Marxist form of the problematic. In the process he has also rejected the term 'representation' as entailing precisely the subject/object structure of knowledge which Althusser wished to evict from Marxist discourse. In Hirst's argument, the 'ideological' is specified and produced in practices of *signification* – the term he prefers to 'representation' – there being no *necessary* correspondence between the products of signification and any 'real' outside of them (indeed, he has more recently argued a 'necessary non-correspondence'). What is at stake here may be illustrated by reference to the representation of women.

One of the most generally influential achievements of the women's movement, in the field of cultural theory, has been its insistence on the extent to which the collusion of women in their own oppression has been exacted, precisely, *through* representations. They have argued that the predominant, traditional, verbal and visual representations of women do not reflect, 'represent', a biologically given 'feminine nature' (natural, therefore unchangeable); on the contrary, what women have to adapt to as their

'femininity' (particularly in the process of growing up) is itself the
product of representations. Representations therefore cannot be
simply tested against the real, as this real is itself *constituted* through
the agency of representations. A search for, or contestation of, the
'truth' of the representation here becomes irrelevant (for all that
this violates common-sense intuition); what is to be interrogated is
its *effects*.

My intention in referring to these debates in cultural theory has
not been to 'explain' them (which would be impossible here) but
merely to point to them, for they lie unavoidably in the path of any
theory which aims to consider photography in its relation to the
general sphere of cultural production. We cannot go around these
debates, we must go through them. I would, however, urge that we
do not in the process simply *confuse* photography theory with a
general theory of culture. To return to the observation with which I
began, photography theory will either develop through attention to
its own specificity or it will not develop at all. For example, by
comparison with, say, films like *Star Wars*, photographs are sensori-
ally restrained objects: mute and motionless variegated rectangles.
Looking at photographs can nevertheless occasion great interest,
fascination, emotion, reverie – or all of these things. Clearly, the
photograph here acts as a *catalyst* – exciting mental activity which
exceeds that which the photograph itself provides. It follows that
photography theory must take into account the active participation
of the mental processes of the viewer, and that such an account will
have a substantial place within the theory. To grant, say,
psychoanalytic theory a certain importance within a theory of
photography is not, however, necessarily to give it the same promi-
nence within cultural theory as a whole. Reciprocally, to accept the
privilege of the economic, class, instance in the context of a general
theory of society is not automatically to grant it the same primacy
within photography theory. It is essential to realise that a theory
does not find its object 'sitting waiting for it' in the world; theories
constitute their own objects in the process of their evolution.
'Water' is not the same *theoretical* object in chemistry as it is in
hydraulics – an observation which in no way denies that chemists
and engineers alike drink, and shower in, the same *substance*. By
much the same token, 'photography' is not the same object in
photography theory as it is when it appears in a general theory of the
social formation. Each theory will have its own theoretical object

and its own configuration of priorities (to argue otherwise, on the left, is to forget Lysenko). One of the priorities of the writings gathered here is the consideration of photography as a form of art practice, and it is to this topic that I now wish to turn.

III

When photography emerged on to the mid-nineteenth-century public stage it was, unsurprisingly, conceived of within terms of mid-nineteenth-century thought. In so far as it concerned the image, and characterised most schematically, this thought was in the process of opposing Realism to Romanticism. Kantian epistemology, positing a 'noumenal' world behind appearances which could not be known to the intellect, had allowed aestheticians to claim the primacy of the emotions in art as the way to a 'deep' knowledge of the world denied to science. The attack on the philosophical foundations of Romanticism came from the Positivism of Auguste Comte: it is not the intellect which imposes its own structure upon external reality, as Kant would have it, rather it is the inherent order of the objective world which must of itself be allowed to guide our thinking; for this we must accept that the reality we can see and touch is the only one there is. Romanticism stressed the primacy of the author: Delacroix writes, in 1850, that painting is no more than a 'pretext', a bridge between the mind of the painter and that of the spectator. Realism, on the other hand, asserted the primacy of the world: Courbet writes, in 1861, that painting can only depict 'real and existing things', an entity which is abstract is not within the realm of painting.

We may note that in Romanticism and Realism alike the image was conceived of as a *relay* – either between one human subject and another, or between a human subject and reality. The painted surface – or that of the newly emerged photograph – was conceived of as a projection, a communication from a singular founding presence 'behind' the picture, either that of the author or that of the world. The image was thus held, paradoxically, to give presence to an absence. A decisive break with this mode of thought came with Cubism: Cubism emphasised the surface of the painting as a substantial object in its own right, and the painted sign as a *material* entity, the meaning of which could not be unproblematically ascribed either to the intention of an author or to any empirically given reality. From this moment on, however, there occurs a

splitting of concerns – the *surface* and the *sign* become the points of departure for two quite separate lines of development of art practice and theory.

In the course of that development which we know as 'Modernism', most specifically in the meaning that this word has been given in the writings of Clement Greenberg and his followers (but the essential features of which are present in the earlier writings of Clive Bell and Roger Fry), the sign was to be totally erased from the surface. The art work was to become a totally autonomous material *object* which made no gesture to anything beyond its own boundaries; the surface itself – its colour, its consistency, its edge – was to become the only content of the work. After Cubism, Modernism was to free art from its old obligations to representation, but 'representation' defined in those very terms which Cubism itself had called into question: illusion and communication. Photography, however, was unable to follow painting into modernist abstraction without the appearance of straining after effect; the unprecedented capacity of photography for resemblance seemed most appropriately to determine its specific *work* and to distinguish it from painting. Certainly there has emerged over the modern period a form of 'photographic modernism' founded on concepts of 'photographic seeing', but, as I argue in one of my own contributions to this collection, it has only the most tenuous and uneasy purchase on those considerations of 'content' which remain so obstinately central to our experience of photographs.

So far as this content is concerned, to a very great extent our ways of conceiving of photography have not yet succeeded in breaking clear of the gravitational field of nineteenth-century thinking: thinking dominated by a metaphor of *depth*, in which the surface of the photograph is viewed as the projection of something which lies 'behind' or 'beyond' the surface; in which the frame of the photograph is seen as marking the place of entry to something more *profound* – 'reality' itself, the 'expression' of the artist, or both (a reality refracted through a sensibility). The surface of the photograph, however, conceals nothing but the fact of its own superficiality. Whatever meanings and attributions we may construct at its instigation can know no final closure, they cannot be held for long upon those imaginary points of convergence at which (it may comfort some to imagine) are situated the experience of an author or the truth of a reality.

The essays in this collection, from one direction or another, all

approach this central issue of the production of meaning in photo-
graphy. They also refer extensively to the practice and institution of
art as a site of such meaning-production, a site which is nevertheless
viewed constantly in its relationship to other sites of photographic
practice – most notably journalism and advertising. Walter Benja-
min's complex and subtle text (Chapter 1) introduces many of the
considerations which are addressed in the essays which follow: the
relation of 'art' practices to the broader social world which supports
and contains them; the use of the image in the 'mass media'; the
aestheticising effect of 'concerned' photography; the political func-
tion of the artist/intellectual; the functional relation between
photographic image and caption; and so on. Benjamin's ideas
emerge against a background of Soviet aesthetic debates of the
1920s with which he was well acquainted (his friend Tretyakov, of
whom he speaks, was particularly interested in photography), and it
is to these debates that we must look for the initiation of that
'separate line of development' to which I have alluded.

 In Russia the exploration of the objective autonomy of the art
object had undergone a more accelerated development than in the
West, a development which culminated in Malevich's *White on
White* paintings of 1918; and Malevich's subsequent declaration, in
1920, of the end of painting, his assessment of the painter as 'a
prejudice of the past'. The Russian *avant-garde* received the social
revolution of 1917 both as the political counterpart to their own
revolution in art and as a challenge to their ability to integrate their
specialist concerns as artists with the broader concerns of a society
in the process of self-renewal. To some of the young painters of this
period, photography held the attraction of a modern technology,
relatively unfettered by tradition, which would allow them to
extend their pictorial preoccupations into the realm of necessary
social production. The Russian *avant-garde* in criticism, unlike their
counterparts in the West, were not hostile to considerations of
content. The Russian Formalist school of literary critics, centred on
the Moscow Linguistic Circle (founded in 1915), and OPOYAZ
(Society for the Study of Poetic Language, 1916) were contem-
poraries of Bell and Fry but moving in a different direction. Initially
attacking Symbolism, the Formalists rejected the Symbolist idea of
form in which form, the perceivable, was conceived in opposition to
content, the intelligible. They extended the notion of form to cover
all aspects of a work. Todorov writes:

The Formalist approach was completely opposed to this aesthetic appreciation of 'pure form'. They no longer saw form as opposed to some other internal element of a work of art (normally its content) and began to conceive it as the totality of the work's various components. This makes it essential to realise that the form of a work is not its only formal element: its content may equally well be formal.

When, with the onset of the 1930s, the intellectual and artistic ferment of Soviet socialist formalism was effectively repressed, the ideas of the period nevertheless continued to evolve in the West. The efflorescence of 'Structuralism' in France in the 1960s was extensively fed by this intellectual current from the East (not least through the physical presence of such émigrés as Roman Jakobson and Tzvetan Todorov). When Roland Barthes's germinal 'Eléments de sémiologie' appeared in issue 4 (1964) of the journal *Communications*, it was accompanied by his 'Rhétorique de l'image', which extends the project of his longer essay into the problematical area of the photograph. In this latter article, now widely known in English translation (and for this reason only, not included here), Barthes identifies 'anchorage' and 'relay' functions of the caption in its relation to the image; the image itself, however, remains for Barthes the paradox of a 'message without a code' (an assertion to which he emphatically returns in his final book, *La chambre claire*). In a short but influential passage (Chapter 2) from a longer article on film, Umberto Eco argues that while there may be no single code at work in the photographic image – no homogeneous 'language of photography' – there is nevertheless a *plurality* of codes, most of which pre-exist the photograph, which interact in the photograph in complex ways. My own essay 'Photographic Practice and Art Theory' (Chapter 3) seeks to synthesise Eco's insights within Barthes's semiology, together with a presentation of what other of the 'classic' work in semiotics seemed applicable to the photographic image at that time (1975).

The implication of an *overly* formalistic approach inherent in the trajectory of early semiotics is redressed in the subsequent essays. In Chapter 4 Allan Sekula employs a framework of semiotic concepts in an essay in practical criticism in which he examines the mythological and monolithic opposition between 'realism' and 'expression', here exemplified in the imagos of Steiglitz and Hine. In

Chapter 5 John Tagg also addresses the issue of realism in photography, again via a methodology which seeks to combine the insights of semiotics with those of a social history. 'Looking at Photographs' (Chapter 6) is a brief account, in its application to photography, of the transition from a 'semiotics of systems' to a semiotics which takes account of the (psychoanalytic) *subject* inscribed in the system in question. Simon Watney's article (Chapter 7) traces the extensive ramifications and reduplications of the critical concept/aesthetic strategy of 'making strange', addressed to this subject, demonstrating its extraordinary grip on art (and) photography from its origins in both Eastern and Western Europe to this present day. My own essay which concludes this collection (Chapter 8) returns to re-examine a particular Soviet aesthetic debate of the 1920s – centred on one particular 'device' for making strange – in the light of some recent theory.

It remains for me to explain an absence. There are no essays by women in this anthology. This is a matter neither of oversight nor prejudice, it is the contingent effect of a conjuncture. Much of the work by women on representation occupies different theoretical registers, and/or engages different practical projects from those of this present collection. On the one hand, the sort of writing associated with, for example, the journal *m/f*, is of too general a level of abstraction to *appear* to engage the particular histories of art (and) photography addressed here; on the other hand, the work specifically on photography of, say, Jo Spence, has had its own quite distinct (albeit allied) cultural-political project (see Jo Spence's own compilation of essays on photography, listed in the bibliography). Again, writing by women which would otherwise fit very happily into this present book is not specifically about photographs (for example, Laura Mulvey's work on film and Griselda Pollock's work on painting). Nevertheless, I wish to emphasise in conclusion that the theoretical project to which this book is a contribution owes itself to the initial and continuing insistence of the women's movement on the *politics* of representation.

London, 1980

Chapter 1

The Author as Producer[1]

Walter Benjamin

Il s'agit de gagner les intellectuels à la classe ouvrière, en leur faisant prendre conscience de l'identité de leurs démarches spirituelles et de leurs conditions de producteur.

(Ramon Fernandez)

You will remember how Plato, in his project for a Republic, deals with writers. In the interests of the community, he denies them the right to dwell therein. Plato had a high opinion of the power of literature. But he thought it harmful and superfluous – in a *perfect* community, be it understood. Since Plato, the question of the writer's right to exist has not often been raised with the same emphasis; today, however, it arises once more. Of course it only seldom arises in this *form*. But all of you are more or less conversant with it in a different form, that of the question of the writer's autonomy: his freedom to write just what he pleases. You are not inclined to grant him this autonomy. You believe that the present social situation forces him to decide in whose service he wishes to place his activity. The bourgeois author of entertainment literature does not acknowledge this choice. You prove to him that, without admitting it, he is working in the service of certain class interests. A progressive type of writer does acknowledge this choice. His decision is made upon the basis of the class struggle: he places himself on

the side of the proletariat. And that's the end of his autonomy. He directs his activity towards what will be useful to the proletariat in the class struggle. This is usually called pursuing a tendency, or 'commitment'. Here you have the key word around which a debate has been going on for a long time. You are familiar with it, and so you know how unfruitful this debate has been. For the fact is that this debate has never got beyond a boring 'on-the-one-hand', 'on-the-other-hand': *on the one hand* one must demand the right tendency (or commitment) from a writer's work, *on the other hand* one is entitled to expect his work to be of a high quality. This formula is, of course, unsatisfactory so long as we have not understood the precise nature of the relationship which exists between the two factors, commitment and quality. One can declare that a work which exhibits the right tendency need show no further quality. Or one can decree that a work which exhibits the right tendency must, of necessity, show every other quality as well.

This second formulation is not without interest; more, it is correct. I make it my own. But in doing so I refuse to decree it. This assertion must be *proved*. And it is for my attempt to prove it that I now ask for your attention. You may object that this is a rather special, indeed a far-fetched subject. You may ask whether I hope to advance the study of fascism with such a demonstration. That is indeed my intention. For I hope to be able to show you that the concept of commitment, in the perfunctory form in which it generally occurs in the debate I have just mentioned, is a totally inadequate instrument of political literary criticism. I should like to demonstrate to you that the tendency of a work of literature can be politically correct only if it is also correct in the literary sense. That means that the tendency which is politically correct includes a literary tendency. And let me add at once: this literary tendency, which is implicitly or explicitly included in every correct political tendency, this and nothing else makes up the quality of a work. It is because of this that the correct political tendency of a work extends also to its literary quality: because a political tendency which is correct comprises a literary tendency which is correct.

I hope to be able to promise you that this assertion will presently become clearer. For the moment allow me to interject that I could have chosen a different point of departure for the considerations I wish to put before you. I began with the unfruitful debate concern-

ing the relationship between the tendency and the quality of literary works. This argument is discredited, and rightly so. It is regarded as a textbook example of an attempt to deal with literary relationships undialectically, with stereotypes. But what if we treat the same problem dialectically?

For the dialectical treatment of this problem – and now I come to the heart of the matter – the rigid, isolated object (work, novel, book) is of no use whatsoever. It must be inserted into the context of living social relations. You rightly point out that this has been undertaken time and again in the circle of our friends. Certainly. But the discussion has often moved on directly to larger issues and therefore, of necessity, has often drifted into vagueness. Social relations, as we know, are determined by production relations. And when materialist criticism approached a work, it used to ask what was the position of that work *vis-à-vis* the social production relations of its time. That is an important question. But also a very difficult one. The answer to it is not always unequivocal. And I should now like to propose a more immediate question for your consideration. A question which is somewhat more modest, which goes less far, but which, it seems to me, stands a better chance of being answered. Instead of asking: what is the position of a work *vis-à-vis* the productive relations of its time, does it underwrite these relations, is it reactionary, or does it aspire to overthrow them, is it revolutionary? Instead of this question, or at any rate before this question, I should like to propose a different one. Before I ask: what is a work's position *vis-à-vis* the production relations of its time, I should like to ask: what is its position *within* them? This question concerns the function of a work within the literary production relations of its time. In other words, it is directly concerned with literary *technique*.

By mentioning technique I have named the concept which makes literary products accessible to immediate social, and therefore materialist, analysis. At the same time, the concept of technique represents the dialectical starting-point from which the sterile dichotomy of form and content can be surmounted. And furthermore this concept of technique contains within itself an indication of the right way to determine the relationship between tendency and quality, which was the object of our original inquiry. If, then, we were entitled earlier on to say that the correct political tendency of a work includes its literary quality because it includes its literary

tendency, we can now affirm more precisely that this literary tendency may consist in a progressive development of literary technique, or in a regressive one. It will surely meet with your approval if, at this point, and with only apparent inconsequence, I turn to a set of entirely concrete literary relations: those of Russia. I should like to guide your attention to Sergey Tretyakov and to the type of 'operative' writer he defines and personifies. This operative writer offers the most palpable example of the functional dependency which always and in all circumstances exists between the correct political tendency and a progressive literary technique. Admittedly it is only one example; I reserve the right to quote others later on. Tretyakov distinguishes between the operative and the informative writer. The operative writer's mission is not to report but to fight: not to assume the spectator's role but to intervene actively. He defines this mission with the data he supplies about his own activity. When, in 1928, in the period of total collectivisation of Russian agriculture, the slogan 'Writers to the Collective Farm!' was issued, Tretyakov went to the 'Communist Lighthouse' commune and, in the course of two prolonged visits, understood the following activities: calling mass meetings; collecting funds for down-payments on tractors; persuading private farmers to join the collective farm; inspecting reading-rooms; launching wall newspapers and directing the collective farm newspaper; reporting to Moscow newspapers; introducing radio, travelling film shows, etc. It is not surprising that the book *Feld-Herren* ('Field Commanders') which Tretyakov wrote following these visits is said to have exercised considerable influence on the subsequent organising of collective farms.

You may admire Tretyakov and yet think that his example is not particularly meaningful in this connection. The tasks he undertook, you may object, are those of a journalist or propagandist; all this has not much to do with literary creation. Yet I quoted Tretyakov's example deliberately in order to point out to you how wide the horizon has to be from which, in the light of the technical realities of our situation today, we must rethink the notions of literary forms or genres if we are to find forms appropriate to the literary energy of our time. Novels did not always exist in the past, nor must they necessarily always exist in the future; nor, always, tragedies; nor great epics; literary forms such as the commentary, the translation, yes, even the pastiche, have not always existed merely as minor

exercises in the margin of literature, but have had a place, not only in the philosophical but also the literary traditions of Arabia or China. Rhetoric was not always a trifling form; on the contrary, it left an important mark on large areas of ancient literature. All this to familiarise you with the idea that we are in the midst of a vast process in which literary forms are being melted down, a process in which many of the contrasts in terms of which we have been accustomed to think may lose their relevance. Let me give an example of the unfruitfulness of such contrasts and of the process of their dialectical resolution. This will bring us once more to Tretyakov. For my example is the newspaper.

'In our literature,' writes an author of the Left:[2]

contrasts which, in happier epochs, used to fertilise one another have become insoluble antinomies. Thus, science and *belles lettres*, criticism and original production, culture and politics now stand apart from one another without connection or order of any kind. The newspaper is the arena of this literary confusion. Its content eludes any form of organisation other than that which is imposed upon it by the reader's impatience. And this impatience is not just the impatience of the politician waiting for information or that of the speculator waiting for a tip-off: behind it smoulders the impatience of the outsider, the excluded man who yet believes he has a right to speak out in his own interest. The editorial offices have long ago learned to exploit the fact that nothing binds the reader to his newspaper so much as this impatience, which demands fresh nourishment every day; they exploit it by continually throwing open new columns for readers' questions, opinions and protests. Thus the unselective assimilation of facts goes hand in hand with an equally unselective assimilation of readers, who see themselves elevated instantaneously to the rank of correspondents. There is however a dialectical factor hidden in this situation: the decline of literature in the bourgeois press is proving to be the formula for its regeneration in the Soviet press. For as literature gains in breadth what it loses in depth, so the distinction between author and public, which the bourgeois press maintains by artificial means, is beginning to disappear in the Soviet press. The reader is always prepared to become a writer, in the sense of being one who describes or prescribes.[3] As an expert – not in any particular trade, perhaps, but anyway an expert on

the subject of the job he happens to be in – he gains access to authorship. Work itself puts in a word. And writing about work makes up part of the skill necessary to perform it. Authority to write is no longer founded in a specialist training but in a polytechnical one, and so becomes common property. In a word, the literarisation of living conditions becomes a way of surmounting otherwise insoluble antinomies, and the place where the word is most debased – that is to say, the newspaper – becomes the very place where a rescue operation can be mounted.

I hope to have shown by the foregoing that the view of the author as producer must go all the way back to the press. Through the example of the press, at any rate the Soviet Russian press, we see that the vast melting-down process of which I spoke not only destroys the conventional separation between genres, between writer and poet, scholar and populariser, but that it questions even the separation between author and reader. The press is the most decisive point of reference for this process, and that is why any consideration of the author as producer must extend to and include the press.

But it cannot stop there. For, as we know, the newspaper in Western Europe does not yet represent a valid instrument of production in the writer's hands. It still belongs to capital. Since, on the one hand, the newspaper is, technically speaking, the writer's most important strategic position, and since, on the other hand, this position is in the hands of the enemy, it should not surprise us if the writer's attempt to understand his socially conditioned nature, his technical means and his political task runs into the most tremendous difficulties. One of the decisive developments in Germany during the last ten years was that many of her productive minds, under the pressure of economic circumstances, underwent a revolutionary development in terms of their *mentality* – without at the same time being able to think through in a really revolutionary way the question of their own work, its relationship to the means of production and its technique. As you see, I am speaking of the so-called left intelligentsia and in so doing I propose to confine myself to the bourgeois left intelligentsia which, in Germany, has been at the centre of the important literary-political movements of the last decade. I wish to single out two of these movements, Activism and New Objectivity (*Neue Sachlichkeit*), in order to show by their

example that political commitment, however revolutionary it may seem, functions in a counter-revolutionary way so long as the writer experiences his solidarity with the proletariat only *in the mind* and not as a producer. The slogan which sums up the claims of the Activist group is 'logocracy', or, translated into the vernacular, the sovereignty of mind. This is apt to be understood as the rule of 'men of mind', or intellectuals; indeed, the notion of 'men of mind' has become accepted by the left-wing intelligentsia and dominates their political manifestos, from Heinrich Mann to Döblin. Quite obviously this notion was coined without any regard to the position of the intelligentsia in the production process. Hiller himself, the theoretician of Activism, does not want the notion of 'men of mind' to be understood to mean 'members of certain professions' but as 'representatives of a certain characterological type'. Naturally, this characterological type occupies, as such, a position between the classes. It includes any number of private persons without offering the smallest basis for their organisation into a collective. When Hiller formulates his rejection of the various Party leaders, he concedes that they may have many advantages over him; they may 'have more knowledge of important things . . . speak the language of the people better . . . fight more courageously' than he, but of one thing he is certain: 'their thinking is more faulty'. I dare say it is; but what is the use of that if the important thing in politics is not private thinking but, as Brecht once put it, the art of thinking inside other people's heads?[4] Activism tried to replace materialist dialectics by the value, undefinable in class terms, of ordinary common sense. At best, its 'men of mind' represent a certain attitude. In other words: the principle upon which this collective is based is in itself a reactionary one; no wonder then that the effect of the collective was never revolutionary.

The pernicious principle behind such a method of forming a collective continues, however, to operate. We saw it at work when Döblin published his *Wissen und Verändern* ('To Know and to Change') three years ago. This text, as we all remember, took the form of a reply to a young man – Döblin calls him Herr Hocke – who had addressed himself to the famous author with the question: 'What is to be done?' Döblin invites Herr Hocke to espouse the cause of Socialism, but on certain questionable conditions. Socialism, according to Döblin, is 'freedom, spontaneous association of

human beings, refusal of all constraint, revolt against injustice and constraint; it is humanity, tolerance and peaceful intentions'. Be that as it may, he takes this socialism as the starting-point for an all-out attack upon the theory and practice of the radical working-class movement. 'Nothing,' writes Döblin, 'can develop out of another thing unless it is already present in it: out of murderously exacerbated class struggle may come justice, but not socialism.' 'You, my dear sir' – this is how Döblin formulates the advice which, for this and other reasons, he offers to Herr Hocke –

> cannot, by joining the proletarian front, give practical effect to the affirmation with which you respond in principle to the struggle [of the proletariat]. You must confine yourself to approving this struggle with emotion and with sorrow; for you must know that, if you do more, then a tremendously important position will fall vacant . . . the original communist position of individual human freedom, of spontaneous solidarity and unity among men. . . . This, my dear Sir, is the only position appropriate to you.

Here it becomes palpably clear where the concept of the 'man of mind' as a type defined according to his opinions, intentions or predispositions, but not according to his position within the production process, must lead. This man, says Döblin, should find his place *at the side* of the proletariat. But what sort of a place is that? The place of a well-wisher, an ideological patron. An impossible place. And so we come back to the thesis we proposed at the beginning: the place of the intellectual in the class struggle can only be determined, or better still chosen, on the basis of his position within the production process.

Brecht has coined the phrase 'functional transformation' (*Umfunktionierung*) to describe the transformation of forms and instruments of production by a progressive intelligentsia – an intelligentsia interested in liberating the means of production and hence active in the class struggle. He was the first to address to the intellectuals the far-reaching demand that they should not supply the production apparatus without, at the same time, within the limits of the possible, changing that apparatus in the direction of Socialism. 'The publication of the *Versuche*,' we read in the author's introduction to the series of texts published under that title, 'marks a point at which certain works are not so much intended to represent individual experiences (i.e. to have the character of finished works)

as they are aimed at using (transforming) certain existing institutes and institutions.' It is not spiritual renewal, as the fascists proclaim it, that is desirable; what is proposed is technical innovation. I shall return to this subject later. Here I should like to confine myself to pointing out the decisive difference between merely supplying a production apparatus and changing it. I should like to preface my remarks on the New Objectivity with the proposition that to supply a production apparatus without trying, within the limits of the possible, to change it, is a highly disputable activity even when the material supplied appears to be of a revolutionary nature. For we are confronted with the fact – of which there has been no shortage of proof in Germany over the last decade – that the bourgeois apparatus of production and publication is capable of assimilating, indeed of propagating, an astonishing amount of revolutionary themes without ever seriously putting into question its own continued existence or that of the class which owns it. In any case this remains true so long as it is supplied by hacks, albeit revolutionary hacks. And I define a hack as a man who refuses as a matter of principle to improve the production apparatus and so prise it away from the ruling class for the benefit of Socialism. I further maintain that an appreciable part of so-called left-wing literature had no other social function than that of continually extracting new effects or sensations from this situation for the public's entertainment. Which brings me to the New Objectivity. It launched the fashion for reportage. Let us ask ourselves whose interests were advanced by this technique.

For greater clarity let me concentrate on photographic reportage. Whatever applies to it is transferable to the literary form. Both owe their extraordinary development to publication techniques – radio and the illustrated press. Let us think back to Dadaism. The revolutionary strength of Dadaism lay in testing art for its authenticity. You made still-lifes out of tickets, spools of cotton, cigarette stubs, and mixed them with pictorial elements. You put a frame round the whole thing. And in this way you said to the public: look, your picture frame destroys time; the smallest authentic fragment of everyday life says more than painting. Just as a murderer's bloody fingerprint on a page says more than the words printed on it. Much of this revolutionary attitude passed into photomontage. You need only think of the works of John Heartfield, whose technique made the book jacket into a political instrument. But now let us follow the

subsequent development of photography. What do we see? It has
become more and more subtle, more and more modern, and the
result is that it is now incapable of photographing a tenement or a
rubbish-heap without transfiguring it. Not to mention a river dam or
an electric cable factory: in front of these, photography can now
only say 'How beautiful'. *The World is Beautiful* – that is the title of
the well-known picture book by Renger-Patzsch in which we see
New Objectivity photography at its peak. It has succeeded in
turning abject poverty itself, by handling it in a modish, technically
perfect way, into an object of enjoyment. For if it is an economic
function of photography to supply the masses, by modish proces-
sing, with matter which previously eluded mass consumption –
Spring, famous people, foreign countries – then one of its political
functions is to renovate the world as it is from the inside, i.e. by
modish techniques.

 Here we have an extreme example of what it means to supply a
production apparatus without changing it. Changing it would have
meant bringing down one of the barriers, surmounting one of the
contradictions which inhibit the productive capacity of the intel-
ligentsia. What we must demand from the photographer is the
ability to put such a caption beneath his picture as will rescue it from
the ravages of modishness and confer upon it a revolutionary use
value. And we shall lend greater emphasis to this demand if we, as
writers, start taking photographs ourselves. Here again, therefore,
technical progress is, for the author as producer, the basis of his
political progress. In other words, intellectual production cannot
become politically useful until the separate spheres of competence
to which, according to the bourgeois view, the process of intellectual
production owes its order, have been surmounted; more precisely,
the barriers of competence must be broken down by each of the
productive forces they were created to separate, acting in concert.
By experiencing his solidarity with the proletariat, the author as
producer experiences, directly and simultaneously, his solidarity
with certain other producers who, until then, meant little to him.

 I spoke of the photographer; let me now, very briefly, quote a
remark of Hanns Eisler's about the musician:

> In the development of music, both in production and in reproduc-
> tion, we must learn to recognise an ever-increasing process of
> rationalisation. . . . The gramophone record, the sound film, the

nickelodeon can . . . market the world's best musical productions in canned form. The consequence of this process of rationalisation is that musical reproduction is becoming limited to groups of specialists which are getting smaller, but also more highly qualified, all the time. The crisis of concert-hall music is the crisis of a form of production made obsolete and overtaken by new technical inventions.

In other words, the task consisted in the 'functional transformation' of the concert-hall form of music in a manner which had to meet two conditions: that of removing, first, the dichotomy of performer and audience and, second, that of technical method and content. On this point Eisler makes the following interesting observation: 'We should beware of overestimating orchestral music and thinking of it as the only high art-form. Music without words acquired its great importance and its full development only under capitalism.' This suggests that the task of transforming concert music requires help from the word. Only such help can, as Eisler puts it, transform a concert into a political meeting. The fact that such a transformation may really represent a peak achievement of both musical and literary technique – this Brecht and Eisler have proved with their didactic play *The Measures Taken*.

If, at this point, you look back at the melting-down of literary forms of which we spoke earlier, you will see how photography and music join the incandescent liquid mass from which the new forms will be cast; and you will ask yourselves what other elements may likewise enter into it. Only the literarisation of all living conditions gives some idea of the scope of this melting-down process; and the temperature at which the melting-down takes place (perfectly or imperfectly) is determined by the state of the class struggle.

I have spoken of the way in which certain modish photographers proceed in order to make human misery an object of consumption. Turning to the New Objectivity as a literary movement, I must go a step further and say that it has turned *the struggle against misery* into an object of consumption. In many cases, indeed, its political significance has been limited to converting revolutionary reflexes, in so far as these occurred within the bourgeoisie, into themes of entertainment and amusement which can be fitted without much difficulty into the cabaret life of a large city. The characteristic feature of this literature is the way it transforms political struggle so

that it ceases to be a compelling motive for decision and becomes an
object of comfortable contemplation; it ceases to be a means of
production and becomes an article of consumption. A perceptive
critic[5] has commented on this phenomenon, using Erich Kästner as
an example, in the following terms:

> This left-radical intelligentsia has nothing to do with the working-
> class movement. It is a phenomenon of bourgeois decadence and
> as such the counterpart of that mimicry of feudalism which, in the
> Kaiser's time, was admired in a reserve lieutenant. Left-radical
> journalists of Kästner's, Tucholsky's or Mehring's type are a
> mimicry of the proletarian for decadent strata of the bourgeoisie.
> Their function, viewed politically, is to bring forth not parties but
> cliques; viewed from the literary angle, not schools but fashions;
> viewed economically, not producers but agents. Agents or hacks
> who make a great display of their poverty and turn the gaping
> void into a feast. One couldn't be more comfortable in an
> uncomfortable situation.

This school, as I said, made a great display of its poverty. By so
doing it evaded the most urgent task of the writer of today: that of
recognising how poor he is and how poor he must be in order to be
able to begin again at the beginning. For that is the point at issue.
True, the Soviet State does not, like Plato's Republic, propose to
expel its writers, but it does – and this is why I mentioned Plato at
the beginning – propose to assign to them tasks which will make it
impossible for them to parade the richness of the creative personali-
ty, which has long been a myth and a fake, in new masterpieces. To
expect a renovation – in the sense of more personalities and more
works of this kind – is a privilege of fascism, which, in this context,
produces such foolish formulations as the one with which Günther
Gründel rounds off the literary section of *The Mission of the Young
Generation*: 'We cannot close this . . . review of the present and
outlook into the future . . . in a better way than by saying that the
Wilhelm Meister, the *Grüne Heinrich* of our generation have not yet
been written.' Nothing will be further from the mind of an author
who has carefully thought about the conditions of production today
than to expect or even to want such works to be written. He will
never be concerned with products alone, but always, at the same
time, with the means of production. In other words, his products
must possess an organising function besides and before their

character as finished works. And their organisational usefulness must on no account be confined to propagandistic use. Commitment alone will not do it. The excellent Lichtenberg said: 'It is not what a man is convinced of that matters, but what his convictions make of him.' Of course, opinions matter quite a lot, but the best opinion is of no use if it does not make something useul of those who hold it. The best 'tendency' is wrong if it does not prescribe the attitude with which it ought to be pursued. And the writer can only prescribe such an attitude in the place where he is active, that is to say in his writing. Commitment is a necessary, but never a sufficient, condition for a writer's work acquiring an organising function. For this to happen it is also necessary for the writer to have a teacher's attitude. And today this is more than ever an essential demand. *A writer who does not teach other writers teaches nobody.* The crucial point, therefore, is that a writer's production must have the character of a model: it must be able to instruct other writers in their production and, second, it must be able to place an improved apparatus at their disposal. This apparatus will be the better, the more consumers it brings in contact with the production process – in short, the more readers or spectators it turns into collaborators. We already possess a model of this kind, of which, however, I cannot speak here in any detail. It is Brecht's epic theatre.

Tragedies and operas are being written all the time, apparently with a trusty stage apparatus to hand, whereas in reality they do nothing but supply an apparatus which is obsolete. As Brecht says:

> This confusion among musicians, writers and critics about their situation has enormous consequences, which receive far too little attention. Believing themselves to be in possession of an apparatus which in reality possesses them, they defend an apparatus over which they no longer have control, which is no longer, as they still believe, a means *for* the producers but has become a means to be used *against* the producers.

This theatre of complex machineries, gigantic armies of stage extras and extra-refined stage effects has become a means to be used against the producers, not least by the fact that it is attempting to recruit them in the hopeless competitive struggle forced upon it by film and radio. This theatre – it matters little whether we think of the theatre of culture or that of entertainment, since both are complementary to one another – is the theatre of a saturated stratum for

which anything that comes its way is a stimulant. Its position is a lost
one. Not so the position of a theatre which, instead of competing
against the newer means of communication, tries to apply them and
to learn from them – in short, to enter into a dialogue with them.
This dialogue the epic theatre has adopted as its cause. Matching the
present development of film and radio, it is the theatre for our time.
In the interests of this dialogue Brecht went back to the most
fundamental and original elements of theatre. He confined himself,
as it were, to a podium, a platform. He renounced plots requiring a
great deal of space. Thus he succeeded in altering the functional
relationship between stage and audience, text and production,
producer and actor. Epic theatre, he declared, must not develop
actions but ɪepresent conditions. As we shall see presently, it
obtains its 'conditions' by allowing the actions to be interrupted. Let
me remind of you of the 'songs', whose principal function consists in
interrupting the action. Here, then – that is to say, with the principle
of interrruption – the epic theatre adopts a technique which has
become familiar to you in recent years through film and radio,
photography and the press. I speak of the technique of montage, for
montage interrupts the context into which it is inserted. Allow me,
however, to explain very briefly why it is here that this technique
enjoys special, and perhaps supreme, rights.
The interrupting of the action, the technique which entitles
Brecht to describe his theatre as *epic*, always works against creating
an illusion among the audience. Such illusion is of no use to a theatre
which proposes to treat elements of reality as if they were elements
of an experimental set-up. Yet the conditions stand at the end, not
the beginning of the test. These conditions are, in one form or
another, the conditions of our life. Yet they are not brought close to
the spectator; they are distanced from him. He recognises them as
real – not, as in the theatre of naturalism, with complacency, but
with astonishment. Epic theatre does not reproduce conditions;
rather, it discloses, it uncovers them. This uncovering of the condi-
tions is effected by interrupting the dramatic processes; but such
interruption does not act as a stimulant; it has an organising
function. It brings the action to a standstill in mid-course and
thereby compels the spectator to take up a position towards the
action, and the actor to take up a position towards his part. Let me
give an example to show how Brecht, in his selection and treatment
of gestures, simply uses the method of montage – which is so

essential to radio and film – in such a way that it ceases to be a modish technique and becomes a human event. Picture to yourself a family row: the wife is just about to pick up a bronze statuette and hurl it at the daughter; the father is opening a window to call for help. At this moment a stranger enters. The process is interrupted; what becomes apparent in its place is the condition now exposed before the stranger's view: disturbed faces, open window, a devastated interior. There exists, however, a viewpoint from which even the more normal scenes of present-day life do not look so very different from this. That is the viewpoint of the epic dramatist.

He opposes the dramatic laboratory to the finished work of art. He goes back, in a new way, to the theatre's greatest and most ancient opportunity: the opportunity to expose the present. At the centre of his experiments stands man. The man of today: a reduced man, therefore, a man kept on ice in a cold world. But since he is the only one we have got, it is in our interest to know him. We subject him to tests and observations. The outcome is this: events are not changeable at their climax, not through virtue and resolve, but only in their strictly ordinary, habitual course, through reason and practice. The purpose of epic theatre is to construct out of the smallest elements of behaviour what Aristotelian drama calls 'action'. Its means, therefore, are more modest than those of traditional theatre; its aims likewise. It sets out, not so much to fill the audience with feelings – albeit possibly feelings of revolt – as to alienate the audience in a lasting manner, through thought, from the conditions in which it lives. Let me remark, by the way, that there is no better starting-point for thought than laughter; speaking more precisely, spasms of the diaphragm generally offer better chances for thought than spasms of the soul. Epic theatre is lavish only in the occasions it offers for laughter.

You may have noticed that the reflections whose conclusions we are now nearing make only one demand on the writer: the demand to *think*, to reflect upon his position in the production process. We can be sure that such thinking, *in the writers who matter* – that is to say, the best technicians in their particular branches of the trade – will sooner or later lead them to confirm very soberly their solidarity with the proletariat. To conclude, I should like to quote a topical proof of this in the form of a short passage from the Paris periodical *Commune*. This periodical held an inquiry under the title: 'For whom do you write?' I shall quote from the reply by René Maublanc

and then some relevant comments by Aragon. Maublanc says:

There is no doubt that I write almost exclusively for a bourgeois public. First, because I am obliged to [here he refers to his professional duties as a grammar-school teacher], and secondly because I am of bourgeois origin, had a bourgeois education, and come from a bourgeois environment and therefore am naturally inclined to address the class to which I belong, which I know best and can best understand. But that does not mean that I write to please that class or to uphold it. On the one hand, I am convinced that the proletarian revolution is necessary and desirable; on the other hand, I believe that the weaker the resistance of the bourgeoisie, the more rapid, the easier, the more successful and the less bloody this revolution will be. . . . The proletariat today needs allies in the bourgeois camp, just as in the eighteenth century the bourgeoisie needed allies in the feudal camp. I should like to be among those allies.

Aragon's comment on this is as follows:

Our comrade here touches upon a state of affairs which affects a very large number of present-day writers. Not all have the courage to look it straight in the eye. . . . Those who are as clear about their own position as René Maublanc are rare. But it is precisely from these that we must demand still more. . . . It is not enough to weaken the bourgeoisie from within: it is necessary to fight it *together with* the proletariat. . . . René Maublanc and many of our friends among writers who are still hesitant have before them the example of Soviet Russian writers who came from the Russian bourgeoisie and yet became pioneers of Socialist construction.

Thus far Aragon. But how did these writers become pioneers? Surely not without very bitter struggles and agonising conflicts. The considerations I put before you are an attempt to draw a positive balance from these struggles. They are founded upon the concept to which the debate concerning the attitude of Russian intellectuals owes its solution: the concept of the *expert*. The solidarity of the expert with the proletariat – and therein lies the beginning of this solution – can never be other than mediated. The Activists and adherents of New Objectivity may strike whatever poses they like, they can do nothing about the fact that even the proletarianisation

of the intellectual hardly ever makes him proletarian. Why? Because the bourgeois class has endowed him with a means of production – in the form of his education – which, on the grounds of educational privilege, creates a bond of solidarity which attaches him to his class, and still more attaches his class to him. Aragon was therefore perfectly right when, in another context, he said: 'The revolutionary intellectual appears first of all and above everything else as a traitor to his class of origin.' In a writer this betrayal consists in an attitude which transforms him, from a supplier of the production apparatus, into an engineer who sees his task in adapting that apparatus to the ends of the proletarian revolution. That is a mediating effectiveness, but it nevertheless frees the intellectual from the purely destructive task to which Maublanc, and many comrades with him, believe he has to be consigned. Will he succeed in furthering the unification of the means of intellectual production? Does he see ways of organising the intellectual workers within their actual production process? Has he suggestions for changing the function of the novel, of drama, of poetry? The more completely he can address himself to these tasks, the more correct his thinking will be and, necessarily, the higher will be the technical quality of his work. And conversely: the more precisely he thus understands his own position within the production process, the less it will occur to him to pass himself off as a 'man of mind'. The mind, the spirit that makes itself heard in the name of fascism, *must* disappear. The mind which believes only its own magic strength *will* disappear. For the revolutionary struggle is not fought between capitalism and mind. It is fought between capitalism and the proletariat.

Chapter 2

Critique of the Image

Umberto Eco

The natural resemblance of an image to the reality it represents is given a theoretical basis in the notion of *iconic sign*. Now this notion is being steadily revised, and we will indicate here only its fundamental lines. Further than this I can only refer to my present studies on this theme.[1]

From Peirce, through Morris, to the various positions of semiotics today, the iconic sign has cheerfully been spoken of as *a sign possessing some properties of the object represented*. Now a simple phenomenological inspection of any representation, either a drawing or a photo, shows us that an image possesses none of the properties of the object represented; and the motivation of the iconic sign, which appeared to us as indisputable, opposed to the arbitrariness of the verbal sign, disappears – leaving us with the suspicion that the iconic sign, too, is completely arbitrary, conventional and unmotivated.

A closer inspection of the data, however, leads us at once to a concession: iconic signs reproduce some of the conditions of perception, correlated with normal perceptive codes. In other words we perceive the image as a message referred to a given code, but this is the normal perceptive code which presides over our every act of cognition. However, the iconic sign *reproduces* the conditions of perception, but only *some* of them: here we are then faced with the problem of a new transcription and selection.

Critique of the Image

There is a principle of economy both in the recollection perceived things and in the recognition of familiar objects, and it is based on what I shall call *codes of recognition.* These codes list certain features of the object as the most meaningful for purposes of recollection or future communication: for example, I recognise a zebra from a distance without noting the exact shape of the head or the relation between legs and body. It is enough that I recognise two pertinent characteristics – four-leggedness and stripes.

These same codes of recognition preside over the selection of the conditions of perception which we decide to transcribe into an iconic sign. Thus we generically represent a zebra as a striped four-legged animal, while in some hypothetical African tribe where the only four-legged animals known are the zebra and hyena, both with a striped coat, a representation of them would have to accentuate other conditions of perception to distinguish between two icons. Given the conditions of reproduction, transcribing is done according to the rules of a graphic code which is the true iconic code, and using it I can fill in the legs anyway I like – with thin lines, dots of colour, etc.

In reality there are numerous types of iconic codes. I can achieve the representation of a body via a continuous outline (and the only property that the true object certainly *does not have* is just this outline) right up to the play of matching tones and lights which, by convention, create the conditions of perception needed to distinguish subject from background. This example applies as much to water-colours as to photography, the only difference being one of degree. The theory of the photo as an *analogue* of reality has been abandoned, even by those who once upheld it – we know that it is necessary to be trained to recognise the photographic image. We know that the image which takes shape on celluloid is analogous to the retinal image but not to that which we perceive. We know that sensory phenomena are *transcribed,* in the photographic emulsion, in such a way that even if there is a causal link with the real phenomena, the graphic images formed can be considered as wholly arbitrary with respect to these phenomena. Of course, there are various grades of arbitrariness and motivation, and this point will have to be dealt with at greater length. But it is still true that, to differing degrees, *every image is born of a series of successive transcriptions.*

It could be observed that the iconic sign embodies in a different

substance the same *form* as the perceived datum. That is to say, the
iconic sign is based on the same operation allowing the predication
of a structure common to two diverse phenomena (in the same way
as the system of positions and differences in a language can be
homologous to the system of positions and differences in a kinship
bond). Let us make this one of our starting-points too. But the
elaboration of a structural model is precisely the elaboration of a
code. Structure has no existence of its own (or at least I do not agree
with those who say it does) but is posited through an act of
theoretical invention, through a choice of operative conventions.

These conventions rest on systems of choices and oppositions.
The structural skeleton which magically appears in two different
things at once is not a problem of analogical resemblance defying
analysis: it can be dealt with in terms of *binary choices*.[2]

As Barthes has already said in his *Elements of Semiology*, the
analogical and the digital (or binary) meet within the same system.
But this encounter will tend to generate a cycle, founded on the
double tendency to naturalise the unmotivated and to culturalise
the motivated. Because basically the most natural phenomena,
apparently analogical in their relationships (for example, percep-
tion), can be reduced today to digital processes – i.e. the forms can
be outlined in the brain according to alternative selections. The
genetic structuralism of Piaget teaches us this, as do the
neurophysiological theories built upon cybernetic scenarios.

Thus we can say that everything which in images appears to us still
as analogical, continuous, non-concrete, motivated, natural, and
therefore 'irrational', is simply something which, in our present
state of knowledge and operational capacities, *we have not yet
succeeded in* reducing to the discrete, the digital, the purely diffe-
rential. As for the mysterious phenomenon of the image which
'resembles', it may be enough for the moment to have recognised
processes of codification concealed in the mechanisms of percep-
tion themselves. If there is codification on this basis, then there is all
the more reason for syntagms[3] of stylistic value to be acquired, at
the level of larger syntagmatic groups and of iconological conven-
tions.

Undoubtedly the iconic codes are weaker, more transitory,
limited to restricted groups or to the choices of a single person,
inasmuch as they are not strong codes like those of verbal language;
and in them the optional variants prevail over the truly pertinent

features. But we have been taught, too, that the optional variants, like the prosodic features (that is to say, the intonations which add determinative meanings, on the phonetic plane, to the phonological articulations) can be subjected to conventionalisation.

Undoubtedly, too, it is difficult to separate distinctly an iconic sign into its elements of primary articulation. An iconic sign, as was said before, is nearly always a *seme*[4] – i.e. something which does not correspond to a word in the verbal language but is still an utterance. The image of a horse does not mean 'horse' but as a minimum 'a white horse stands here in profile'.

And Martinet's school (I am referring in particular to the latest investigations of Luis Prieto) has demonstrated that codes exist which conventionalise semes not otherwise subdivisible into minor articulatory units. Thus codes exist with a single articulation only, either the first or the second (we shall return to this point below). It would be enough, then, for a semiological investigation to catalogue conventional semes, and then decodify at that level. And now all that has gone before enables us to draw up a table of possible and recognisable articulations in a more analytical way, if for no other reason than to indicate directions for subsequent testing.[5]

Summary of Codes

1 *Perceptive codes:* studied within the psychology of perception. They establish the conditions for effective perception.

2 *Codes of recognition:* these build blocs of the conditions of perception into *semes* – which are blocs of signifieds (for example, black stripes on a white coat) – according to which we recognise objects or recall perceived objects. These objects are often classified with reference to the blocs. The codes are studied within the psychology of intelligence, of memory, or of the learning apparatus, or again within cultural anthropology (see the methods of classification of primitive civilisations).

3 *Codes of transmission:* these construct the determining conditions for the perception of images – the dots of a newspaper photo, for instance, or the lines which make up a TV image. They can be analysed by the methods of information-theory physics. They establish how to transmit a sensation, not a prefabricated perception. In defining the texture of a certain image, they infringe on the aesthetic qualification of the message and hence give rise to *tonal*

codes, codes of taste, stylistic codes, and codes of the unconscious.

4 *Tonal codes:* this is the name we are giving to (i) the systems of optional variants already conventionalised – the prosodic features which are connoted by particular intonations of the sign (such as 'strength', 'tension', etc.); (ii) the true systems of connotations already stylised (for example, the 'gracious' or the 'expressionistic'). These systems of conventions accompany the pure elements of iconic signs as an added or complementary message.

5 *Iconic codes:* usually based on perceptible elements actualised according to codes of transmission. They are articulated into *figures, signs,* and *semes.*

(a) *Figures.* These are conditions of perception (e.g. subject – background relationship, light contrasts, geometrical values) transcribed into graphic signs according to the rules of the code. These figures are not infinite in number, nor are they always discrete. For this reason the second articulation of the iconic code appears as a continuum of possibilities from which many individual messages emerge, decipherable within the context, but not reducible to a precise code. In fact the code is not yet recognisable, but this is not to say it is absent. At least we know this: if we alter the connection between figures beyond a certain limit, the conditions of perception can no longer be denoted.

(b) *Signs.* These denote (i) semes of recognition (nose, eye, sky, cloud) by conventional graphic means; or (ii) 'abstract models', symbols, conceptual diagrams of the object (the sun as a circle with radiating lines). They are often difficult to analyse within a seme, since they show up as non-discrete, as part of a graphic continuum. They are recognisable only in the context of the seme.

(c) *Semes.* These are more commonly known as 'images' or 'iconic signs' (a man, horse, etc.). In fact they formulate a complex iconic phrase (of the kind 'this is a horse standing in profile', or at least 'here is a horse'). They are the most simply catalogued, and an iconic code often works at their level only. Since it is within their context that iconic signs can be recognised, they stand as the key factors in communication of these signs, juxtaposing them one against the other. Semes should therefore be considered – with respect to the signs permitting identification – as an *ideolect.*

Iconic codes shift easily within the same cultural model, or even the same work of art. Here visual signs denote the foreground

subject, articulating the conditions of perception into figures; while the background images are reduced to all-encompassing semes of recognition, leaving the rest in shadow. (In this sense the background figures of an old painting, isolated and exaggerated, tend to look like some modern paintings – modern figurative art moving further and further away from the simple reproduction of conditions of perception, to reproduce only a few semes of recognition.)

6 *Iconographic codes:* these elevate to 'signifier' the 'signified' of iconic codes, in order to connote more complex and culturalised semes (not 'man', 'horse', but 'king', 'Pegasus', 'Bucephalus', or 'ass of Balaam'). Since they are based on all-encompassing semes of recognition, they are recognisable through iconic variations. They give rise to syntagmatic configurations which are very complex yet immediately recognisable and classifiable, such as 'nativity', 'universal justice', 'the four horsemen of the Apocalypse'.

7 *Codes of taste and sensibility:* these establish (with extreme variability) the connotations provoked by semes of the preceding codes. A Greek temple could connote 'harmonious beauty' as well as 'Grecian ideal' or 'antiquity'. A flag waving in the wind could connote 'patriotism' or 'war' – all connotations dependent on the situation. Thus one kind of actress in one historical period connotes 'grace and beauty', while in another period she looks ridiculous. The fact that immediate reactions of the sensibilities (such as erotic stimuli) are superimposed on this communicative process does not demonstrate that the reaction is natural instead of cultural: it is convention which makes one physical type more desirable than another. Other examples of codification of taste include: an icon of a man with a black patch over one eye, connoting pirate within the iconological code, comes to connote by superimposition 'a man of the world'; another icon connotes 'wicked', and so on.

8 *Rhetorical codes:* these are born of the conventionalisation of as yet unuttered iconic solutions, then assimilated by society to become models or norms of communication. Like rhetorical codes in general, they can be divided into *rhetorical figures, premises,* and *arguments.*
　(a) *Visual rhetorical figures.* These are reducible to verbal, visualised forms. We find examples in metaphor, metonymy, litotes, amplification, etc.

(b) *Visual rhetorical premises.* These are iconographic semes bearing particular emotive or taste connotations. For example, the image of a man walking into the distance along a never-ending tree-lined road connotes 'loneliness'; the image of a man and woman looking lovingly at a child, which connotes 'family' according to an iconographic code, becomes the premise for an argument along the lines: 'A nice happy family is something to appreciate.'

(c) *Visual rhetorical arguments.* These are true syntagmatic concatenations imbued with argumentative capacity. They are encountered in the course of film editing so that the succession/opposition between different frames communicates certain complex assertions. For example, 'the character *X* arrives at the scene of the crime and looks at the corpse suspiciously – he must either be the guilty party, or at least someone who is to gain by the murder'.

9 *Stylistic codes:* these are determinate original solutions, either codified by rhetoric, or actualised once only. They connote a type of stylistic success, the mark of an 'auteur' (e.g. for a film ending: 'the man walking away along a road until he is only a dot in the distance – Chaplin'), or the typical actualisation of an emotive situation (e.g. a woman clinging to the soft drapes of an antechambre with a wanton air – Belle Epoque eroticism'), or again the typical actualisation of an aesthetic ideal, technical-stylistic ideal, etc.

10 *Codes of the unconscious:* these build up determinative configurations, either iconic or iconological, stylistic or rhetorical. By convention they are held to be capable of permitting certain identifications or projections, of stimulating given reactions, and of expressing psychological situations. They are used particularly in persuasive media.

Chapter 3

Photographic Practice and Art Theory[1]

Victor Burgin

I

... than at any time does a simple *reproduction of reality* tell us anything about reality. A photograph of the Krupp works or GEC yields almost nothing about these institutions. Reality proper has slipped into the functional. The reification of human relationships, the factory, let's say, no longer reveals these relationships. Therefore something has actually to be *constructed*, something artificial, something set up.

These remarks by Brecht were quoted nearly fifty years ago by Walter Benjamin in his article 'A Short History of Photography'.[2] In the intervening years considerable attention has been paid to the mechanics of signification, work of great relevance to those concerned to construct meanings from appearances. However, and leaving aside film, the influence of such theory within art has so far been confined to a very few of those manifestations which have attracted the journalistic tag 'conceptual'. One thing conceptual art has done, apart from underlining the central importance of theory, is to make the photograph an important tool of practice. The consequence of such moves has been to further render the categorical distinction between art and photography ill-founded and irrelevant. The only gulf dividing the arts today separates the majori-

ty still laden with the aesthetic luggage of Romanticism and Romantic Formalism (Modernism) from the rest.

Benjamin accurately described the debate over the respective merits of painting and photography as 'devious and confused . . . the symptom of a historical transformation the universal impact of which was not realised by either of the rivals'.[3] In the nineteenth century the arts of painting and sculpture entered a crisis from which they did not recover. Increasingly estranged from their social context by the processes of democratisation, they suffered added displacement with the invention of photography and the harnessing of this invention to the means of mass production. In 'The Work of Art in the Age of Mechanical Reproduction' Benjamin describes the functional dislocation of works of art which occurred when their mechanical reproduction severed them from their cult value as autonomous objects. He finds that photography also suffered in the encounter, particularly from

> this fetishistic, fundamentally anti-technical notion of *Art* with which theorists of photography have tussled for almost a century without, of course, achieving the slightest result. For they sought nothing beyond acquiring credentials for the photographer from the judgement-seat which he had already overturned.[4]

The fetishistic and anti-technical notion of art is no less prevalent now than it was at the time Benjamin named it. Its correlate is an equally fetishistic and anti-technical notion of the production of meaning. It seems to be extensively believed by photographers that meanings are to be found in the world much in the way that rabbits are found on downs, and that all that is required is the talent to spot them and the skill to shoot them. A certain *je ne sais quoi*, which may be recognised but never predicted, may produce art out of the exercise. But those moments of truth for which the photographic opportunist waits, finger on the button, are as great a mystification as the notion of autonomous creativity.

On the back cover of my paperback volume of Diane Arbus photographs I can read the opinions of two 'authorities'.[5] One tells me 'Her pictures . . . are concerned with private rather than social realities. . . . Her real subject is no less than the unique interior lives of those she photographed.' The other, having informed me that Arbus is 'a legend', goes on to say of her pictures: 'it is their dignity that is, I think, the source of their power'. Typical of the romantic aesthetic attitudes which continue to prevail today is the notion that

there are unique essences within things and people which are ordinarily concealed from us by appearances but which artistic genius can reveal to us. Typical of the 'criticism' informed by such notions is the luxury of being equivocal about what is already vague. Now consider the Arbus photographs. For example, Figure 3.1(b) is of a family, perhaps the most important basic structural unit in society. The desirability, the 'closeness', and the joy of family life are centrally important concepts in legitimating and supporting this unit. In an environment of billboards, popular press, television, and commercial cinema it is difficult to pass a single day without encountering some visual representation of the family. One such representation is reproduced on p. 42 (Figure 3.1(a)) alongside the Diane Arbus version; no further comment is required. Or, again, consider the series in the second row. Here the Arbus picture (Figure 3.2(b)) has a component in common in the pose depicted. This pose is a conventional sign for sexual desirability allied, at least in principle, to accessibility. Although its origins are probably elsewhere, in our own time it belongs to the visual vocabulary of the 'glamour pic', an example of which is provided on p. 43 (Figure 3.2(a)). The quotation of this form by Arbus is rendered ironic through its amalgamation with an anomalous content.

Yet again, the effect of the Diane Arbus photograph of identical twins (Figure 3.3(a)) is largely an effect of *similarity* itself, just as the press photograph reproduced alongside (Figure 3.3(b)) gains its effect, conversely, from the dissimilarity between its main elements. It is not a matter of 'genius' on the one hand, and the lucky snapping of a 'moment of truth' on the other.

The point is: the basis of any 'mood' or 'feeling' these pictures might produce, as much as any overt 'message' they might be thought to transmit, depends not on something individual and mysterious but rather on our common knowledge of the typical representation of prevailing social facts and values: that is to say, on our knowledge of the way objects transmit and transform ideology, and the ways in which photographs in their turn transform these. To appreciate such operations we must first lose any illusion about the neutrality of objects before the camera.

II

Obviously, photography only takes place where there is light and a substance which reflects light. This substance is the stuff of our

Figure 3.1(a) Sherry advertisement

Figure 3.1(b) Diane Arbus, *A family on their lawn one Sunday in Westchester, N.Y.*, 1968

Figure 3.2(b) Diane Arbus, *Nudist lady with swan sunglasses, Pa.*, 1965

Figure 3.2(a) Pin-up

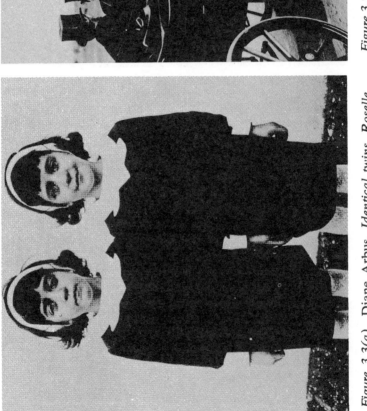

Figure 3.3(a) Diane Arbus, *Identical twins, Roselle, N.J., 1967*

Figure 3.3(b) Central Press, *King George V at the Derby*

material environment; amongst it we discriminate between hard and soft stuff, animate and inanimate stuff, and so on; we discriminate between physical things. Certainly it is these 'things' which photography provides pictures of, but things are never simply *things* to us. Externalising his physical needs, man ascribes a *use-value* to the things about him (for example, he opposes the edible to the inedible). Further, he intervenes in the environment, re-forming through his labour the substances given in nature. A stone which is first a brute physical substance becomes here a hammer, there an axe. The axe and the hammer may be said to belong to the same object system within which, in spite of their similarities, they are differentiated according to observable characteristics: bluntness on the one hand, sharpness on the other. These characteristics are at once the signs of their actual or potential use and the trace of man's activity upon them. Obviously they are no longer mere fragments of rock. Although remaining substantially identical they are now formally differentiated, they have taken on a meaning. Moreover, all previously 'mute' stones in the environment are now overlain with projected significance. This one is hard in a certain way, say obsidian, and is 'good for axes'; this one is hard and heavy, say granite, and 'good for hammers'; another is soft and powdery, pumice, and 'good for scouring'.

Differences imposed upon material substances are *transformed* in sound. The variants bluntness and sharpness become designated by conventions of sound variation. Humanly produced cries, themselves at first brute physical 'sound substances', become here the word 'blunt', there the word 'sharp'. Material production and language production both stem from the same need to order the environment. The human labourer must learn how to differentiate and compose his materials. He must learn how to form what is natural (the stone, his cries) into what is cultural (the axe, the word). Language is an artefact among other artefacts, an instrument among other instruments by which man organises his environment. It is a *tool* used to perform a certain class of operations in the environment. It is however a doubly privileged tool: not only providing the means of socialising all instrumental operations but also providing the means of constructing those abstractions which locate these operations within a *culture*.

In the very moment of their being perceived, objects are *placed* within an intelligible system of relationships (no reality can be

innocent before the camera). They take their position, that is to say, within an *ideology*. By ideology we mean, in its broadest sense, a complex of propositions about the natural and social world which would be generally accepted in a given society as describing the actual, indeed necessary, nature of the world and its events. An ideology is the sum of taken-for-granted realities of everyday life; the pre-given determinations of individual consciousness; the common frame of reference for the projection of individual actions. Ideology takes an infinite variety of forms; what is essential about it is that it is contingent and that *within it the fact of its contingency is suppressed.*

It is in this taking for granted as natural and immutable that which is historical and contingent that we encounter ideology in the classic Marxist sense. In this sense the essence of ideology is that it represents the individual's 'false consciousness' of his actual conditions of existence. For example, Marx declared that the belief common to both factory owner and factory worker that labour may fairly be bought for wages is a mystification. The illusion conceals the fact that, as the value of a commodity depends on the labour invested in it, the owner is appropriating as profit what belongs by right to the labourer: profits are unpaid wages. Where such a conception is embedded in the prevailing ideology, it will also be embodied in prevalent forms of language. It is common, for instance, to speak of people 'making money' out of speculation in stocks or currency. These people do not make money in any literal sense; that is the business of the Royal Mint. And neither do they create wealth, which is done by those engaged in productive labour. The expression 'making money' therefore presents as a mystification, as a sort of knack of conjuring money out of the air, the less utterable fact that wealth is again merely being appropriated.

Forms of artefacts, as much as forms of language, serve to communicate ideologies. If clothing were simply functional, then it is unlikely we would see either the static uniformity of dress in People's China or the dynamic uniformity of dress in the King's Road. Each ostensibly functional material item which appears in the world is classified as an object variant and integrated into an object system. The greater the range of object variants, the richer the semantic possibilities (more is 'said' with motor-cars in the West than in the East). It is not simply a matter of 'status symbols', a

notion as ambiguous as it is ubiquitous. The total ideology of a society is imprinted in its production and consumption of material objects. Even the natural landscape is appropriated by ideology, being rendered, in anthropocentric perception, 'beautiful' or 'hostile' or 'picturesque'. All that constitutes reality for us is, then, impregnated with meanings. These meanings are the contingent products of history and in sum reflect our ideology. We may acknowledge this in an act of theroretical reflection, but not at the moment of perception. As Stephen Heath has put it:[6]

At the level of absolute acceptance meaning, paradoxically, would be everywhere and nowhere: everywhere in the perfect clarity of the immediately and always intelligible reality, nowhere in that this reality is lived as immediacy, as isomorphically simultaneous with Reality, in a manner which reduces the process of knowledge to one of recognition.

This distancing of the subject from a separate and neutral reality, in what Husserl called the 'natural attitude', is magnified when the world is viewed through a lens. Compressed against the viewing screen into a single plane, chopped by the viewfinder into neat rectangles, the world is even more likely to be experienced as remote and inert (news cameramen have been killed by their 'shot' of a soldier pointing a gun). However, the naturalness of the world ostensibly open before the camera is a deceit. Objects present to the camera are *already in use* in the production of meanings, and photography has no choice but to operate upon such meanings. There is, then, a 'pre-photographic' stage in the photographic production of meaning which must be accounted for.

The contradictory impulses of man to semanticise objects and to camouflage his communicative intention is a dominant theme in much of Roland Barthes's writing. In *Mythologies* Barthes presents a Marxist-inspired critique of the collective representations – photography, shows, cooking, reporting, etc. – of bourgeois society. The bourgeoisie, 'the social class which does not want to be named', presents its ideology, here called 'myth', as nature. Barthes attempts a systematic demystification of this 'nature', systematic because myth, according to Barthes, is a system of communication, a form. It would be irrelevant, therefore, to attempt to differentiate mythical objects on the basis of their substance. The very notion of

'mythical object' is unfounded without knowledge of the system within which it serves; thus 'there are formal limits to myth, there are no substantial ones . . . every object in the world can pass from a closed, silent existence to an oral state, open to appropriation by society.'[7]

One of the examples Barthes gives of mythical speech is that of a *Paris-Match* cover showing a young Negro, dressed in French uniform and giving a military salute, his eyes uplifted, 'no doubt fixed on a fold of the tricolour'. Barthes observes that the literal meaning of the image is indisputable: It is that a Negro is giving the French salute. 'But whether naively or not, I see very well what it signifies to me: that France is a great Empire, that all her sons, without any colour discrimination, faithfully serve under her flag, and that there is no better answer to the detractors of an alleged colonialism than the zeal shown by this Negro in serving his so-called oppressors.'[8]

Here, it is as if the natural meaning were drained from the image. Converted into mere vacant form, it now serves to receive an ideological content. But even in the instant we make this observation the literal meaning returns. Just as when driving I cannot focus simultaneously on the windscreen and the landscape I can see beyond it, neither can I grasp simultaneously the literal meaning and its ideological motivation: these are caught in a constant 'turnstile':

> The meaning will be for the form like an instantaneous reserve of history, a tamed richness, which it is possible to call and dismiss in a sort of rapid alternation. . . . It is this constant game of hide-and-seek between the meaning and the form which defines myth.[9]

The literal meaning, Barthes says, serves as 'alibi' to the myth.

'Alibi', 'turnstile', 'hide-and-seek', this heaping of metaphors to hold down an intuition is a familiar strategy. Barthes, however, attempts beyond this to grasp the operation of the production of sense in a non-metaphorical expression, to describe the way myth works in structural terms independent of individual manifestations. To this end he turns to the schema offered by linguistic science.

The formation of structural descriptions of social phenomena according to linguistic models may be recognised as a 'structuralist' strategy. This is not the place to survey the field of so-called Structuralism. Obviously, provided it is not completely amorphous,

any phenomenon may be described in structural terms and there are few insights into Structuralism to be gained from a meditation on the word 'structure'. We might in fact concur with the view that 'Structuralism exists only for those who do not participate in it.'[10] It should be emphasised therefore that what follows is not a description of Structuralism but only of an aspect, or type, of structuralist analysis. Particularly, in the main, the type associated with Roland Barthes, more particularly the Barthes of *Mythologies, Elements of Semiology*, and *Système de la Mode*. As Structuralism enjoyed such a vogue in the 1960s, at least in France, it may be all the more tempting now for those who gave scant attention to the texts in the first place to dismiss it as *passé*. Like any other scientific postulate, however, the classic framework of structuralist analysis will 'live dangerously' until replaced by a more promising set of hypotheses. As Barthes himself has put it:

If one agreed to define the social sciences as coherent, exhaustive and simple languages (Hjelmslev's empirical principle), that is as operations, each new science would then appear as a new language which would have as its object the metalanguage which precedes it, while being directed towards *the reality object which is at the root of these 'descriptions'*; the history of the social sciences would thus be, in a sense, a diachrony of metalanguages, and each science, including of course semiology, would contain the seeds of its own death, in the shape of the language destined to speak it.[11]

The texts resumed here have been extensively discussed elsewhere, and now belong to a *history* of semiology. However, I make no apologies for *re*presenting them at this present juncture, because art and photographic theory and practice in Britain and America have not yet confronted them.

III

In a publication of 1966, Roland Barthes remarked that:

The present pre-eminence of linguistic problems is irritating some people, who see it as an excessive fashion . . . however . . . we have to discover language, just as we are in process of discovering space: our century will perhaps be marked by these two explorations.[12]

With *Elements of Semiology* Barthes had recommended that descriptive models from structural linguistics be tentatively

generalised to signifying systems other than natural language: 'The
Elements here presented have as their sole aim the extraction from
linguistics of analytical concepts which we think *a priori* to be
sufficiently general to start semiological research on its way.'[13] As
his point of departure Barthes took the work of the Swiss linguist
Ferdinand de Saussure, whose *Course in General Linguistics* appeared, three years after Saussure's death, in 1916. In the *Course*,
Saussure had said:

> *A science that studies the life of signs within society* is conceivable;
> it would be a part of social psychology and consequently of
> general psychology; I shall call it *semiology* (from Greek sémeîon: 'sign'). Semiology would show what constitutes signs, what
> laws govern them. Since the science does not yet exist, no-one can
> say what it would be; but it has a right to existence, a place staked
> out in advance.[14]

Saussure predicted that linguistics was destined to become simply
a part of this general science of signs. Fifty years after Saussure,
however, Barthes observed:

> though working at the outset on non-linguistic substances,
> Semiology is required, sooner or later, to find language (in the
> ordinary sense of the term) in its path, not only as model, but also
> as component, relay or signified. Even so, such language is not
> quite that of the linguist: it is a second-order language, with its
> unities no longer monemes or phonemes, but larger fragments of
> discourse referring to objects or episodes whose meaning *underlies* language, but can never exist independently of it. Semiology
> is therefore perhaps destined to be absorbed into a translinguistics. . . . In fact, we must now face the possibility of inverting Saussure's declaration: linguistics is not a part of the general
> science of signs, even a privileged part, it is semiology which is a
> part of linguistics.[15]

Elements of Semiology is constructed around the discussion of
four pairs of dichotomous concepts, named in the headings to the
book's four chapters: *Language (Langue) and Speech*; *Signifier and
Signified*; *Syntagm and System*; *Denotation and Connotation*. The
first three pairs come from Saussure's *Course*, and the final pair is
from the writings of the Danish linguist Louis Hjelmslev. In each
chapter Barthes first describes the linguistic concepts in some detail
and then suggests their possible application outside linguistics.

Language (Langue) and Speech

In its experienced totality, the phenomenon of language *(le lan-gage)* consists of a complex of disparately based events: psychological, physiological, physical, social, etc. Saussure saw that a properly constituted *science* of linguistics must disengage its own object from this phenomenological confusion. He therefore conceived of a general linguistics which, prior to the study of any particular language in itself, would provide concepts by whose means the proper object of linguistic study might be isolated. This object Saussure called *la langue*. Langue *('la partie social du langage')* is a purely institutional object:

a storehouse filled by the members of a given community through their active use of speaking, a grammatical system that has a potential existence in each brain, or, more specifically, in the brains of a group of individuals. For language is not complete in any speaker; it exists perfectly only within a collectivity.[16]

Parole on the other hand is a purely individual act of selection involving in its performance individual peculiarities of intonation, hesitations, mistakes, accent, etc: 'In separating language from speaking we are at the same time separating: (1) what is social from what is individual; and (2) what is essential from what is accessory and more or less accidental.'[17]

The majority of modern linguists agree with the methodological necessity of the distinction between *langue* and *parole*. Chomsky's concepts of 'competence' and 'performance' make roughly this distinction, but they diverge on the question of the criteria upon which the distinction is to be made. For present purposes it is sufficient to note that individual utterances, or speech acts *(parole)* are taken by linguists as the empirical evidence of an underlying, communally understood system *(langue)*. It is this system of elements, rules and relations which determines the common structural characteristics of individual utterances, and it is this system which the linguist aims to describe.

It is necessary at this juncture to emphasise two important facts:

(1) the elements of the system are defined *only* in their relationships with other elements of the system;

(2) evolutionary, historical relationships are irrelevant to the description of the system.

The first point concerns Saussure's notion of *value*, the second his notion of 'static' or *synchronic* description.

Barthes remarks that the effect of the idea of value 'is to de-psychologise linguistics and bring it closer to economics'. In both economics and linguistics we are dealing with a system in which dissimilar things are *exchanged* (work and wage, *signifier* and *signified*) and also in which similar things are *contrasted:* a 5p piece may be exchanged for a newspaper or a bar of chocolate, but it also has a place in a system in which it stands in contrast to a 2p and a 10p piece. The French word *'mouton'* covers both the live animal and the cooked meat on the table, whereas the English term 'mutton' covers only the meat. The value of the English term 'mutton' is partially derived from its coexistence with the term 'sheep', that is to say, from the opposition *cooked/living*.

The concept of value is of fundamental importance in structural-ist analysis. It is this principle which denies the validity of conceiving the elements of a system as substantial individuals:

> For instance, we speak of the identity of two 8:25p.m. Geneva-to-Paris trains that leave at twenty-four hour intervals. We feel that it is the same train each day, yet everything – the locomo-tives, coaches, personnel – is probably different. Or if a street is demolished, then rebuilt, we say that it is the same street even though, in a material sense, perhaps nothing of the old one remains. Why can a street be completely rebuilt and still be the same? Because it does not constitute a purely material entity; it is based on certain conditions that are distinct from the materials that fit the conditions, e.g. its location with respect to other streets. Similarly, what makes the express is its hour of departure, its route, and in general every circumstance that sets it apart from other trains. Whenever the same conditions are fulfilled, the same entities are obtained. Still, the entities are not abstract since we cannot conceive of a street or a train outside its material realization.[18]

Or again, the shape of the letter *u* as it recurs in a handwritten manuscript may vary considerably: what is important is that varia-tion is confined within certain bounds so that it is not, for example, confused with the letters *a* or *y*. The *u* is a *form* determined only in its functional oppositions to other forms within the alphabetic system.

Saussure illustrates the principle of synchrony by analogy with a game of chess. A game may have been in progress for a number of days; but when it comes to describing the state of play the spectator

who has watched every move has no advantage over the person who looks at the board for the first time. We do not need to know the history of the moves to describe the state of play at any given moment. (Saussure refers therefore to an *'état de langue'*.) Or, to take an example from photography, the fact that the 'soft-focus' style of photography originated as a response to purely technical exigencies is irrelevant to a description of its present signification.

A theory of 'photographic competence' would restrict its attention to a synchronically given 'state' of photography. A given individual 'image' would be of interest only to the extent that it provided evidence of the underlying interplay of forms of which the image is a contingent substantial realisation. The parameters of these forms would be differentially determined in their mutual oppositions within a system. The purpose of the theory would be to identify those systems of regularities which allow the production of meanings through photography.

Signifier and Signified

In Saussurian terminology, the signifier and the signified (*signifiant*, *signifié*) are the two components of the *sign*. The notion of the sign is of fundamental importance to linguistics and is also notoriously difficult to define; however, it may initially be described as: 'an entity which (1) can become sensible and (2) for a given group of users, *marks an absence* in itself'.[19] The part of the sign which can become sensible is, in Saussure, the signifier. The 'absent' part is the signified. The relation which joins them is that of signification.

The signifier is that substantial entity which the unreflecting person may mistakenly *identify* with the sign: for example, the printed words on this page, or the physical sounds when they are read aloud. The signified is the *sense* with which the reader invests these graphic or phonic configurations (in Saussure's terms, the 'concepts' he associates with them). The sign is therefore 'the union of a signifier and a signified (in the fashion of the recto and verso of a sheet of paper)'.[20]

The image of a coin may help clarify Saussure's notion of the sign. A penny has both a 'head' and a 'tail' side, yet we would not say that the penny is either one or the other. The penny is the simultaneous presence of the two. Similarly the sign is the simultaneous presence of signifier and signified.

The major disadvantage of Saussure's notion of the sign is that it

presents a misleading picture of language as a set of coded one-to-
one correspondences; each signifier appearing, as it were, with a
signified engraved on its reverse. This may be the case with road-
signs but not with language, which is not passively decoded but
creatively interpreted. In a radical critique of such a notion of the
sign, Derrida has identified a 'metaphysics of presence' throughout
Western thought bound particularly to the notion of the primacy of
oral speech over writing. He quotes Aristotle:

Sounds emitted by the voice are symbols of states of the soul, and
written words the symbols of words emitted by the voice [and he
observes that here] the voice, producer of *prime symbols*, has an
essential and immediate relation with the soul. Producer of the
first signifier, it is not a simple signifier amongst others. It
signified the 'state of the soul' which itself reflects or reflects upon
things by means of natural likeness. Between existence and the
soul, between things and affections, there would be a relation of
translation or of natural signification; between the soul and the
logos, a relation of conventional symbolization.[21]

Thus oral speech (logos) is in a privileged proximity to the subject,
to the communicative *presence* which is the sole authoritative source
of the meaning of the communication. Writing, on the other hand,
Derrida observes, was condemned by Plato precisely because it
severs the communication from the communicator, the source of its
veracity. The written text, particularly the literary text, is the
occasion for a play of interpretations, a play of differences between
elements, in which 'the meaning' is constantly deferred. This simul-
taneity of differing and deferring Derrida indicates in the term
différance.
As Derrida himself observes:

Peirce goes very far in the direction which we have called . . . the
de-construction of the transcendental signified . . . the so-called
'thing itself' is always already a *representamen* abstracted from the
simplicity of what is intuitively obvious. The *representamen* func-
tions only in giving rise to an *interpretant* which itself becomes sign
and so on to infinity. The identity itself of the signified is
concealed and displaced ad infinitum.[22]

Thus, presented with any text whatsoever, visual or verbal, the
notion of 'true signified' must yield to Derrida's *différance* or

Peirce's 'unlimited semiosis'. The alternative is a metaphysics of interpretation through which an attempt is made to reconstitute the missing 'presence' which is felt to be the source of a singular and true content of the empirically given form of the text. All too obviously such a metaphysics provides the framework of most photographic criticism with its preoccupation with intentions (the 'committed photographer', etc.). Jonathan Culler has remarked that, within such a framework, 'Notions of truth and reality are based on a longing for an unfallen world in which there would be no need for the mediating systems of language and perception but everything would be itself, with no gap between form and meaning.'[23] It is this logocentric longing which is expressed in the 'window-on-the-world' realism of the great majority of writers on photography.

Syntagm and System

In discourse, 'words acquire relations based on the linear nature of language because they are chained together. This rules out the possibility of pronouncing two elements simultaneously. . . . Combinations supported by linearity are *syntagms*.'[24]

Opposed to the plane of syntagms is what Saussure called the plane of 'associations'. Outside discourse, 'words acquire relations of a different kind. Those that have something in common are associated in the memory, resulting in groups marked by diverse relations.'[25]

In modern linguistics, Saussure's plane of associations is referred to as the plane of the 'system' or 'paradigm'. A particular linguistic unit is said to enter into syntagmatic relations with all the other units with which it is actually associated in a spoken or written chain. It is said to enter into paradigmatic relations with all the other units which might potentially replace it at its particular position in that chain. Thus, 'by virtue of its potentiality of occurrence in the context /-et/ the expression element /b/ stands in paradigmatic relationship with /p/,/s/, etc.; and in syntagmatic relationship with /e/,/t/'. Moreover, these relations obtain at every level of linguistic description, so 'by virtue of its potentiality of occurrence in such contexts as *a . . . of milk*, the word *pint* contracts paradigmatic relations with such other words as *bottle*, *cup*, *gallon*, etc., and syntagmatic relations with *a*, *of*, and *milk*'.[26]

Syntagm and system are, therefore, the two 'axes' of language. The plane of the syntagm is that of *addition*, of the combination of linguistic elements. The plane of the system is that of *substitution*. In a celebrated study of aphasia Jakobson has shown that although the language deficiencies of aphasia have an anatomical cause (lesions at the cerebral centre for the affected linguistic function), these deficiences may be subjected to a purely linguistic categorisation. Thus the two main types of aphasia align themselves along the two major axes of sign usage: in *similarity disorders* the ability to select and substitute elements is affected, while the ability to combine is relatively unimpaired; in *contiguity disorders* it is combination which becomes progressively chaotic, while selection and substitution remain comparatively normal.

In the course of this study Jakobsen assimilates the two dimensions of 'combination' and 'selection' to 'the two polar figures of speech', *metaphor* and *metonymy*, and has shown that style may be interpreted according to these polarities. In the metaphoric mode, the primary mode of poetry, elements are associated by virtue of their similarity. In the metonymic mode, typical of 'realist' prose, elements are associated through their contiguity. Jakobsen himself has indicated the application of this dichotomy in the analysis of signifying systems other than language itself:

> The same oscillation occurs in sign systems other than language. A salient example from the history of painting is the manifestly metonymical orientation of Cubism, where the object is transformed into a set of synecdoches; the surrealist painters responded with a patently metaphorical attitude. Ever since the productions of D. W. Griffith, the art of the cinema, with its highly developed capacity for changing the angle, perspective and focus of 'shots', has broken with the tradition of the theatre and ranged an unprecedented variety of synecdochic 'close-ups' and metonymic 'set-ups' in general. In such motion pictures as those of Charlie Chaplin and Eisenstein, these devices in turn were overlayed by a novel, metaphoric 'montage' with its 'lap dissolves' – the filmic similes.[27]

Denotation and Connotation

It was through a reflection upon the dual nature of the sign that Saussure arrived at his conception of *langue* as essentially a form:

'Linguistics then works in the borderland where the elements of sound and thought combine; *their combination produces a form, not a substance.*'[28] The 'glossematic' theory of the Danish linguist Louis Hjelmslev develops the concern with form to the extent of disassociating it from any phonological or semantic actuality. It is at this level of abstraction that linguistics draws closest to 'languages' other than natural language and promises to become, as Saussure wished, a general science of all languages: semiology.

Hjelmslev defined a language as consisting of two planes, the planes of 'expression' and 'content'. The first corresponds to the plane of the signifiers and the second to the plane of the signifieds. Within each of these two planes he applies the dichotomy form/substance. Following Hjelmslev[29] we may speak of a 'conformal language' when the two planes have exactly the same formal organisation, differing only in substance (as in the case of mathematical systems, where the elements and relations are coterminal with their meaning). Among the non-conformal languages is 'denotative language', where neither of the two planes is itself a language (as in natural language in its everyday use). When the plane of content itself is a language, we are in the presence of a 'meta-language' (as in the technical language of linguistics which has natural language as its content).

When the plane of expression itself already constitutes a language, then this is a case of 'connotative language' (as in the literary uses of natural language). For example:

When Stendhal uses an Italian word, signifier, it is not only the term used, but the fact that, to express a certain idea, the author may have decided to turn to Italian, and this recourse has as its signified a certain idea of passion and of liberty, connected, in the Stendhalian world, with Italy.[30]

In the case of connotion, then, the signifier is not so much the word chosen as the fact of its having been chosen.

Thus, while the expressions 'Close the door, please', 'Do be so kind as to close the door', and 'Put t'wood in t'ole, will yer', are at the denotative level interchangeable, as connotators they are quite distinct.

The different formations of denotation, metalanguage and connotation are easiest to grasp in the diagram form Barthes has suggested:

Denotation	E	R	C
Metalanguage	E	R	C

$$\underbrace{E \quad R \quad C}$$

Connotation	E	R	C

$$\overbrace{E \quad R \quad C}$$

Expression (*E*) and content (*C*) are defined only in their mutual relation (*R*). *ERC* is a (*denotative*) language. When a language becomes the *object language* of another (second-degree) language, that is to say when a language (*ERC*) becomes the content (*C*) of another language, then the second-degree language is a *metalanguage*. When a language is taken up as the expression plane (*E*) of another language, then the language of the second degree is a *connotative* language.

Barthes emphasises that all three formations may be found in a single text. Fashion writing is metalinguistic in taking a 'language' (the vestimentary system) as its object. Simultaneously, the metalinguistic text is absorbed as expression plane within a connotative language. Thus we recognise a difference in 'tone' between types of fashion writing (see below):

	E	R	C
			Ideology of:
	$\overbrace{\text{E} \quad \text{R} \quad \text{C}}$		(i) conspicuous consumption
Fashion writing of:			(ii) radical chic
(i) *Vogue*			
(ii) *Nova*			
	$\overbrace{\text{E} \quad \text{R} \quad \text{C}}$		
	extant garments		vestimentary meanings

Following Hjelmslev ('the Danish language is expression for a content that is the Danish nation, the family and the home; and in the same way, different styles are expressions, or symbols, for contents consisting of certain elements that lie outside the styles'[31]), it is Barthes who has been most concerned to examine the relationship between connotation and ideology. *Mythologies* aims to show that by describing the process of signification of mythical speech we may thereby 'undo' it. In describing Barthes's work, Stephen Heath

has asserted that 'semiology cannot but bring a derangement of sense in its train'. In respect of myth's operation the schema of connotation provides 'at once the means of comprehending this operation and of representing this comprehension', so that 'in its encounter with connotation semiology is to be defined as a tool of ideological analysis'.[32] Such claims are problematic, but this is not the place to discuss the putative objectivity of semiology as a means of describing ideology.

IV

The rudimentary mechanics of the linguistic model described so far can be illustrated in its semiological extension by applying it to the case of clothing. There are identifiable, commonly used units of clothing (shoes, jackets, hats, etc.) which are combined according to commonly held conventions. There are rules of syntagmatic association (the shirt is worn under the jacket); and rules of syntagmatic exclusion (a tie is not worn with a roll-neck jersey); and within the completed syntagm of a fully dressed individual there is ample scope for paradigmatic substitution (a bowler for a beret). In the case of clothing the conventional elements and rules of combination together constitute a *langue*. *Parole* would then be the individual choices of elements and 'grammatical style', with certain examples of *parole* being absorbed into *langue* (the Wellington boot, the Windsor knot). At the level of denotation the signifier 'bowler hat' will take as its signified such a sense as 'article of clothing to be worn on the head for protection against the elements'. At the level of connotation it may take such signifieds as, neologistically,[33] 'cityness'.

The above is a simple, indeed simplistic, example of the manner in which a signifying phenomenon which itself does not belong to natural language may nevertheless be analysed in terms of a linguistic model. However, to develop the application in sufficient detail for the results to become interesting is to court very great difficulties. The extent of what a truly tenacious application of the linguistic model would entail is to be found in Barthes's own *Système de la Mode*. Barthes here takes as his object-language those descriptions of garments which constitute the *vêtement écrit*. *Système de la Mode* is widely accepted as the very model of methodological rigour in structuralist analysis. However, in the foreword to this work Barthes states that 'by the time the author had undertaken [the

work] and conceived its form, linguistics was no longer the model it
had been in the eyes of certain researchers', with the result that
when the book was published it was 'already dated . . . *already* a part
of the history of semiology'.[34]
Largely because of the pioneering work of Roland Barthes, the
term 'semiology' is today understood as referring to that part of
semiotics which adheres exclusively to linguistics. Umberto Eco has
written:

> we could speak of semiology . . . but Barthes has reversed the
> Saussurian definition and has seen in semiology a translinguistics
> which examines every system of signs in relation to the laws of
> language. If, on the contrary, we want to be allowed to study sign
> systems according to a method which does not necessarily depend
> on linguistics . . . we should speak of semiotics.

He observes that, in any case, we may adopt the term 'semiotic'
without involving ourselves in discussions upon the philosophical or
methodological implications of the two terms as

> we are conforming, quite simply, to the decision made in January
> 1969 in Paris by an international committee, which gave birth to
> the 'International Association for Semiotic Studies' and accepted
> (without excluding use of the term 'semiology') the term 'semio-
> tics' as being that which will from now on cover all possible senses
> of the two terms under discussion.[35]

Eco's own work provides many examples of departures from
strict linguistic lines. The one I shall describe here concerns the
photographic image and 'double-articulation'.
When *Elements of Semiology* first appeared, in the journal *Com-
munications* (1964), it was accompanied by Barthes's analysis of an
advertisement, *Rhetoric of the Image*. In the course of this article
Barthes compares photography with drawing:

> of all images it is only the photograph which possesses the ability
> to transmit [literal] information without forming it by means of
> discontinuous signs and rules of transformation. It is therefore
> necessary to oppose the photograph, a message without a code, to
> the drawing, which even when denoted, is a coded message.[36]

Clearly the artist is involved in an act of selection, both in what he
presents of the object before him and in how he presents it. If he is

drawing a portrait and dislikes the shape of his sitter's nose, then he is at liberty to change its appearance in the drawing or even to omit it entirely. In rendering the roundness of the head he may resort to a set of conventions in which this is achieved through a variation in the thickness of the outline, or to a system of parallel strokes which stand for shadow, a combination of the two, or some other convention. The camera, on the other hand, will mechanically reproduce every detail of what is actually present in the scene during the moment of exposure of the film. Surely no code here intervenes between the object and its representation on paper. Surely,

it is no longer necessary to operate the relay of a third term under the heading of a psychic image of the object . . . the relationship of the signified with the signifier is quasi-tautological . . . a quasi identity is posed . . . and we are dealing with the paradox . . . of a *message without a code.*[37]

Certainly the difference between language and iconic imagery is most marked in the case of the photograph. The linguistic sign bears an arbitrary[38] relationship to its referent; the photographic image, it may be held, does not. There is no law in nature which dictates that the linguistic sign 'tree' (or *l'arbre* or *Baum*) should be associated with the *thing* with which it is in fact associated: this is a matter of cultural convention. In the case of the photograph, on the other hand, the image is in a sense *caused* by its referent. A photosensitive emulsion necessarily registers the distribution of light to which it is exposed. The chiaroscuro of the photographic image replicates that present to the exposed film: 'In every photograph,' says Barthes, 'there is the stupefying evidence of *this-is-what-happened and how.*'[39]

In an ingenuous assumption the photograph is held to *reproduce* its object. However, the relationship between a photographic image and its referent is one of reproduction only to the extent that Christopher Wren's death-mask reproduces Christopher Wren. The photograph abstracts from, and mediates, the actual. For example, a photograph of three people grouped together may, in reality, have comprised a live model, a two-dimensional 'cut-out' figure, and a wax dummy. In the actual presence of such an assembly I would quickly know them for what they were. No such certainty accompanies my cognition of the photographic group. It is precisely the *difference* between our comprehension of an object

and our comprehension of its image that Eco takes as the starting-point of the observations which led him to reject both Barthes's notion of the 'uncoded' message and also the 'dogma of double articulation'.[40] *Double articulation* is a defining attribute of natural language. It is that feature by which the very great number of words of a language are formed by means of different combinations of only a small number of sounds. The principle of double articulation accounts not only for the great economy of language – Barthes cites the example of American Spanish with twenty-one distinctive units to about 100,000 significant units – it is also the root of the autonomy of language. Phonemes in isolation from one another do not signify. They have no meaning in themselves, nor are they affected by the meanings of the words in which they participate. They thus *guarantee* the arbitrariness of the sign.

The classification of linguistic units is achieved through the *commutation test*. In varying the pronunciation of a word there comes a point at which a significantly different unit of the language is recognised. When, for example, *bet* is distorted into *bit* the fact that a new phoneme has been isolated is signalled by a change in the meaning of the utterance. The fact that *bitter* and *rabbit* are unit morphemes of the English language, whereas *abbrit* is not, is similarly established by reference to sense. 'The commutation test,' Barthes writes, 'allows us in principle to spot, by degrees, the significant units which together weave the syntagm, thus preparing the classification of those units into paradigms.'[41]

The apparent absence of a level of secondary articulation in the photograph led Metz in his earlier work to speak of a 'quasi-fusion' of a sign and referent which precludes the possibility of an iconic *langue*. Following Barthes, Metz maintained that each image, of which there are an infinite number, is irreducibly unique. There can be no commutation of the image and thus no paradigmatic systems of the image. Consequently Metz's cinema semiotics developed primarily as a semiotics of the syntagm, and has underlined the main items of realist aesthetics (certainly, since Bazin, the dominant cine ideology), illusion and linear narrative.

Eco, in an essay of 1967,[42] argued, against Metz, that articulations 'below' the level of the image may be posited. Eco's methodology is formed by reference to information theory and to the psychology of perception. For example, much has been made of the

'digital', discontinuous character of language as opposed to the 'analogical', continuous nature of the image. Eco refers here to the systems for storing, transmitting and displaying pictures with the aid of computers, in which the apparently analogical has been interpreted in digital terms. He also points out that modern reproductive processes, from half-tone blocks to TV images, present us with discontinuous systems. But more importantly Eco reminds us that there can be no uncoded visual message, as the act of perception itself is a decoding operation. Saussure was not referring simply to brute sensation when he said that the linguistic *signifier* is a sound-image: 'When we hear people speaking a language that we do not know,' he remarked, 'we perceive the sounds but remain outside the social fact because we do not understand them.'[43] Saussure's *signifier* is not a physical phenomenon but 'the psychological imprint of the sound . . . the impression that it makes on our senses'.[44] When considering the visual channel we can similarly distinguish between the physical and the social fact. Panofsky writes:

> When an acquaintance greets me on the street by removing his hat, what I see from a formal point of view is nothing but the change of certain details within a configuration forming part of the general pattern of colour, lines and volumes which constitutes my world of vision.[45]

In identifying the configuration as an object (gentleman) and the change of detail as an event (hat-removing) he observes that he has overstepped the limits of purely formal perception and entered a sphere of meaning.

Eco similarly maintains that, in perception, the brute stimuli of a given perceptual field are ordered and interpreted according to learned schemes:

> There's a principle of economy, both in the recollection of perceived things and in the recognition of familiar objects, and it's based on what I shall call 'codes of recognition'. These codes list certain features of the object as the most meaningful for purposes of recollection or future communication: for example, I recognize a zebra from a distance without noticing the exact shape of the head or the relation between legs and body. It is enough that I recognize two pertinent characteristics – four-leggedness and stripes.[46]

Such pertinent features Eco terms 'signs',[47] the 'emergent proper-
ties' which we abstract from the continuum of sense impressions
which constitutes our actual perception of an object. The yet
unordered elements from which 'signs' are constructed Eco calls
'figures'. These are the various elements of perception, meaningless
in themselves, which we might begin to analyse in terms of such
oppositions as light/dark; horizontal/vertical; straight/bent;
acute/oblique; etc. They are 'conditions of perception (e.g. subject
– background relationships, light contrasts, geometrical values)
transcribed into graphic signs according to the rules of the code'.[48]
Finally, the 'most simply catalogued' elements in Eco's tripartite
system of articulations are the 'semes', the iconic images them-
selves.

As an illustration, consider the example of two silhouette heads
which are identical in all features except the nose – one is 'ac-
quiline', the other 'retroussé'. The 'seme' in this case is the iconic
image (head) which may be decomposed into the 'signs' (throat),
(chin), (lips), (nose), (brow), (crown), (nape). We are accustomed
to seeing the sign (nose) rendered schematically (via another iconic
interpretant) as two lines. One line is horizontal, the other, about
twice the length of the first, meets one end of this horizontal line at
an angle of about 60°. The sign (nose) in this example may thus be
decomposed into the figures 'lines' (more accurately, perhaps,
'changes in direction and segmentation of line'). *These lines have no
intrinsic meaning.* The change of significance from 'aquiline' to
'retroussé' is thus brought about by the modification of an expres-
sion element which itself has no counterpart in the content plane.
Once commutation is established, paradigms follow. In 'identikit'
pictures a great many tokens of the type 'face' are generated by
combining 'signs' drawn from paradigms established through
changes in a small number of expression elements (the 'figures' –
lines, shadings, and their relations) which in themselves have no
significance.

At this point the argument concerns iconic signs of a different
type from that of photographs. Eco, however, notes that an iconic
sign may signify either some of the emergent features of the object
by conventional schemata or, as in the case of photography or realist
painting, it may simulate perceptual conditions that permit the
perception of the object itself, 'permitting a psychological transac-
tion equal to the one that would come about were one concerned
with putting into shape (so as to produce a perceptum) several

stimuli from the so-called "natural" perceptive field'.[49]
Eco's analysis is linguistic in its inspiration in that it looks for
levels of 'articulation' in the visual image. It is further guided by
linguistics in that it finds one of these levels, that of the 'figures', to
be composed of expression elements which have no equivalent on
the content plane. (Like phonemes, 'figures' are meaningless in
themselves; they only produce meanings in combination with one
another.) However, where he finds that his data cannot be packed
into the two 'boxes' provided by linguistics (roughly: one for
sounds, one for words) Eco constructs a third rather than attempt a
cramming job. The linguistic model is not imposed willy-nilly, with
disregard for empirical facts. The result is a tripartite system having
little in common with its linguistic ancestor.

Received habits of thought have accustomed us to oppose the
schematic to the non-schematic. On closer consideration, however,
we may recognise these two states as highly theoretical, the ideal
antipodes of a unified world. We should more realistically speak of
degrees of schematisation, or iconicity, of signs (Eco speaks of
'grades of arbitrariness and motivation'). Moreover, at any point on
this scale we will find that there is a complex interplay of codes
which may themselves be independently described. Eco has pro-
vided a provisional list of ten interacting codes in the visual image.[50]
For example, *codes of transmission* construct the 'determining
conditions' for the perception of the image. The dots of a half-tone
block, the apparent lines of a TV image, are obviously examples of
such codes and are equally obviously based on arbitrary conven-
tions even though they may closely approach the high iconicity of
'photography proper'. The photograph, however, is not *innocent* of
arbitrariness for its being in a more directly causal and apparently
unmediated relationship to its referent, because the interaction
between the photographic emulsion and the light reflected from the
object is selectively controlled. It is such manipulation of the codes
of transmission which gives rise to what Eco terms *tonal codes*.
These carry the optional variants which are equivalent to the
prosodic features of natural language.[51] A photograph, for example,
may exhibit 'hard' or 'soft' focus, large or small grain, and thus carry
such connotational oppositions as masculine/feminine.

Metz has written:

> Modern studies, as much in semiotics as in the psychology of
> perception, cultural anthropology, or even in aesthetics, no

longer make it possible to oppose as simply as in the period of Saussure the conventional and the non-conventional, the schematic and the non-schematic.

The partial similarities between photographic perception and everyday perception

> . . . are not due to the fact that the first is natural, but to the fact that the second is not; the first is codified, but its codes are in part the same as those of the second. The *analogy*, as Umberto Eco has clearly shown, is not between the effigy and its model, but exists – while remaining partial – between the two perceptual situations.[52]

When discussing such larger units of the linguistic text as sentences, the linguist need make no reference to phonological facts. Nevertheless his knowledge that the arbitrariness of the linguistic sign is guaranteed by the phonemes prevents him from making errors based on false assumptions about the nature of language. Similarly in our analysis of photographic texts we may generally find that we do not need to refer to such an account of the technical formation of the image as that given by Eco. Such accounts are as yet provisional: nevertheless they are essential in guarding us against the pitfalls of an unreflectingly naturalist attitude to photographs.

V

In some naive applications of the linguistic analogy photographic images are seen as equivalent to words. An act of reflection, however, shows that an image is more like a complex utterance than it is like a word. A photograph of a man is less the equivalent of 'man' than it is 'A middle-aged man in an overcoat, wearing a hat, walking through a park . . . etc.', or some other such list, depending on the particular image. Even a 'close-up' of the hat alone, with no discernible detail around it, proclaims not 'hat' but 'Here is a hat, seen from above; it is a trilby, the band is soiled . . . etc.' Metz has made the following observations, which are as apposite of still as of film images:

(1) Film images are, like statements and unlike words, infinite in

number; they are not in themselves discrete units. (2) They are in principle the invention of the speaker (in this case, the film-maker), like statements but unlike words. (3) They yield to the receiver a quantity of indefinite information, like statements but unlike words. (4) They are actualized units, like statements, and unlike words, which are purely virtual units (lexical units). (5) Since these images are indefinite in number, only to a small degree do they assume their meaning in paradigmatic opposition to the other images that could have appeared at the same point along the filmic chain. In this last respect again they differ less from statements than from words, since words are always more or less embedded in paradigmatic networks of meaning.[53]

'Still' photographic practice is at present quite arbitrarily grounded in an ideology of the image. This *image* functions at once as a metaphorical representation of creative individuality, singular and set apart, and an aesthetic mystification. In fact, the technical means of production of photography readily offers a *plurality* of images. The *image* therefore represents a contingent repression of latent practices: it is in this that it is ideological. By way of counterbalancing the great weight of attention devoted to the 'indivisible' image we might do well to consider the function of montage in the photographic production of meaning.

The phenomenon of 'third effect' has long been familiar, certainly since Kuleshov's experiments with the actor Mozhukhin in the early 1920s.

We had a particular dispute with a certain famous actor to whom we said: Imagine this scene: a man, sitting in jail for a long time, is starving because he is not given anything to eat: he is brought a plate of soup, is delighted by it, and gulps it down.

Imagine another scene: a man in jail is given food, fed well, full of capacity, but he longs for his freedom, for the sight of sunlight, houses, clouds. A door is opened for him. He is led out on to the street, and he sees birds, clouds, the sun and houses and is extremely pleased by the sight. And so, we asked the actor: Will the face reacting to the soup and the face reacting to the sun appear the same on film or not? He answers us disdainfully: It is clear to anyone that the reaction to the soup and the reaction to freedom will be totally different.

Then we shot these two sequences, and regardless of how I

transposed these shots and how they were examined, no one was able to perceive any difference in the face of this actor, in spite of the fact that his performance in each shot was absolutely different. With proper montage, even if one takes the performance of an actor directed at something quite different it will still reach the viewer in the way intended by the editor, because the viewer himself will complete the sequence and see what is suggested to him by the montage.[54]

Kuleshov's reminiscence concerns an exemplary case of practical semiotics; it also administers a firm rebuff to the naturalist tendency to consider photographic portraits as 'mirrors of the soul'. But to return to the question of montage in 'stills'. Beyond the basic proven fact of 'third effect' may we postulate the existence of more extensive signifying structures than that expressed in the formula $1+1=3$? One response to this question has taken the form of a consideration of the figures of rhetoric.

As is well known the possibilities of visual metaphor were of considerable interest in the early Russian cinema, not least to Eisenstein. It was, however, the literary wing of the Russian *avant-garde* which provided the most extensive indications that parts of ancient rhetoric may serve as expressive forms and tools of textual analysis. Todorov has observed that the Russian Formalist Victor Shklovsky, in analysing *War and Peace*, reveals, for example, the *antithesis* formed by pairs of characters: '1. Napoleon–Koutouzov; 2. Pierre Bezoukov–Andre Bolkonsky and at the same time Nicolos Rostov who serves as point of reference for both pairs'. *Gradation* is also found; several members of a family exhibit the same character traits but to different degrees. Thus in *Anna Karenina* 'Stiva is situated on a lower echelon in relation to his sister.' Having noted these and other constructions in Shklovsky's analysis, Todorov remarks: 'But parallelism, antithesis, gradation, and repetition are only rhetorical devices. One can then formulate the thesis implicit in Shklovsky's remarks. There are devices in the *récit* which are projections of rhetorical devices.'[55]

Shklovsky demonstrated that literary forms may be seen as projections of rhetorical forms. Todorov has sought to demonstrate that these rhetorical forms may in turn be reduced to linguistic forms. For example, he has identified syllepsis as one of a number of rhetorical figures based on polysemy. In Racine's expression 'I

suffer . . . burning with more fire than I could kindle', the single term 'fire' figures in two propositions: 'The fire of the first proposition is imaginary; it burns the soul of the person, while the fire of the second proposition corresponds to real flames.'[56]
Todorov finds that syllepsis is widely used in the *récit*. In one example he gives this description of a novella by Boccaccio:

> Peronnella receives her lover while her husband, a poor mason, is absent. But one day he comes home early. Peronnella hides the lover in a cask; when the husband comes in, she tells him that somebody wanted to buy the cask and that this somebody is now in the process of examining it. The husband believes her and is delighted with the sale. The lover pays and leaves with the cask.[57]

Here, a single state of affairs, the man being inside the barrel, acquires two interpretations: the man is hiding from his mistress's husband; the man is examining a prospective purchase. Todorov remarks: 'It is not a question of a different action here but of a different perception of the same action.' Similarly, in language, a single term may carry more than one sense. The English term 'bank' may signify a place where money is kept or the ground at a river's edge.

We may object, to return to the example from Racine, that although we can recognise the operation of syllepsis here we must also admit the operation of metaphor in the first proposition. Does the inseparability of figures from each other and from such other literary facts as 'description' pose a problem for analysis not simply in terms of the complexity of its undertaking but in terms of its validity? Todorov has met this objection. No science, he has pointed out, is required to give account of the ontological status of its theoretical concepts so long as they have operational value. Terms such as 'temperature' and 'volume' are useful to physics quite independently of the fact that the phenomena to which they refer may not be isolated from each other, nor from a complex of other phenomena like 'mass' and 'resistance'. By the same token we do not need to isolate a pure 'description' or a pure 'action' or a pure 'figure' in order to use the *concepts* of description, action and figure.

Todorov's remarks are applicable, *mutatis mutandis*, to the semiotic analysis of visual images: few of the codes identified in the course of analysis will be manifested in isolation, but this does not of itself invalidate the analysis.

The possibility of an approach to still photography modelled on rhetorical analysis was first suggested by Barthes in *Rhetoric of the Image:* 'This rhetoric,' he remarked, 'can only be constituted on the basis of a fairly broad inventory, but even at this stage we can foresee that we will find in this rhetoric several of the figures collected in former times by the Ancients and the Classics.'[58]

In a series of articles written in 1965 Jean-Louis Swiners has seen in the rhetorical figure a tool for the analysis of the photo-journalistic *mise en page.*[59] Swiners opposed the conception of photography as a 'means of saying something' to the 'traditional pictorial conception of photography'. Compared with a painting, he observed, the photograph may be found lacking, but as a means of communication it can be incomparable. The best extant communicative use of photography Swiners found to be the type of photo-journalism developed by *Life* magazine. Such magazine picture-stories are particularly suitable to a linguistic type of analysis. A syntagmatic plane is clearly established in the turning of the pages and the left-to-right reading of a double-page spread. A paradigmatic plane is present in the top-to-bottom distribution of pictures on a page. In the case of the picture-story these two planes correspond to, respectively, the diachronic and synchronic axes of the story. Swiners went on to observe:

> It can easily be verified: (a) That certain rhetorical figures (as, for example, metaphor, simile, antonomasia, asyndeton, paronomasia, synedoche, etc. . . .) have . . . their visual equivalents. (b) That certain other figures of rhetoric (chiasmus, zeugma, etc. . . .) though not yet having been visually transmitted, may easily be so and thus allow us to envisage a finer structuring of photographic 'discourse' and a renewal of the aesthetics of the lay-out.[60]

VI

A more extensive and systematic treatment of rhetoric in a discussion of photography is given by Jacques Durand in an article of 1970.[61] This article, which takes the advertising image as its visual subject, is additionally of interest as it reminds us that the rhetorical structures we find in such images may also be traced in the general manifestations of our psychic life. Durand defines rhetoric 'at least summarily, as "the art of fake speech"' (*l'art de la parole feinte*). Rhetoric puts in play two levels of language, 'language proper' and

'figured language', it being supposed that that which is said in a 'figured' fashion could have been expressed in a simpler, more direct and neutral manner. Certainly, Durand observes, 'this thesis is in part mythic: strictly speaking the "simple proposition" is not formulated and nothing assures us of its existence'. Nevertheless it would in principle be possible to identify this simple message, either by interviewing a representative sample of readers or by textual analysis, and so the conception remains operationally valid.

In contrast to literature, which since Romanticism has valued the 'natural' and the 'sincere', advertising has developed wilful excess and artifice. Advertising is *openly* fake and there is no question of the public being unable to distinguish truth from pretence. The question therefore arises as to the reason for the conceit: 'if we want to say one thing, why say another?' Durand finds some light is shed on this problem by the Freudian concepts of 'desire' and 'censure'. For example, the correspondent to an agony column who declares 'I married a bear', confesses, in the literal sense of her statement, to a transgression of social and sexual norms. The sheer improbability of such a contestation of norms, however, dictates that the literal meaning be rejected in favour of some supposed underlying proposition such as: 'My husband is as beastly as a bear.' Nevertheless, even though only pretence, the transgression satisfies a prohibited desire; and, because it is only pretence, it gives unpunished satisfaction.

According to Durand, all figures of rhetoric may be analysed as mock transgressions of some norm: the norms of language, morals, society, logic, physical reality, etc. He finds that in the case of the photographic image the rules broken are above all those of physical reality:'The rhetoricized image, in its immediate reading, is heir to the fantastic, the dream, hallucinations: Metaphor becomes metamorphosis, repetition, seeing-double, hyperbole, gigantism, ellipsis, levitation, etc.' On the occasions when a realistic 'justification' is given for the image 'unreality is not eliminated, but only displaced'. For example, the suggestion of a divided personality contained in the double-image (*dédoublement*) of the model in a swimsuit advertisement is 'justified' by the incongruous presence of a mirror on a beach.

In a course on rhetoric given at the Ecole Pratique des Hautes Etudes in 1964–5 Barthes proposed a preliminary division of the figures of rhetoric into two large classes: the *metabolas,* based on the substitution of one signifier for another, and the *parataxes,*

based on the modification of normally existing relationships between successive signs. The former class would be sited at the level of the paradigm, the latter at the level of the syntagm. Durand retains the axes of paradigm and syntagm but has recourse to both in the definition of any figure:

> The figure of rhetoric being defined as an operation which, starting from a simple proposition, modifies certain elements of that proposition, the figures will be classed along two dimensions:
>
> – on the one hand, the nature of the *operation.*
> – on the other, the nature of the *relation* which unites the variable elements.

The operation is situated mainly at the level of the syntagm, the relation at the level of the paradigm. We may say also that the former is linked to the expression form (signifiers) and the latter to the content form (signifieds).

The Rhetorical Operations

The multitude of classical figures can be reduced to a small number of fundamental operations.

An examination of the 'figures of diction' shows that they can be divided into five categories: repetition of a single sound (rhyme, assonance, etc.), addition of a sound (prothesis, paragogue), suppression of a sound (aphaeresis), substitution of one sound for another (dieresis), inversion of order of two sounds (metathesis).

The 'figures of construction' are reducible to the same operation, applied to words: repetition of the same word (anaphora), addition of a word (pleonasm), suppression of a word (ellipsis), etc.

Analogous mechanisms, moreover, are recognized, as Freud has shown, in the dream, the *mot d'esprit*, etc., repetition (*Le mot d'esprit*, p.264), suppression (forgetting), substitution (slips of the tongue). . . .

In short, there are two fundamental operations:

– *addition:* one or more elements are added to the proposition (repetition being included as a special case: addition of identical elements).

– *suppression:* one or more elements of the proposition are suppressed, and two derived operations:

– *substitution*, analysed as a suppression followed by an addition: an element is suppressed in order to be replaced by another.

– *exchange*, which includes two reciprocal substitutions: two elements of the proposition are permutated.

The Relations

The relations which exist between two propositions can similarly be classed according to a fundamental dichotomy: that of the 'same' and the 'other', of similitude and of difference. However, Durand observes: 'The problem is to know how to use these two concepts to define the supplementary degrees of relation.' Following a discussion of responses to this problem in the work of Barthes, Greimas and Lupasco, Durand concludes:

In fact it seems that there may be not one but two dichotomies: on the one hand similitude and difference, on the other solidarity and opposition. And the relations between these two dichotomies are unstable and ambiguous. At the pre-oedipien state, when there is acquired the distinction of the self and the other similitude is a sign of belonging to a single class, of an extension of the self, and difference is a sign of exteriority, of separation. With the oedipien state the homology is reversed: difference of sex signifies complementarity and desire, whereas identity of sex entails identity of object of desire, rivalry, conflict.

Durand decides on more formal definitions based on the concept of the paradigm:

Two elements will be said to be 'opposed' if they belong to a paradigm which is limited in its terms (for example: masculine/feminine) – 'other' if they belong to a paradigm which includes other terms – 'same' if they belong to a paradigm consisting of a single term. We pass from the notion of paradigm to the notion of transgression if we acknowledge that two terms of a single paradigm must not, normally, figure in the same proposition: the transgression is weak for two 'other' elements (simple coincidence), strong for two 'opposed' elements (meeting of two antagonistic elements), very strong for two 'same' elements (duplication of a single element).

According to the elementary connections which unite their respective elements two propositions may be bound by the following relations:

– identity: uniquely 'same' relations;
– similarity: at least one 'same' relation and 'other' relations;
– opposition: at least one 'opposed' relation;
– difference: uniquely 'other' relations.

How will the constituent elements of a proposition be defined?
... The most simple division admits of only two elements: form
and content ... this division is difficult to apply to the advertising
image. But it is at the foundation of the classical figures. These
two elements already suffice to generate nine different types of
relations between propositions [see Table 3.1].

Table 3.1

Content relation	Form relation		
	Same	Other	Opposed
Same	Identity	Similarity of content	Paradox
Other	Similarity of form	Difference	Opposition of form
Opposed	Ambiguity	Opposition of content	Homologous opposition

Paradox and ambiguity are interesting figures as they present a
contamination of content relation by form relation: the content
relation is at first seen as homologous with the form relation, then
on closer inspection this reading is inverted.

Table of Classification of Figures

All of the figures of rhetoric can be classified according to the two
dimensions defined above. We indicate here a particular figure as
an example at each position in the table [see Table 3.2].

VII

Durand goes on to discuss the membership of each of the twenty-
five classes of figures identified in the above inventory, with refer-
ence to advertising campaigns in France. On the basis of a small
sample of images gathered almost at random from the pages of
English magazines we may give here some limited indication of the
mechanics of the analogy:

In classical rhetoric the figures of similarity (A.2 in Table 3.2) are
divided between those based on a similarity of form (e.g. rhyme,
paronomasia) and those based on a similarity of content (e.g.

Table 3.2

Relation between elements	Rhetorical operation			
	A Addition	**B** Suppression	**C** Substitution	**D** Exchange
1 Identity	Repetition	Ellipsis	Hyperbole	Inversion
2 Similarity				
of form	Rhyme		Allusion	Hendiadys
of content	Simile	Circumlocution	Metaphor	Homology
3 Difference	Accumulation	Suspension	Metonymy	Asyndeton
4 Opposition				
of form	Zeugma	Dubitation	Periphrasis	Anacoluthon
of content	Antithesis	Reticence	Euphemism	Chiasmus
5 False homologies				
Ambiguity	Antanaclasis	Tautology	Pun	Antimetabola
Paradox	Paradox	Preterition	Antiphrasis	Antilogy

pleonasm, simile). In the simile, one thing is said to be like another thing even though the forms of the things compared are actually different ('O, my love is like a red, red rose'). In Figures 3.4(a) and (b) we are told, respectively and visually: 'These cigarettes are like (taste as "smooth" as) cream', and, 'These cigarettes are like (are as wholesome as) bread baked from natural ingredients'.

Durand defines a figure of similarity as 'an ensemble of elements of which some are carriers of similitude and others of difference'. This more abstract formulation permits the identification of a great variety of photographic types based on constructions of similarity. For example, in Figure 3.5 (a) the model is the same in each picture, as is the context and general configuration of the pose (elements carrying similitude). The element (*garment*), however, is a carrier of difference, signalling the purpose of the series: the exploration of a section of the garment paradigm. Implication of temporal succession is suppressed, the syntagm being effectively 'frozen' at one of its points to allow the fullest paradigmatic play.

In Figure 3.5(a) we are presented with user as syntagm, product as paradigm. In Figure 3.5(b) we find, conversely, product as syntagm, user as paradigm, the product being the only constant element in a temporal continuum (indicated by a gradation of light level).

At first glance, Figure 3.6 may seem a case of identity (A.1 in the

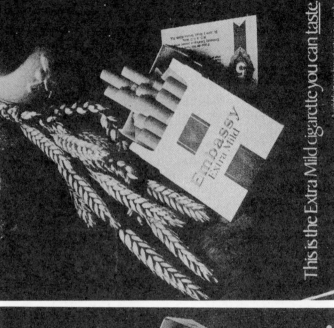

Figure 3.4(b) Cigarette advertisement

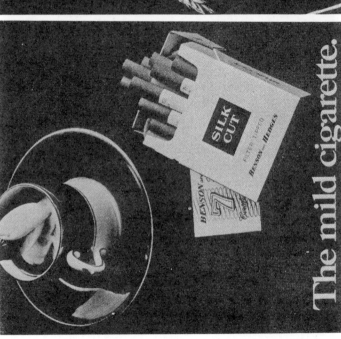

Figure 3.4(a) Cigarette advertisement

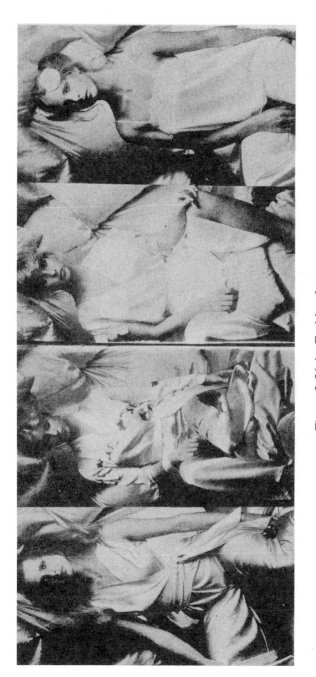

Figure 3.5(a) Fashion feature

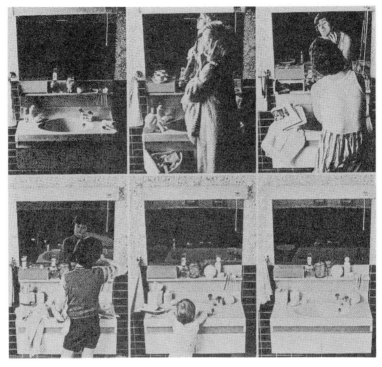

Figure 3.5(b) Bathroom advertisement

table) of which repetition is one of the classical figures ('I have seen,
I have seen true tears flow'). The visual repetition in Figure 3.6,
however, is subjected to an operation by the captions which trans-
form it into a figure of ambiguity (A.5 in the table). In antanaclasis,
one of the classical figures of ambiguity, the same word is repeated
with a different signification ('In thy youth learn some craft, that in
thy old age thou mayest get thy living without craft').[62] The adver-
tisement shown in Figure 3.6 is an example of a frequently used
antanaclasis in which a series of visually identical signifiers are given
differing signifieds in the captions.

 In epitrochasm, one of the figures of accumulation (A.3 in the
table), there occurs a hurried summary of points. The primary

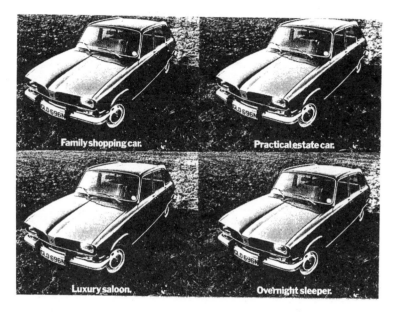

Figure 3.6 Car advertisement

signifieds of accumulation are those of abundance and disorder. As in the visual example of this figure (given in Figure 3.7(a)), objects are presented in confusion rather than judiciously arranged. As Durand observes, 'relations of identity and opposition are not only absent, they are denied. Expressing profusion, accumulation is, then, a romantic figure.' Even the apparent absence of order is therefore accommodated within the order of rhetoric.

We may acknowledge that Figure 3.7(b) is also an example of accumulation. As this is our final example, however, we should perhaps pause to note that accumulation is not the only figure present. There is antithesis, weak in expression but emotive enough in content (the opposition masculine/feminine). There is also ellip-

Figure 3.7(b) Aftershave advertisement

Figure 3.7(a) Cigarette advertisement

sis: the implied proximity of the unseen individuals whose tastes, habits and social position are written in their possessions and their choice of breakfast. We could continue, albeit with some reduction in credibility: the watches form a subsidiary figure of paronomasia within the larger structure, and so on.

Our recognition of a good advertising photograph has little to do with its efficacy in the service of a product (who would know how to measure that?). It is rather the recognition of that organised richness of signification, combined with a foregrounding of the device, which may lead us to make the attribution 'aesthetic' in respect of any particular message whatsoever, whether it be visual or verbal and regardless of its institutional context. It is therefore not to be supposed that rhetorical analysis is suited only to advertising images. We could equally well have applied it as a means of sorting and refining our initial observations concerning the Diane Arbus pictures.

Durand concludes his article with a purely notational logical formalisation of his description of rhetoric. He is confident of its pertinence to practice:

> The myth of 'inspiration', of 'the idea', reigns in the creation of advertising at the present time. In reality however the most original ideas, the most audacious advertisements, appear as transpositions of rhetorical figures which have been indexed over the course of numerous centuries. This is explained in that *rhetoric is in sum a repertory of the various ways in which we can be 'original'.* It is probable then that the creative process could be enriched and made easier if the creators would take account consciously of a system which they use intuitively (my italics).

The close relationship between language phenomena and the unconscious was first observed by Freud: 'The formation of substitutions and contaminations in speech mistakes is . . . the beginning of that work of condensation which we find taking a most active part in the construction of the dream.'[63] Most recently, interest in Freud's texts has been revived by Jacques Lacan and the Freudian School of Paris. Lacan finds in the mechanisms described by Freud a rhetoric of the unconscious. The unconscious is structured in its entirety like a language, thus: 'if the symptom is a metaphor, it is not a metaphor to say so, no more than to say that man's desire is a metonymy. For the symptom *is* a metaphor whether one likes it or

not, as desire *is* a metonymy for all that men mock the idea.'[64]
The functional union which Freud establishes between the manif-
est data of a dream and its latent content is likened by Lacan to the
union of signifier and signified. As Jean-Marie Benoist observes:

> Dreams can thus be compared to cryptic texts, or palimpsests,
> whose *polysemy* must be deciphered by the psychoanalyst. And
> the romantic conception of the Unconscious as a kind of deep
> layer or mysterious cave, where occult forces are at work, can be
> dismissed entirely.[65]

Obviously, a certain conception of the nature of the symbol, the
result of a popularisation and corruption of Freud's work, and
which still prevails in some writing on photography, cannot be
sustained. It was Freud himself who remarked that, in the dream,
sometimes a cigar is merely a cigar.

VIII

The remarks by Brecht with which we began impute an intrinsic
inadequacy to photography. Benjamin agreed:

> At this point, the caption must step in, thereby creating a photo-
> graphy which literalizes the relationships of life and without
> which photographic construction would remain stuck in the
> approximate. [And he continues] 'The illiterate of the future', it
> has been said, 'will not be the man who cannot read the alphabet,
> but the one who cannot take a photograph.' But must we not also
> count as illiterate the photographer who cannot read his own
> pictures?[66]

Benjamin's emphasis is clear. He asks: 'Will not the caption
become the most important part of the shot?' Certainly the funda-
mental importance of the verbal text in its ubiquitous associations
with photography is not to be denied. If there has been no reference
to it here, however, it is simply because our topic has been precisely
that *reading of the image* which was not available to Benjamin but
which we may now contemplate. In the absence of such reading,
photography is indeed, captioned or not, 'stuck in the approximate',
or worse.

Without in any way reducing the importance of the verbal, but on
the contrary by emphasising it, work in semiology and semiotics has

developed far-reaching implications for art theory and thus carries the potential of transforming art practice. It not only demands a radical overhaul of the thinking behind such terms as 'figurative' and 'abstract' but even more profoundly it has irrevocably undermined the foundations of the distinction between 'visual' and 'non-visual' communication. Simply because a message is, in substance, visual, it does not follow that all of its codes are visual. Visual and non-visual codes interpenetrate each other in very extensive and complex ways. Metz has put it well:

> In truth, the notion of 'visual', in the totalitarian and monolithic sense that it has taken on in certain recent discussions, is a fantasy or an ideology, and the *image* (at least in this sense) is something which does not exist.[67]

Chapter 4

On the Invention of Photographic Meaning

Allan Sekula

I

The meaning of a photograph, like that of any other entity, is inevitably subject to cultural definition. The task here is to define and engage critically something we might call the 'photographic discourse'. A discourse can be defined as an arena of information exchange, that is, as a system of relations between parties engaged in communicative activity. In a very important sense the notion of discourse is a notion of limits. That is, the overall discourse relation could be regarded as a limiting function, one that establishes a bounded arena of shared expectations as to meaning. It is this limiting function that determines the very possibility of meaning. To raise the issue of limits, of the closure affected from within any given discourse situation, is to situate oneself *outside*, in a fundamentally metacritical relation, to the criticism sanctioned by the logic of the discourse.

Having defined discourse as a system of information exchange, I want to qualify the notion of *exchange*. All communication is, to a greater or lesser extent, tendentious; all messages are manifestations of interest. No critical model can ignore the fact that interests contend in the real world. We should from the start be wary of succumbing to the liberal-utopian notion of disinterested 'academic' exchange of information. The overwhelming majority of messages sent into the 'public domain' in advanced industrial

society are spoken with the voice of anonymous authority and preclude the possibility of anything but affirmation. When we speak of the necessary agreement between parties engaged in communicative activity, we ought to beware of the suggestion of freely entered social contract. This qualification is necessary because the discussion that follows engages the photograph as a token of exchange both in the hermetic domain of high art and in the popular press. The latter institution is anything but neutral and anything but open to popular feedback.

With this notion of tendentiousness in mind, we can speak of a message as an embodiment of an argument. In other words, we can speak of a rhetorical function. A discourse, then, can be defined in rather formal terms as the set of relations governing the rhetoric of related utterances. The discourse is, in the most general sense, the context of the utterance, the conditions that constrain and support its meaning, that determine its semantic target.

This general definition implies, of course, that a photograph is an utterance of some sort, that it carries, or is, a message. However, the definition also implies that the photograph is an 'incomplete' utterance, a message that depends on some external matrix of conditions and presuppositions for its readability. That is, the meaning of any photographic message is necessarily context-determined. We might formulate this position as follows: a photograph communicates by means of its association with some hidden, or implicit text; it is this text, or system of hidden linguistic propositions, that carries the photograph into the domain of readability. (I am using the word 'text' rather loosely; we could imagine a discourse situation in which photographs were enveloped in spoken language alone. The word 'text' is merely a suggestion of the weighty, institutional character of the semiotic system that lurks behind any given icon.)

Consider for the moment the establishment of a rudimentary discourse situation involving photographs. The anthropologist Melville Herskovits shows a Bush woman a snapshot of her son. She is unable to recognise any image until the details of the photograph are pointed out. Such an inability would seem to be the logical outcome of living in a culture that is unconcerned with the two-dimensional, analogue mapping of three-dimensional 'real' space, a culture without a realist compulsion. For this woman, the photograph is unmarked as a message, is a 'non-message', until it is framed linguistically by the anthropologist. A metalinguistic prop-

osition such as 'This is a message', or, 'This stands for your son', is necessary if the snapshot is to be read.

The Bush woman 'learns to read' after learning first that a 'reading' is an appropriate outcome of contemplating a piece of glossy paper.

Photographic 'literacy' is learned. And yet, in the real world, the image itself appears 'natural' and appropriate, appears to manifest an illusory independence from the matrix of suppositions that determines its readability. Nothing could be more natural than a newspaper photo, or a man pulling a snapshot from his wallet and saying, 'This is my dog.' Quite regularly, we are informed that the photograph 'has its own language', is 'beyond speech', is a message of 'universal significance' – in short, that photography is a universal and independent language or sign system. Implicit in this argument is the quasi-formalist notion that the photograph derives its semantic properties from conditions that reside within the image itself. But if we accept the fundamental premise that information is the outcome of a culturally determined relationship, then we can no longer ascribe an intrinsic or universal meaning to the photographic image.

But this particularly obstinate bit of bourgeois folklore – the claim for the intrinsic significance of the photograph – lies at the centre of the established myth of photographic truth. Put simply, the photograph is seen as a re-presentation of nature itself, as an unmediated copy of the real world. The medium itself is considered transparent. The propositions carried through the medium are unbiased and therefore true. In nineteenth-century writings on photography we repeatedly encounter the notion of the unmediated agency of nature. Both the term 'heliography' used by Samuel Morse and Fox Talbot's 'pencil of nature' implicitly dismissed the human operator and argued for the direct agency of the sun. Morse described the daguerreotype in 1840 in the following terms: 'painted by Nature's self with a minuteness of detail, which the pencil of light in her hands alone can trace . . . *they cannot be called copies of nature, but portions of nature herself*.'[1] In the same year Edgar Allan Poe argued in a similar vein:

> In truth the daguerreotype plate is infinitely more accurate than any painting by human hands. If we examine a work of ordinary art, by means of a powerful microscope, all traces of resemblance

to nature will disappear – but the closest scrutiny of the photographic drawing discloses only a more absolute truth, more perfect identity of aspect with the thing represented.[2]

The photograph is imagined to have a primitive core of meaning, devoid of all cultural determination. It is this uninvested analogue that Roland Barthes refers to as the *denotative* function of the photograph. He distinguishes a second level of invested, culturally determined meaning, a level of *connotation*. In the real world no such separation is possible. Any meaningful encounter with a photograph must necessarily occur at the level of connotation. The power of this folklore of pure denotation is considerable. It elevates the photograph to the legal status of document and testimonial. It generates a mythic aura of neutrality around the image. But I have deliberately refused to separate the photograph from a notion of task. A photographic discourse is a system within which the culture harnesses photographs to various representational tasks. Photographs are used to sell cars, commemorate family outings, to impress images of dangerous faces on the memories of post-office patrons, to convince citizens that their taxes did in fact collide gloriously with the moon, to remind us of what we used to look like, to move our passions, to investigate a countryside for traces of an enemy, to advance the careers of photographers, etc. Every photographic image is a sign, above all, of someone's investment in the sending of a message. Every photographic message is characterised by a tendentious rhetoric. At the same time, the most generalised terms of the photographic discourse constitute a denial of the rhetorical function and a validation of the 'truth value' of the myriad propositions made within the system. As we have seen, and shall see again, the most general terms of the discourse are a kind of disclaimer, an assertion of neutrality; in short, the overall function of photographic discourse is to render itself transparent. But however the discourse may deny and obscure its own terms, it cannot escape them.

The problem at hand is one of *sign emergence*; only by developing a historical understanding of the emergence of photographic sign systems can we apprehend the truly *conventional* nature of photographic communication. We need a historically grounded sociology of the image, both in the valorised realm of high art and in the culture at large. What follows is an attempt to define, in historical

terms, the relationship between photography and high art.

II

I would like to consider two photographs, one made by Lewis Hine
in 1905, the other by Alfred Stieglitz in 1907. The Hine photo is
captioned *Immigrants Going Down Gangplank, New York*; the
Stieglitz photo is titled *The Steerage*. (see Figures 4.1 and 4.2). I am
going to assume a naïve relation to these two photos, forgetting
for the moment the monumental reputation of the Stieglitz. If
possible, I would extend my bogus ignorance to the limit, divesting
both images of authorship and context, as though I and the photo-
graphs fell from the sky. I am aspiring to a state of innocence,
knowing full well that I am bound to slip up. Regarded separately,
each image seems to be most significantly marked by the passage of
time. My initial inclination is to anchor each image temporally,
somewhere within a decade. Already I am incriminating myself.
Viewed together the two photographs seem to occupy a rather
narrow iconographic terrain. Gangplanks and immigrants in
middle-European dress figure significantly in both. In the Hine
photo, a gangplank extends horizontally across the frame, angling
outward, towards the camera. A man, almost a silhouette, appears
ready to step up on to the gangplank. He carries a bundle, his body is
almost halved by the right edge of the photo. Two women precede
the man across the gangplank. Both are dressed in long skirts; the
woman on the left, who is in the lead, carries a large suitcase. Given
this information, it would be somewhat difficult to identify either
the gangplank or the immigrant status of the three figures without
the aid of the legend. In the Stieglitz photo, a gangplank, broken by
the left border, extends across an open hold intersecting an upper
deck. Both this upper deck and the one below are crowded with
people: women in shawls, Slavic-looking women in black scarves
holding babies, men in collarless shirts and workers' caps. Some of
the people are sitting, some appear to be engaged in conversation.
One man on the upper deck attracts my eye, perhaps because his
boater hat is a highly reflective ellipse in a shadowy area, or perhaps
because his hat seems atypical in this milieu. The overall impression
is one of a crowded and impoverished sea-going domesticity. There
is no need even to attempt a 'comprehensive' reading at this level.
 Although rather deadpan, this is hardly an innocent reading of

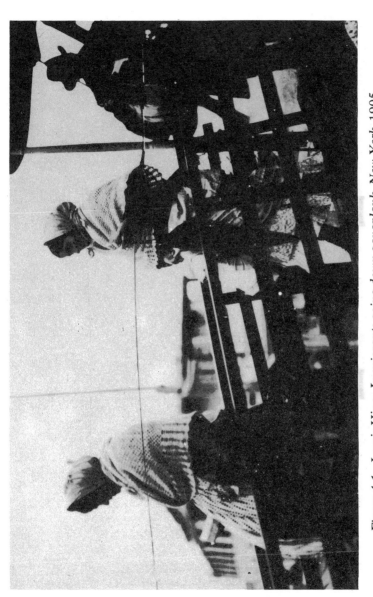

Figure 4.1 Lewis Hine, *Immigrants going down gangplank, New York*, 1905

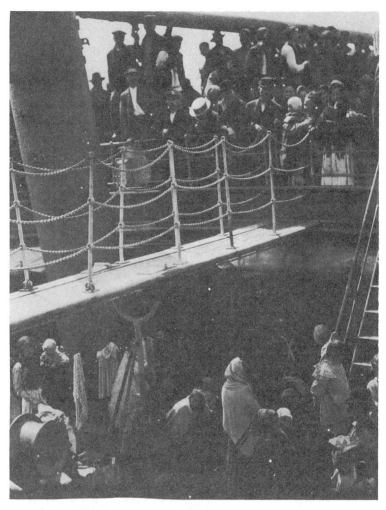

Figure 4.2 Alfred Stieglitz, *The Steerage*, 1907

the two photographs. I have constructed a scenario within which
both images appear to occupy one end of a discourse situation in
common, as though they were stills from the same movie, a
documentary on immigration perhaps. But suppose I asserted the
autonomy of each image instead. For the moment, I decide that
both images are art and that a meaningful engagement with the two
photographs will result in their placement, relative to each other, on

some scale of 'quality'. Clearly, such a decision forces an investment in some theory of 'quality photography'; already the possibility of anything approaching a neutral reading seems to have vanished. Undeterred, I decide that quality in photography is a question of design, that the photograph is a figurative arrangement of tones in a two-dimensional, bounded field. I find the Hine attractive (or unattractive) in its mindless straightforwardness, in the casual and repetitive disposition of figures across the frame, in the suggestion of a single vector. And I find the Stieglitz attractive (or unattractive) for its complex array of converging and diverging lines, as though it were a profound attempt at something that looked like Cubism. On the other hand, suppose I decide that quality in photographic art resides in the capacity for narrative. On what grounds do I establish a judgement of narrative quality in relation to these two artefacts, the Hine and the Stieglitz? I like/dislike, am moved/unmoved by the absolute banality of the event suggested by the Hine; I like/dislike, am moved/unmoved by the suggestion of epic squalor in the Stieglitz. The problem I am confronted with is that every move I could possibly make within these reading systems devolves almost immediately into a literary invention with a trivial relation to the artefacts at hand. The image is appropriated as the object of a secondary artwork, a literary artwork with the illusory status of 'criticism'. Again, we find ourselves in the middle of a discourse situation that refuses to acknowledge its boundaries; photographs appear as messages in the void of nature. We are forced, finally, to acknowledge what Barthes calls the 'polysemic' character of the photographic image, the existence of a 'floating chain of significance, underlying the signifier'.[3] In other words, the photograph, as it stands alone, presents merely the *possibility* of meaning. Only by its embeddedness in a concrete discourse situation can the photograph yield a clear semantic outcome. Any given photograph is conceivably open to appropriation by a range of 'texts', each new discourse situation generating its own set of messages. We see this happening repeatedly, the anonymously rendered flash-lit murder on the front page of the *Daily News* is appropriated by The Museum of Modern Art as an exemplary moment in the career of the primitive freelance genius Weegee. Hine prints that originally appeared in social-work journals reappear in a biographical treatment of his career as an artist only to reappear in labour-union pamphlets. Furthermore, it is impossible even to conceive of an *actual* photograph in a 'free state', unattached to a system of

validation and support, that is, to a discourse. Even the invention of
such a state, of a neutral ground, constitutes the establishment of a
discourse situation founded on a mythic idea of bourgeois intel-
lectual privilege, involving a kind of 'tourist sensibility' directed at
the photograph. Such an invention, as we have already seen, is the
denial of invention, the denial of the critic's status as social actor.

How, then, are we to build a criticism that can account for the
differences or similarities in the semantic structures of the Hine and
Stieglitz photographs? It seems that only by beginning to uncover
the social and historical contexts of the two photographers can we
begin to acquire an understanding of meaning as related to inten-
tion. The question to be answered is this: what, in the broadest
sense, was the *original* rhetorical function of the Stieglitz and the
Hine?

Stieglitz's *Steerage* first appeared in *Camera Work* in 1911.
Camera Work was solely Stieglitz's invention and remained under
his direct control for its entire fourteen-year history. It is useful to
consider *Camera Work* as an artwork in its own right, as a sort of
monumental container for smaller, subordinate works. In a pro-
found sense Stieglitz was a magazine artist; not unlike Hugh
Hefner, he was able to shape an entire discourse situation. The
covers of *Camera Work* framed *avant-garde* discourse, in the other
arts as well as in photography, in the USA between 1903 and 1917,
and whatever appeared between these covers passed through Stieg-
litz's hands. Few artists have been able to maintain such control
over the context in which their work appeared.

Through *Camera Work* Stieglitz established a genre where there
had been none; the magazine outlined the terms under which
photography could be considered art, and stands as an implicit text,
as scripture, behind every photograph that aspires to the status of
high art. *Camera Work* treated the photograph as a central object of
the discourse, while inventing, more thoroughly than any other
source the myth of the semantic autonomy of the photographic
image. In this sense *Camera Work* necessarily denied its own
intrinsic role as text, in the valorisation of the photograph.

Seen as a monumental framing device, *Camera Work* can be
dissected into a number of subordinate ploys; one of the most
obvious is the physical manner in which photographs were pre-
sented within the magazine. The reproductions themselves were
quite elegant; it has been claimed that they often were tonally

superior to the originals. Stieglitz tipped in the gravures himself. Each image was printed on extremely fragile tissue; the viewer could see the print only by carefully separating the two blank sheets of heavier paper that protected it. One of these sheets provided a backing for the otherwise translucent image. The gravures were often toned, usually in sepias but occasionally in violets, blues, or greens. No more than a dozen or so prints were included in any one issue of the magazine, and these were usually distributed in groupings of three or four throughout the text. No titles or legends were included with the images; instead they were printed on a separate page prefacing each section of photographs.

The point quite simply is this: the photographs in *Camera Work* are marked as precious objects, as products of extraordinary craftsmanship. The very title *Camera Work* connotes craftsmanship. This may seem like a trivial assertion when viewed from a contemporary vantage point – we are by now quite used to 'artful' reproductions of photographs. But it was *Camera Work* that established the tradition of elegance in photographic reproduction; here again is a clear instance of sign emergence. For the first time the photographic reproduction signifies an intrinsic value, a value that resides in its immediate physical nature, its 'craftedness'. The issue is not trivial; consider the evolving relationship between craftsmanship and the large-scale industrial reproduction of images in the nineteenth and early twentieth centuries. With the invention of the ruled cross-line halftone screen in the late 1880s, photographs became accessible to offset printing, allowing rapid mechanical reproduction of photographic copy. *Camera Work's* fourteen-year history parallels the proliferation of cheap photographic reproductions in the 'mass' media. By 1910 'degraded' but informative reproductions appeared in almost every illustrated newspaper, magazine and journal. Given this context, *Camera Work* stands as an almost Pre-Raphaelite celebration of craft in the teeth of industrialism. In a technological sense, the most significant feature of the photograph is reproducibility; the status of the photograph as 'unique object' had an early demise with Talbot's invention of a positive–negative process. And yet the discourse situation established around the unique image in *Camera Work* is prefigured historically in the folklore that surrounded the daguerreotype. The daguerreotype process produced a single, irreproducible silver image on a small copper plate. Photographic literature of the 1840s

is characterised by an obsession with the jewel-like properties of the image: 'The specimen at Chilton is a most remarkable gem in its way. It looks like fairy work, and changes its colour like a camelion [*sic*] according to the hue of the approximating objects.'[4] Manifesting a kind of primitive value, a value invested in the object by nature, the daguerreotype achieved the status of the Aeolian harp. The fetishism surrounding the daguerreotype had other manifestations, all stemming from a popular uncertainty about the process; women were commonly held to feel their eyes 'drawn' toward the lens while being photographed.[5] The daguerreotype took on the power of evoking the presence of the dead. Dead children were photographed as though asleep. In one documented case, the camera was thought to be capable of conjuring up an image of a long-buried infant.[6]

But outright spiritualism represents only one pole of nineteenth-century photographic discourse. Photographs achieve semantic status as fetish objects *and* as documents. The photograph is imagined to have, depending on its context, a power that is primarily affective or a power that is primarily informative. Both powers reside in the mythical truth-value of the photograph. But this folklore unknowingly distinguishes two separate truths: the truth of magic and the truth of science. The fetish (such as the daguerreotype of a dead child) evokes meaning by virtue of its imaginary status as relic – that is, by the transcendental truth of magic. The evocation is imagined to occur in an affectively charged arena, an arena of sentiment bounded by nostalgia on one end and hysteria on the other. The image is also invested with a magical power to penetrate appearances to transcend the visible: to reveal, for example, secrets of human character.

At the other pole is what I have chosen to call the 'informative' function of the photograph, that by which it has the legal power of proof; this function is grounded in empiricism. From this point of view the photograph represents the real world by a simple metonymy: the photograph stands for the object or event that is curtailed at its spatial or temporal boundaries, or it stands for a contextually related object or event. An image of a man's face stands for a man, and perhaps, in turn, for a class of men. Thus bureaucratic 'rationalism' seized the photograph as a tool; the Paris police, for example, appropriated photography as an instrument of class war when they documented the faces of the survivors of the

Commune of 1871. Here was the first instance of the photographic
identity card and the photographic wanted poster; other equally
'rational' functions were invented for photography during the
nineteenth century; solemn portraits of American Indians were
made as the race was exterminated; French imperial conquests in
Egypt were memorialised. Reproduced, these images served as an
ideologically charged reification of the expanding boundaries of the
bourgeois state. The mythical image of the 'frontier' was realised by
means of photographs. While theories of affect regard the photo-
graph as a unique and privately engaged object, informative value is
typically coupled to the mass reproduction of the image. The
carte-de-visite represented a move in this direction; every French
peasant could own a visiting-card portrait of Louis Napoleon and
family. According to Walter Benjamin, mass reproduction repres-
ents a qualitative as well as a quantitative change in the status of the
photographic message. In *The Work of Art in the Age of Mechanical
Reproduction* (1936) he defined a developing antagonism between
artwork as unique-and-precious-object and artwork as reproduci-
ble entity. In Benjamin's terms, the unique artwork is necessarily a
privileged object. The unique art object stands in the centre of a
discourse within which ideology is obscured; the photograph, on the
other hand, is characterised by a reproducibility, an 'exhibition
value', that widens the field of potential readers, that permits a
penetration into the 'unprivileged' spaces of the everyday world. As
a vehicle for explicit political argument, the photograph stands at
the service of the class that controls the press.

French romantic and proto-symbolist criticism saw both journal-
ism and photography as enemies of art. The complaints against the
emergent 'democratic' media are couched in aesthetic terms but
devolve, almost always, into a schizophrenic class hatred aimed at
both the middle and working classes coupled with a hopeless fantasy
of restoration. Theophile Gautier expends the preface of
Mademoiselle de Maupin in an assault on Fourier, Saint-Simon, and
the realist-utilitarian demands of republican journalism:

a book does not make gelatin soup; a novel is not a pair of
seamless boots; a sonnet, a syringe with a continuous jet; or a
drama, a railway. . . . Charles X . . . by ordering the suppression of
the newspapers, did a great service to the arts and to civilization.
Newspapers deaden inspiration and fill heart and intellect with

such distrust that we dare not have faith either in a poet or government; and thus royalty and poetry, the two greatest things in the world, become impossible. . . . If Louis-Philippe were to suppress the literary and political journals for good and all, I should be infinitely grateful to him.[7]

Edmond and Jules de Goncourt argue in a similar vein (1854):

Industry will kill art. Industry and art are two enemies which nothing will reconcile. . . . Industry starts out from the useful; it aims toward that which is profitable for the greatest number: it is the bread of the people. Art starts out from the useless, it aims toward that which is agreeable to the few. It is the egotistic adornment of aristocracies. . . . Art has nothing to do with the people. Hand over the beautiful to universal suffrage and what becomes of the beautiful? The people rise to art only when art descends to the people.[8]

Finally we come to Baudelaire's famous dictum on photography:

a new industry arose which contributed not a little to confirm stupidity in its faith and to ruin whatever might remain to the divine in the French mind. The idolatrous mob demanded an ideal worthy of itself and appropriate to its nature – that is perfectly understood. In matters of painting and sculpture, the present-day Credo of the sophisticated, above all in France . . . is this 'I believe in Nature, and I believe only in Nature (there are good reasons for that). I believe that art is, and cannot be other than, the exact reproduction of Nature . . . Thus an industry that could give us a result identical to Nature would be the absolute of art.' A revengeful God has given ear to the prayers of this multitude. Daguerre was his Messiah. And now the faithful says to himself: 'Since Photography gives us every guarantee of exactitude that we could desire (they really believe that, the mad fools!), then Photography and Art are the same thing.' From that moment our squalid society rushed, Narcissus to a man, to gaze at its trivial image on a scrap of metal. . . . Some democratic writer ought to have seen here a cheap method of disseminating a loathing for history and for painting among the people.[9]

Where does this rhetoric, the rhetoric of emergent aestheticism, stand in relation to *Camera Work*? The American *avant-garde* was

invented in French terms; the tradition of a dead generation of French intellectuals weighed on Stieglitz's brain like a nightmare. Photography necessarily had to overcome the stigma of its definition at the hands of Baudelaire. The invention of photography as high art is grounded fundamentally in the rhetoric of Romanticism and Symbolism. The fundamental ploy in this elevation is the establishment of the photograph's value, not as primitive jewel, not as fact, but as cameo, to use Gautier's metaphor for his poems. Within this mythos the photograph displays a preciousness that is the outcome of high craftsmanship. This craftsmanship is primarily that of the poet, while only marginally that of the workman.

The thirty-sixth issue of *Camera Work*, the issue in which *The Steerage* appeared for the first time, was a Stieglitz retrospective of sorts. Perhaps a dozen photographs covering a period of eighteen years (1892–1910) were included. No other photographer's work appeared in this issue, nor were there any gravures of non-photographic work. Among the prints included are *The Hand of Man*, *The Terminal*, *Spring Showers*, *New York*, *The Mauritania*, *The Aeroplane*, and *The Dirigible*. The prints cluster around a common iconographic terrain; they are marked by a kind of urban-technological emphasis, marked as a kind of landscape emerging out of an industrial culture. This terrain is defined negatively by its exclusion of portraiture and 'natural' landscape, though Stieglitz produced images of both types in his early career. I think we can discern a kind of montage principle at work, a principle by which a loose concatenation of images limits the polysemic character of any given component image. I would argue, however, that this apparent attempt at 'thematic unity' is less functional in establishing an arena of photographic meaning than the critical writing that appears in another section of the magazine. The major piece of criticism that appears in this particular issue is Benjamin de Casseres's 'The Unconscious in Art'. Without mentioning photography, Casseres establishes the general conditions for reading Stieglitz:

> there are aesthetic emotions for which there are no corresponding thoughts, emotions that awaken the Unconscious alone and that never touch the brain; emotions vague, indefinable, confused; emotions that wake whirlwinds and deep-sea hurricanes. . . . Imagination is the dream of the Unconscious. It is the realm of the gorgeous, monstrous hallucinations of the Un-

conscious. It is the hasheesh of genius. Out of the head of the
artist issues all the beauty that is transferred to canvas, but the
roots of his imagination lie deeper than his personality. The soul
of the genius is the safety-vault of the race, the treasure pocket of
the Unconscious soul of the world. Here age after àge the
Secretive God stores in dreams. And the product of genius
overwhelms us because it has collaborated with the Infinite.[10]

It would be hard to find a better example of modern bourgeois
aesthetic mysticism. In its own time, of course, this piece was hardly
an expression of institutional aesthetics, but stood as the rhetoric of
a vanguard, moving beyond the romantic-symbolist catechism of
'genius and the imagination' into proto-Surrealism. And yet the
echoes of Poe and Baudelaire are explicit to the point of redundan-
cy. Casseres's argument has its roots in a discourse situation from
which photography, in its 'mechanical insistence on truth', had been
excluded. In *Camera Work*, however, this text serves to elevate
photography to the status of poetry, painting and sculpture. A
drastic boundary shift has occurred, an overlap of photographic
discourse and aesthetic discourse where no such arena had existed,
except in the most trivial terms. Casseres's inflated symbolist
polemic both frames and is a manifestation of this emergent dis-
course situation. But in order to get close to the semantic expecta-
tions surrounding any specific artwork such as *The Steerage* we need
evidence more substantial than polemic. In 1942 a portion of
Stieglitz's memoirs was published, including a short text called
"How *The Steerage* Happened":

Early in June, 1907, my small family and I sailed for Europe. My
wife insisted upon going on the 'Kaiser Wilhelm II' – the fashion-
able ship of the North German Lloyd at the time. . . . How I hated
the atmosphere of the first class on the ship. One couldn't escape
the 'nouveaux riches'. . . . On the third day I finally couldn't stand
it any longer. I had to get away from that company. I went as far
forward on deck as I could. . . . As I came to the end of the deck I
stood alone, looking down. There were men and women and
children on the lower deck of the steerage. There was a narrow
stairway leading up to the upper deck of the steerage, a small deck
right at the bow of the steamer.
 To the left was an inclining funnel and from the upper steerage
deck was fastened a gangway bridge which was glistening in its

freshly painted state. It was rather long, white, and during the trip remained untouched by anyone.

On the upper deck, looking over the railing, there was a young man with a straw hat. The shape of the hat was round. He was watching the men and women and children on the lower steerage deck. Only men were on the upper deck. The whole scene fascinated me. *I longed to escape from my surroundings and join these people. . . . I saw shapes related to each other. I saw a picture of shapes and underlying that of the feeling I had about life. And as I was deciding, should I try to put down this seemingly new vision that held me – people, the common people, the feeling of ship and ocean and sky and the feeling of release that I was away from the mob called the rich – Rembrandt came into my mind and I wondered would he have felt as I was feeling. . . .* I had but one plate holder with one unexposed plate. Would I get what I saw, what I felt? Finally I released the shutter. My heart thumping, I had never heard my heart thump before. Had I gotten my picture? I knew if I had, another milestone in photography would have been reached, related to the milestone of my 'Car Horses' made in 1892, and my 'Hand of Man' made in 1902, which had opened up a new era of photography, of seeing. In a sense it would go beyond them, for *here would be a picture based on related shapes and on the deepest human feeling, a step in my own evolution, a spontaneous discovery.*

I took my camera to my stateroom and as I returned to my steamer chair my wife said, 'I had sent a steward to look you you.' I told her where I had been. She said, 'You speak as if you were far away in a distant world.' and I said I was. 'How you seem to hate these people in the first class.' No, I didn't hate them, but I merely felt completely out of place.[11]

As I see it, this text is pure symbolist autobiography. Even a superficial reading reveals the extent to which Stieglitz invented himself in symbolist clichés. An ideological division is made; Stieglitz proposes two worlds: a world that entraps and a world that liberates. The first world is populated by his wife and the 'nouveaux riches', the second by 'the common people'. The photograph is taken at the intersection of the two worlds, looking out, as it were. The gangplank stands as a barrier between Stieglitz and the scene. The photographer marks a young man in a straw hat as a spectator, suggesting this figure as an embodiment of Stieglitz as Subject. The

possibility of escape resides in a mystical identification with the
Other: 'I longed to escape from my surroundings and join these
people.' I am reminded of Baudelaire's brief fling as a republican
editorialist during the 1848 revolution. The symbolist avenues away
from the bourgeoisie are clearly defined: identification with the
imaginary aristocracy, identification with Christianity, identifica-
tion with Rosicrucianism, identification with Satanism, identifica-
tion with the imaginary proletariat, identification with imaginary
Tahitians, and so on. But the final symbolist hideout is in the
Imagination, and in the fetishised products of the Imagination.
Stieglitz comes back to his wife with a glass negative from the other
world.

For Stieglitz, *The Steerage* is a highly valued illustration of this
autobiography. More than an illustration, it is an embodiment: that
is, the photograph is imagined to contain the autobiography. The
photograph is invested with a complex metonymic power, a power
that transcends the perceptual and passes into the realm of affect.
The photograph is believed to encode the totality of an experience,
to stand as a phenomenological equivalent of Stieglitz-being-in-
that-place. And yet this metonymy is so attenuated that it passes
into metaphor. That is to say, Stieglitz's reductivist compulsion is so
extreme, his faith in the power of the image so intense, that he
denies the iconic level of the image and makes his claim for meaning
at the level of abstraction. Instead of the possible metonymic
equation 'common people=my alienation', we have the reduced,
metaphorical equation 'shapes=my alienation'. Finally, by a pro-
cess of semantic diffusion we are left with the trivial and absurd
assertion: shape=feelings.

This is Clive Bell's notion of significant form. All specificity
except the specificity of form is pared away from the photograph
until it stands transformed into an abstraction. But all theories of
abstraction are denials of the necessity of metalanguage, of the
embeddedness of the artwork in a discourse. Only if the reader has
been informed that 'this is symbolist art' or 'this photograph is a
metaphor' can he invest the photograph with a meaning appropriate
to Stieglitz's expectations. With a proposition of this order supply-
ing the frame for the reading, the autobiography, or some related
fictional text, can be read back into the image. That is, the reader is
privileged to reinvent, on the basis of this photograph, the saga of
the alienated creative genius. Casseres's 'The Unconscious in Art'
provides the model.

Stieglitz's career represents the triumph of metaphor in the realm of photography. *The Steerage* prefigures the later, explicitly metaphorical works, the *Equivalents*. By the time Stieglitz arrived at his equation of cloud photographs and music the suggestion of narrative had been dropped entirely from the image: 'I wanted a series of photographs which when seen by Ernest Bloch ... he would exclaim: Music! Music! Man, why that is music! How did you ever do that? And he would point to violins, and flutes, and oboes, and brass.'[12] The romantic artist's compulsion to achieve the 'condition of music' is a desire to abandon all contextual reference and to convey meaning by virtue of a metaphorical substitution. In photography this compulsion requires an incredible denial of the image's status as report. The final outcome of this denial is the discourse situation represented by Minor White and *Aperture* magazine. The photograph is reduced to an arrangement of tones. The grey scale, ranging from full white to full black, stands as a sort of phonological carrier system for a vague prelinguistic scale of affect.

Predictably, Baudelaire's celebration of synesthesia, of the correspondence of the senses, is echoed in *Aperture:*

> Both photographer and musician work with similar fundamentals. The scale of continuous gray from black to white, within a photographic print, is similar to the unbroken scales of pitch and loudness in music. A brilliant reflecting roof, can be *heard* as a high pitch or a very loud note against a general fabric of sound or gray tone. This background fabric serves as a supporting structure for either melodic or visual shapes.[13]

Minor White, true to Baudelaire, couples correspondence to affect; an interior state is expressed by means of the image:

> When the photographer shows us what he considers to be an Equivalent, he is showing us an expression of a feeling, but this feeling is not the feeling he had for the object that he photographed. What really happened is that he *recognized* an object or a series of forms that, when photographed, would yield an image with specific suggestive powers that can direct the viewer into a specific and known feeling, state or place within himself.[14]

With White the denial of iconography is complete. *Aperture* proposes a community of mystics united in the exchange of fetishes. The photograph is restored to its primitive status as 'cult object'. White's recent *Aperture* publication *Octave of Prayer* is a polemical

assertion of the photograph's efficacy as a locus of prayer and meditation.

I would argue that the devolution of photographic art into mystical trivia is the result of a fundamental act of closure. This closure was effected in the first place in order to establish photography *as an art.* A clear boundary has been drawn between photography and its social character. In other words, the ills of photography are the ills of aestheticism. Aestheticism must be superseded, in its entirety, for a meaningful art, of any sort, to emerge. The Kantian separation of the aesthetic idea from conceptual knowledge and interest is an act of philosophical closure with a profound influence on romanticism, and through romanticism, on aestheticism. By the time *Camera Work* appeared, idealist aesthetics had been reduced to a highly polemical programme by Benedetto Croce:

> Ideality (as this property which distinguishes intuition from concept, art from philosophy and history, from assertion of the universal, and from perception of narration of events, has also been called) is the quintessence of art. As soon as reflection or judgment develops out of that state of ideality, art vanishes and dies. It dies in the artist, who changes from artist and becomes his own critic; it dies in the spectator or listener, who from rapt contemplator of art changes into a thoughful observer of life.[15]

Croce is the critical agent of the expressive. Art is defined by reduction as the 'true aesthetic a priori synthesis of feeling and image within intuition';[16] any physical, utilitarian, moral, or conceptual significance is denied. In the *Aesthetic* (1901), Croce wrote:

> And if photography be not quite an art, that is precisely because the element of nature in it remains more or less unconquered and ineradicable. Do we ever, indeed, feel complete satisfaction before even the best of photographs? Would not an artist vary and touch up much or little, remove or add something to all of them?[17]

Croce had an impact of sorts on American photography through Paul Strand. Strand's reply (1922) to the argument above is revealing:

> Signor Croce is speaking of the shortcomings of photographers and not of photography. He has not seen, for the simple reason

that it did not exist when he wrote his book, fully achieved photographic *expression*. In the meantime the twaddle about the limitations of photography has been answered by Stieglitz and a few others of us here in America, by work done.[18]

Strand's rebuttal is, in fact, a submission to the terms of idealist aesthetics. The 'element of nature' is eradicated by denying the representational status of the photograph.

Croce, Roger Fry and Clive Bell form a kind of loose aesthetic syndicate around early twentieth-century art. Fry's separation of the 'imaginative' and the 'actual' life, and Bell's 'significant form' are further manifestations of the closure effected around modernist art. These critics represent the legitimacy that photography aspired to. The invention of the 'photographer of genius' is possible only through a disassociation of the image-maker from the social embeddedness of the image. The invention of the photograph as high art was only possible through its transformation into an abstract fetish, into 'significant form.'

With all this said, we can return finally to Lewis Hine. Hine stands clearly outside the discourse situation represented by *Camera Work* any attempt to engage his work within the conditions of that discourse must necessarily deprive him of his history. While *The Steerage* is denied any social meaning from *within*, that is, is enveloped in a reductivist and mystical intentionality from the beginning, the Hine photograph can only be appropriated or 'lifted' into such an arena of denial. The original discourse situation around Hine is hardly aesthetic, but political. In other words, the Hine discourse displays a manifest politics and only an implicit aesthetics, while the Stieglitz discourse displays a manifest aesthetics and only an implicit politics. A Hine photograph in its original context is an explicit political utterance. As such, it is *immediately* liable to a criticism that is political, just as *The Steerage* is *mediately* liable to a criticism that is political.

Hine was a sociologist. His work originally appeared in a liberal-reformist social-work journal first called *Charities and Commons* and then *Survey*. He also wrote and 'illustrated' pamphlets for the National Child Labour Committee and was eventually employed by the Red Cross, photographing European battle damage after the First World War. I think it is important to try, briefly, to define the politics represented by *Charities and Commons* and *Survey* during the early part of this century. The magazines represent the voice of

the philanthropic agents of capital, of an emergent reformist bureaucracy that, for its lack of a clear institutional status, has the look of a political threat to capital. The publications committee included Jane Addams, Jacob Riis and William Guggenheim. Articles were written by state labour inspectors, clergymen, prohibitionists, probation officers, public health officials, dispensers of charity and a few right-wing socialists and had such titles as 'Community Care of Drunkards', 'Industrial Accidents and the Social Cost', 'The Boy Runaway', 'Fire Waste', 'Chicken and Industrial Parasites', 'Strike Violence and the Public'. Politically the magazines stood clearly to the right of the Socialist party, but occasionally they employed 'socialist' polemic (especially in editorial cartoons) on reform issues.

A photograph like *Immigrants Going Down Gangplank* is embedded in a complex political argument about the influx of aliens, cheap labour, ghetto housing and sanitation, the teaching of English, and so on. But I think we can distinguish two distinct levels of meaning in Hine's photography. These two levels of connotation are characteristic of the rhetoric of liberal reform. If we look at a photograph (see Figure 4.3) like *Neil Gallagher, Worked Two Years in Breaker, Leg Crushed Between Cars, Wilkes Barre, Pennsylvania. November 1909*, and another (see Figure 4.4) like *A Madonna of the Tenements*, we can distinguish the two connotations. One type of meaning is primary in the first photo; the other type of meaning is primary in the second.

Neil Gallagher is standing next to the steps of what looks like an office building. His right hand rests on a concrete pedestal, his left leans on the crutch that supports the stump of his left leg. Aged about fifteen, he wears a suit, a cap and a tie. He confronts the camera directly from the centre of the frame. Now I would argue that this photograph and its caption have the status of legal document. The photograph and text are submitted as evidence in an attempt to effect legislation. The caption anchors the image, giving it an empirical validity, marking the abuse in its specificity. At the same time, Neil Gallagher stands as a metonymic representation of a class of victimised child labourers. But the photograph has another level of meaning, a secondary connotation. Neil Gallagher is named in the caption, granted something more than a mere statistical anonymity, more than the status of 'injured child'. Hine was capable of photographing child workers as adults, which may be

Figure 4.3 Lewis Hine, *Neil Gallagher, worked two years in a breaker, leg crushed between cars, Wilkes Barre, Pennsylvania, November*, 1909

one of the mysteries of his style of interaction with his subject, or it may be that these labourers do not often display 'childish' characteristics. The squareness with which Gallagher takes his stance, both on the street and in the frame, suggests a triumph over his status as victim. And yet the overall context is reform; in a political sense, every one of Hine's subjects is restored to the role of victim. What is connoted finally on this secondary level is 'the dignity of the oppressed'. *Neil Gallagher*, then, functions as two metonymic levels. The legend functions at both levels, is both an assertion of legal fact and a dispensation of dignity to the person represented. Once anchored by the caption, the photograph itself stands, in its

Figure 4.4 Lewis Hine, *A Madonna of the tenements*, 1911

typicality, for a legally verifiable class of injuries and for the
'humanity' of a class of wage labourers. What I am suggesting is that
we can separate a level of *report*, of empirically grounded rhetoric,
and a level of 'spiritual' rhetoric.

This second type of rhetoric informs *A Madonna of the Tene-
ments* in its entirety. This photograph appeared on the cover of
Survey, in a circular vignette. A Slavic-looking woman sits holding
her four- or five-year-old daughter. Another child, a boy of about
nine, kneels at his mother's side with his left hand against his sister's
side. The woman looks pensive; the daughter looks as though she
might be ill; the boy looks concerned until we detect the suggestion
of an encroaching smile in his features. The dress of the family is
impoverished but neat; the daughter wears no shoes but the boy

wears a tie. An unfocused wallpaper pattern is visible in the background. The overall impression is of a concerned and loving family relationship. In a sense, what is connoted by this image is the capacity of the alien poor for human sentiment. In addition, the image is invested with a considerable element of religiosity by the title, *Madonna*. That is, this woman and her family are allowed to stand for the purely spiritual elevation of the poor.

A passage in Judith Gutman's biography of Hine suggests his aesthetic roots in nineteenth-century realism:

> he quoted George Eliot . . . as he spoke to the Conference of Charities and Corrections in Buffalo in 1909 . . . 'do not impose on us any aesthetic rules which shall banish from the reign of art those old women with work-worn hands scraping carrots . . . those rounded backs and weather-beaten faces that have bent over the spade and done the rough work of the world, those homes with their tin pans, their brown pitchers, their rough curs and their clusters of onions. It is needful that we should remember their existence, else we may happen to leave them out of our religion and our philosophy, and frame lofty theories which only fit the world of extremes.'[19]

If Hine ever read an essay entitled 'What Is Art?' it wasn't Croce's version, or Clive Bell's, but Tolstoy's:

> The task for art to accomplish is to make that feeling of brotherhood and love of one's neighbor, now attained only by the best members of society, the customary feeling and instinct of all men. By evoking under imaginary conditions the feeling of brotherhood and love, religious art will train men to experience those same feelings under similar circumstances in actual life; it will lay in the souls of men the rails along which the actions of those whom art thus educates will naturally pass. And universal art, by uniting the most different people in one common feeling by destroying separation, will educate people to union and will show them, not by reason but by life itself, the joy of universal union reaching beyond the bounds set by life. . . . The task of Christian art is to establish brotherly union among men.[20]

Hine is an artist in the tradition of Millet and Tolstoy, a realist mystic. His realism corresponds to the status of the photograph as report, his mysticism corresponds to its status as spiritual expres-

sion. What these two connotative levels suggest is an artist who
partakes of two roles. The first role, which determines the empirical
value of the photograph as report, is that of *witness*. The second
role, through which the photograph is invested with spiritual signifi-
cance, is that of *seer*, and entails the notion of expressive genius. It is
at this second level that Hine can be appropriated by bourgeois
aesthetic discourse, and invented as a significant 'primitive' figure in
the history of photography.

III

I would like to conclude with a rather schematic summary. All
photographic communication seems to take place within the condi-
tions of a kind of binary folklore. That is, there is a 'symbolist'
folk-myth and a 'realist' folk-myth. The misleading but popular
form of this opposition is 'art photography' *vs* 'documentary photo-
graphy'. Every photograph tends, at any given moment of reading
in any given context, towards one of these two poles of meaning.
The oppositions between these two poles are as follows: photo-
grapher as seer *vs* photographer as witness, photography as expres-
sion *vs* photography as reportage, theories of imagination (and
inner truth) *vs* theories of empirical truth, affective value *vs* infor-
mative value, and finally, metaphoric signification *vs* metonymic
signification.

It would be a mistake to identify liberal and 'concerned'
documentary entirely with realism. As we have seen in the case of
Hine, even the most deadpan reporter's career is embroiled in an
expressionist structure. From Hine to W. Eugene Smith stretches a
continuous tradition of expressionism in the realm of 'fact'. All
photography that even approaches the status of high art contains
the mystical possibility of genius. The representation drops away
and only the valorised figure of the artist remains. The passage of
the photograph from report to metaphor (and of photographer
from reporter to genius) in the service of liberalism is celebrated in
one of the more bizarre pieces on photography ever written. This is
the enemy:

> [Strand] believes in human values, in social ideals, in decency and
> in truth. These are not clichés to him. That is why his people,
> whether Bowery derelict, Mexican peon, New England farmer,

Italian peasant, French artisan, Breton or Hebrides fisherman, Egyptian fellahin, the village idiot, or the great Picasso, are all touched by the same heroic quality – humanity. To a great extent this is a reflection of Strand's personal sympathy and respect for his subjects. But it is just as much the result for his acuteness of perception which finds in the person a core of human virtue and his unerring sense of photographic values that transmits that quality to us. It is all part of an artistic process in which the conception of form, the just balance of mass and space and pattern to frame, the richness of texture and detail transform a moment of intuition into an immutable monument.[21]

The celebration of abstract humanity becomes, in any given political situation, the celebration of the dignity of the passive victim. This is the final outcome of the appropriation of the photographic image for liberal political ends; the oppressed are granted a bogus Subjecthood when such status can be secured only from within, on their own terms.

Chapter 5

The Currency of the Photograph[1]

John Tagg

I

On 6 October 1951 Berenice Abbott took part in a conference on photography at the Aspen Institute, Colorado. Here, she put forward her view that photography has a strong affinity to writing and that, in the USA, this is to 'a glorious tradition of unsurpassed realist writers'.[2] In the course of her argument she reminded her audience that: 'Jack London in his powerful novel *Martin Eden* pleads not only for realism but impassioned realism, shot through with human aspirations and faith, life as it is, real characters in a real world – real conditions.' She asked: 'Is this not exactly what photography is meant to do with the sharp, realistic, image-forming lens?' And a little later, as if in answer, she concluded: 'Photography cannot ignore the great challenge to reveal and celebrate reality.'[3]

The comparison with the author of 'proletarian' and 'revolutionary' fiction is surely a surprising one for a former pupil and assistant of Man Ray to draw. The same might be said for other references in the lecture; to the communist writer Theodore Dreiser, and the painter of the 'Ash Can School', John Sloan, through the latter's 'Hairdresser's Window' of 1907 prefigures the many shop-fronts documented by Abbott thirty years later. Clearly, it is important. Abbott deliberately sites her work within an American tradition but, more than this, she identifies this tradition as *realist*.

We must, of course, be careful to establish what exactly Berenice Abbott meant by 'realism'. It is not just a question of subject-matter. Undoubtedly, she believed realism – or 'documentary value' – to be inherent in the photographic process itself and present in every 'good photograph' whose image had not been falsified by exaggerated technical manipulation. Yet, in her reference to Jack London, Abbott also introduced the themes of tendency literature: of a realism which focuses on 'real characters' and is 'shot through' with 'aspirations and faith' which belong both to them and to the author. Again, this seems to introduce a thematic not obvious in Abbott's work. Yet, Abbott wrote that the objectivity of the photographer was 'not the objectiveness of a machine, but of a sensible human being with the mystery of personal selection at the heart of it'.[4] Elsewhere, writing about documentary photography in New York, she urged: 'The work must be done deliberately, in order that the artist actually will set down in the sensitive and delicate photographic emulsion the soul of the city . . . sufficient time must be taken to produce an expressive result in which moving details must coincide with balance of design and significance of subject.'[5]

Here, then, is not the careless style and ranging view of London, but certainly a conception of realism which is not incompatible with Abbott's emphasis on 'personal expression' and 'creative development'. It also introduces the idea that, far from being a neutral presentation of pre-existing facts, realism may involve certain essential formal strategies. As Abbott saw it: 'The second challenge [for the photographer] has been to impose order onto the things seen and to supply the visual context and the intellectual framework – that to me is the art of photography.'[6] It is in this sense that what she called the 'aesthetic factor' in photography was not at odds with its documentary or realist purpose.[7] This should be sufficient to convince us of the complexity of the 'internal' features of Abbott's 'realism'. We must see that here, as generally, realism is defined *at the level of signification,* as the outcome of an elaborate constitutive process. We cannot quantify the realism of a representation simply through a comparison of the representation with a 'reality' somehow known prior to its realisation. The reality of the realist representation does not correspond in any direct or simple way to anything present to us 'before' representation. It is, rather, the product of a complex process involving the motivated and selective

employment of determinate *means of representation.* As Max
Raphael majestically put it:

> Language presses us, even against our will, to compare the
> finished work of art with its model in nature, and thus diverts us
> from the fundamental fact that the work of art has come about
> through a dialectical interaction between the creative forming
> spirit and a situation that is given to begin with. Therefore we
> must sharply distinguish between the given situation (nature), the
> methodical process (the mind), and the total configuration (the
> work of art). The given situation is itself highly complex, for in
> addition to being a component of nature it contains a personal
> psychic experience and a socio-historical condition: nature, his-
> tory and the individual do not tend to coincide, to be harmonious,
> but conflict with each other and so accentuate their differences.
> The artist seizes upon this conflict and thereby divests it of its
> factual character, transforms it into a problem – a task which
> consists in bringing these three factors into a new relatedness,
> merging or fusing them into a new unity with a new, internally
> necessary form. Mere existence is thus made into a process, and
> the result of this process is another existent, and existent of a
> special kind, founded upon a new unity of the conflicting ele-
> ments as perceived by man and embodied in matter. To the
> viewer of the work of art this man-made yet 'autonomous' (i.e.
> self-sufficient) reality is immediately accessible. When he tries to
> analyse it into its components in order to gain insight into the
> process that brought it into being, it is not enough for him to note
> the differences between the finished work of art and the given
> model. He must also know how the respective data of nature,
> history, and the artist's personality were creatively combined, as a
> problem to be solved – and how, thus, the work of art came about
> – in so far as this creative process was not a mere matter of
> psychological accident but was governed by laws.[8]

There is a tendency in Raphael to believe that the constitutive
process of creation and the various unfolding stages of its realisation
are a historically determined representation at a particular level of
the 'deep structure' given for all time and defined in epistemology
or the 'theory of intellectual creation'.[9] This process and these
stages are mirrored, therefore, in a critical procedure which is
similarly 'outside' history. However, while he correctly shows that it

is for the historian to locate in the specific historical context of the particular image the means of figuration, the mode of their deployment and the specific motivation of their use, and to reconstitute the *method* by which the image was realised, the historian must do more than this. It is not enough to reconstitute the complex conditions, means and processes of production. The same analysis must be brought to bear on the mode of reception of the work. We must *historicise the spectator*, or, to make this more precise by returning to Berenice Abbott, we must also take care to specify *to whom* and under what conditions she thought her photographic images would *appear* 'realistic'.

In her essay 'Changing New York' – written, admittedly, to represent the Photographic Division, of which Abbott was supervisor, in a national report compiled in 1936 to throw a favourable light on the work of the Federal Art Project section of the Works Progress Administration – Berenice Abbott claimed that public response to her exhibits proved there was 'a real popular demand for such a photographic record':[10] one, that is, which would 'preserve for the future an accurate and faithful chronicle in photographs of the changing aspect of the world's greatest metropolis'.[11] On the basis of this conviction and having failed to procure the requisite private patronage, Abbott welcomed the practical social support afforded by government sponsorhip under the Works Progress Administration. In return, she argued, there were many immediate and longer-term public uses to which her documentary photography might be put, besides that of adding to the permanent collections of the Museum of the City of New York and similar historical depositories. Her prints were exhibited in demonstration galleries in southern states, in historical museums and in 'numerous community centres in the five boroughs' of New York City.'[12] They were allotted to various High Schools and to the University of Wisconsin. They appeared in the New York City guidebook, in newspapers, government reports and publications ranging from *Life, House and Garden* and *Town and Country*, to social-work dossiers and religious periodicals. Yet, if we look at her list of exhibitions, we see that, aside from individual shows in such private galleries as the Julien Levy Gallery in New York, it is exhibitions at the Museum of the City of New York and the relatively new Museum of Modern Art, New York, which predominate. Furthermore, we may note that many of the exhibitions in which she

participated were not devoted to social or environmental issues but to 'Art'. I am thinking of such exhibitions as 'New Horizons in American Art' of 1936, or 'Art in Our Time' of 1939, both of which were held in the Museum of Modern Art. To understand the public meaning of such exhibits we would, in turn, have to site them within the general policies, purposes and discourse of the management of the privately funded Museum and understand the role within the state of the Museum was beginning to define and assume.

In general, although responsibility for the national and international presentation of American achievements in the sphere of the visual arts had not yet devolved to the Museum of Modern Art, the Museum had already begun to attempt, in its exhibitions, a definition of the character and tradition of a specifically American art. As far as contemporary work was concerned, the policy in the 1930s tended to neglect American abstract art in favour of the very 'realist' figurative work which, by the early 1950s, the director Alfred H. Barr had come to equate with 'totalitarianism'.[13] This must have affected the selection and reception of Berenice Abbott's documentary work – as must the fact that, even at this early date, the Museum had begun that appropriation of photography to Art which brought Walker Evans his one-man show in 1938 and which continues to this day.

The detailed examination of these institutional trends and the rigorous analysis of Abbott's 'realism' are outside the scope of this paper. Its actual destination is a discussion of *the prerequisites of realism*. However, the terrain we shall have to cross is precisely that of the problems raised by Abbott: the relationship of photography to reality; the processes and procedures which constitute meaning in the photograph; the social utility of photographs; and the institutional frameworks within which they are produced and consumed. I shall try to treat these problems under three headings – or in three stages: the currency of the photograph; the regime of truth; and the conditions of realism. I shall attempt to give an adequate account of the first but my treatment of the latter two will be necessarily truncated.

II

Let us begin by looking at two images. In appearance, they are close enough to us in history, culture and the development of photographic rhetoric to be readily identifiable. They represent two

interiors, two groups of people, two collections of furniture and ornaments. It seems 'natural' to identify the pairs of figures as couples, as families; the interiors as homes; their furnishings as the trappings of two social groupings. One (Figure 5.1) shows an elderly middle-class couple from Union Point, Georgia, in 1941; the other (Figure 5.2), recipients of government aid from the Farm Security Administration, at home in Hidalgo County, Texas, in 1939.

Figure 5.1 Jack Delano, *Union Point, Georgia,* 1941

Figure 5.2 Russell Lee, *Hidalgo County, Texas*, 1939

The photographs are dense with connotations, as every detail – of flesh, clothes, posture, of fabric, furniture and decoration – is brought, fully lit, to the surface and presented. Just as we see each detail within the meaning of the total photographic image which they themselves compose, so we see every object both singly and coming together to form an ensemble: an apparently seamless ideological structure called a *home*. We are aware of significant differences but also of striking similarities: of individual objects, possessions, and of their relations; of the way they come together to constitute what is common in the two images – the concepts of *family* and *home*. What we experience is a double movement which typifies ideological discourse. On the one hand, the ideological construction put on the objects and events concretises a general mythical scheme by incorporating it in the reality of these specific historical moments. At the same time, however, the very conjuncture of the objects and events and the mythical schema dehistoricises the same objects and events by displacing the ideological connection to the archetypal level of the *natural and universal* in order to conceal its specifically *ideological nature*. What the mythic schema gains in concreteness is paid for by a loss of historical specificity on the part of the objects and events.

It has been argued that this insertion of the 'natural and universal' in the photograph is particularly forceful because of photography's privileged status as a guaranteed witness of the actuality of the events it represents.[14] The photograph seems to declare: 'This really happened. The camera was there. See for yourself.' However, if this *binding* quality of the photograph is partly enforced at the level of 'internal relations' by the degree of definition, it is also produced and reproduced by certain privileged ideological apparatuses, such as scientific establishments, government departments, the police and the law courts. This power to bestow authority and privilege on photographic representations is not given to other apparatuses, even within the same social formation – such as amateur photography or 'Art photography' – and it is only partially held by photo-journalism. Ask yourself, under what conditions would a photograph of the 'Loch Ness Monster' or an 'Unidentified Flying Object' become acceptable as proof of their existence?

It is only where this functioning of photography within certain ideological apparatuses is ignored that the question of privileged status can be transferred to the alleged 'intrinsic nature' of photography. Thus, even where it is accepted that the choices of event,

aspect, angle, composition and depth represent a whole complex chain of ideologically significant and determinate procedures, it has been maintained that the 'binding quality' of photographs is rooted in a pre-manipulative, *a*-rhetorical level which exists ideally. Roland Barthes imagines a 'natural', 'innocent' or 'Edenic' state of the photograph: 'as if there was at the beginning (even Utopian) a brute photo (frontal and clear) on which man disposed, thanks to certain techniques, signs drawn from a cultural code'.[15] The very word 'natural' should alert us to a conception that is precisely ideological. Looking at these two photographs, and remembering the images of Atget, Abbott and Evans, we must also be aware that the hypothetical 'brute photo (frontal and clear)' is itself locatable within a historical typology of photographic configurations: it is the characteristic format of photographs in official papers and documents, and also predominates in that purer strain of pedigree photographs – 'straight photography' – said by so many critics and ideologues to embody 'universal truths' about existence, about 'being-ness', about the 'stasis-in-continuum'.

Let us return to the problem of the 'double movement' within ideological discourse. While this process is seen at its most explicit in the 'family structure' of the exhibition 'The Family of Man', what it means here is that the ideological conceptions of 'family' and 'home' are both 'proven' and fleshed out in the reality of these two disparate settings; while, on the other hand, our very acceptance of these ideological conceptions leads us to see these 'families' and 'homes' as participating in certain universal, fundamental truths so that the two groups of figures and the two settings are effectively removed from history and we are no longer able or inclined to see, question or account for their very differences. However, we are in danger of overstating the case. We should remember that, whereas ideology presents itself and imposes on our consciousness a well-constructed, coherent and systematic totality which contains our thought within its apparent consistency, it produces this coherence as an *effect*. As Macherey says: 'ideology is essentially contradictory, riddled with all sorts of conflicts which it attempts to conceal. All kinds of devices are constructed in order to conceal these contradictions; but by concealing them, they somehow reveal them.'[16] If the discrepancies in these two photographed rooms clearly signify that the difference between the two is a difference of *class*, then it is equally clear that the one has been realised *within the*

dominant form of the other and that this dominant form is an *ideological form* constituted in the form of life and by the realisation of the values, beliefs and modes of thought of the dominant class. It is the existence of the differences – the discrepancies – of the one within the identity of the other that gives the juxtaposition its poignancy: a poignancy in which we *see* and *feel* the reality of the ideological field of this social formation at this historical moment – middle America 1939, 1941 – revealed, not by 'unmasking', but by its strategies of concealment of its own internal flaws. As Walter Benjamin wrote, ten years before either couple sat for the camera:

> However skillful the photographer, however carefully he poses his model, the spectator feels an irresistible compulsion to look for the tiny spark of chance, of the here and now, with which reality has, as it were, seared the character in the picture; to find that imperceptible point at which, in the immediacy of that long-past moment, the future so persuasively inserts itself that, looking back, we may rediscover it.[17]

For the moment, let us isolate two details from the dense mat of signifying strands. On the rear wall of each room, we find a tapestry. One depicts a Moorish dance in an exotic setting reminiscent of Delacroix's 'Women of Algiers'. The other shows the scene of an eighteenth-century chamber concert, again reminding us of French art, of conversation pieces, though here the style and gestures of the figures do not cohere and the method of figuration and composition do not connote or make reference to any particular style or works of art. In this, it falls short of the pastoral scenes on the tapestry cushion covers in the other room, in the other photograph.

What meanings could such images have for American couples like these? Did the one bring to mind the refined culture of a more secure class in a pre-industrial society where luxury could be conspicuously consumed? Did the other, as in nineteenth-century France, where we may find many such scenes in Romantic paintings, suggest an escape: something exotic, a primitive culture now reachable within French possessions through the expanding tourist industry? Did it hint at something tinged with the erotic, and with risk? And why tapestries -- woven woollen pictures? Did tapestry itself allude to some special meaning: carry, however hidden, some reference to a history of furnishings and homes? And did this allusion diminish with the actual size of the woven image? Was all

this on the walls of these private American dwellings, overlayed by the memory of the very cultures of those social strata which consumed such images in the American past? Did, in fact, these meanings matter? Were the tapestries looked at, studied and admired? Were they hung in special vantage points, with care or indifference? Were their meanings as images separable from their functions as colourful decorations, motifs on a wall, parts of a decorative whole? Were they bought or made? Invented or copied? Were they valuable or worthless? Valued or neglected? Will we discover the answers to these questions by staring very hard at the material items, at these pieces of cloth to be hung on a wall? Will we even recover the meanings of the images depicted on them by patiently analysing their internal features alone? Or must we seek to discover the processes by which these meanings are constituted within definite and specific social practices and rituals at given levels in the precise historical social formation? Here, we are able to see these 'minor works of art' in their actual settings. in the living context of their social uses. Were we to meet them in a museum – whether of 'fine art' or 'decorative art' – we would know only that they had lost their function, however tenuous this might have been, and had left the social relations which once determined their cost and price, their material and 'spiritual' values, to enter a strange 'after-life' as art and art alone. Would art historians then have to talk about their forms and techniques and iconography, and find some place for them in the history and hierarchy of art as art? Stranger transformations have occurred. As Hans Hess has pointed out:

> If we look at a coin of Hadrian or Constantine, we look at it as a work of art, a finely modelled portrait head, a very useful document for art historians, a thing of rarity and beauty. If we look at a 50p piece, we do not think of it as a work of art because it is currency and still functions as money, but it is as much a work of art as the coin of Hadrian which was also used as money in its own day. If, however, our coin is taken out of circulation and goes to a numismatic collection in Japan, let us say, it loses its function and becomes an *objet d'art*.[18]

It is precisely this transformation that we must reverse if we are to understand that the metal die-cast of an academic bas-relief and the coloured cloth woven to form an image once had a use, a value, an

objective social validity, in short had *currency*. We must also understand that, as Marx saw it, this 'currency' could only take force as a 'compulsory action of the State' and this, in turn, could 'take effect only within that inner sphere of circulation which is co-terminous with the territories of the community'.[19]

Now I wish to carry this concept of 'currency' to another level. Let us imagine we have to remind ourselves again that we are not in the presence of tapestries and furnishings but only of two photographs or, rather, in this case, of photo-mechanical reproductions of two images. The theme of photography is subtly introduced within each of the pictures: in the one, by the album at which the couple are looking but which we cannot see; and in the other, by the photographic portraits on the radiogram which echo the arrangement of the 'real' figures and introduce a historical, as well as a representational, displacement into the heart of the picture. If we had the actual photographs, however, we would have – and perhaps this is so obvious it needs stating – two pieces of special paper, tokens, images, exactly like the tapestries: items produced by a certain elaborate mode of production and distributed, circulated and consumed within a given set of social relations; pieces of paper that changed hands, found a use, a meaning and a value, in certain social rituals. We would have two pieces of paper bearing images constituted by a material process, according to real and definite choices constrained by the repertoire of choices available to their specific, individual producers within the moment of their production: images made meaningful and understood within the very relations of their production and sited within a wider ideological complex which must, in turn, be related to the practical and social problems which sustained and shaped it. As Susan Sontag has also stressed, photographs are objects of manipulation:

> They age, plagued by the usual ills of other objects made of paper. They are lost, or become valuable, are bought and sold; they are reproduced. . . . They are stuck in albums, tacked on walls, printed in newspapers, collected in books. Cops alphabetise them; museums exhibit them.[20]

They can be taken as evidence. They can incriminate. They can be aids to masturbation or trophies of conquest. They can be emblems of a symbolic exchange in kinship rituals or vicarious tokens of a world of potential possessions. Through that democratised form of

imperialism known as *tourism*, they can exert a power to colonise new experiences and capture subjects across a range never envisaged in painting. They are on our tables at breakfast. They are in our wallets and stood on our desks and dressing tables. Photographs and photographic practice appear as essential ingredients in so many social rituals – from customs checks to wedding ceremonies, from the public committal of judicial evidence to the private receipt of sexual pleasure – that it has become difficult to imagine what such rituals were like and how they could be conducted before photographs became widely available. It is difficult precisely because the internal stability of a society is preserved at one level through the naturalisation of beliefs and practices which are, on the contrary, historically produced and historically specific. it is in this light that we must see photographs and the various practices of photography.

I am definitely not trying to avoid such questions as how, in these photographs, the simplicity of pictorial means, corresponding to the uncluttered nature of the subjects, carries into the construction of the photographs, on the one hand, the proud and puritan sparseness of poverty, and on the other, the elegant bareness of 'good taste'. Or how a slight asymmetry and a quiet play of light softens the image of the middle-class couple, and how the difference of eye-level between the two photographs changes our relation to the subjects and alters the meaning of the apparently identical images. To make an analysis at this level is exactly to observe what Foucault calls the 'capilary form' of the existence of power: 'at the point where power returns into the very grain of individuals, touches their bodies, and comes to insert itself into their gestures and attitudes, their discourses, apprenticeships and daily lives'.[21] We see it in the individual determinations of the photographs. We see it in the rooms which existed as iconic systems before the photographers began their transformations. When, elsewhere, I characterised these as 'internal' as opposed to 'external' relations I was trying to locate an unresolved stage in the *method of art history* and to define the level at which an adequate analysis must operate.[22] I was not trying to open up a rift in the complex process of constitution of individual images. What I am trying to stress here is the absolute continuity of the photographs' ideological existence with their existence as material objects whose 'currency' and 'value' arise in certain distinct and historically specific social practices and are ultimately a function of the state.

Photography is a mode of production consuming raw materials, refining its instruments reproducing the skills and submissiveness of its labour force, and pouring on to the market a prodigious quantity of commodities. By this mode of production it constitutes images or representations, consuming the world of sight as its raw material. These take their place among and within those more or less coherent systems of ideas and representations in which the thought of individuals and social groups is contained and through which is procured the reproduction of the submissive labour power and the acquiescence to the system of relations within which production takes place. In this sense, while it is also used as a tool in the major educational, cultural and communications apparatuses, photography is itself an apparatus of ideological control under the central 'harmonising' authority of the ideology of the class which, openly or through alliance, holds state power and wields the state apparatus. As Louis Althusser has said: 'No class can hold state power over a long period without at the same time exercising its hegemony over and in the State Ideological Apparatuses.'[23] In the modern bourgeois state the ruling class cannot constitute the state as an apparatus of class repression alone; the necessity for any state to extend its power beyond the level of coercion is reduplicated under capitalism:

> once capitalism had [physically] put invested wealth in popular hands, in the form of raw materials and the means of production, it became absolutely essential to protect this wealth. Because industrial society requires that wealth should be directly in the hands not of those who own it, but those whose labour, by putting it to work, enables a profit to be drawn from it.[24]

The state must therefore be elaborated in the domain of what Gramsci has called 'civil society'. It must install 'a certain number of realities which present themselves to the immediate observer in the form of distinct and specialised institutions'[25] whose function, together with that of the predominantly coercive state apparatuses, is to secure the reproduction of the political conditions within which the means of production may themselves be reproduced. It is the more explicitly repressive state apparatuses – the government, the administration, the army, the courts, the police and the prisons – that both encompass and create the conditions for the effective working of the complex of ideological apparatuses which act as

behind a 'shield', yet constitute a real strength. As Gramsci put it:

> In the West, there was a proper relation between State and civil
> society, and when the State trembled a sturdy structure of civil
> society was at once revealed. The State was only an outer ditch,
> behind which there stood a powerful system of fortresses and
> earthworks: more or less numerous from one state to the next.[26]

It is through the ideological apparatuses that the ideology of the
ruling class must necessarily be realised and within them that the
ideology of the ruled class must be measured and confronted. Thus
the ideological apparatuses both express the general and delimited
levels of class struggle in the society and demarcate the sites of such
a struggle whose ultimate repercussions go far beyond them. None
the less, ideologies do not merely *represent* class interests or forces
properly located at the economic level. Such 'interests' or 'forces'
are constituted at the level of representation (politics and ideology)
by definite means of representation and have no prior existence. In
consequence representations are not reducible to class identities
pre-given at the economic level. Properly understood, the concept
of *representation* entails a rejection both of reductionist readings
and of the idea that class interests or forces exist fully formed but
somehow unrealised prior to their representation.

This is not, however, to imply, as Paul Hirst seems to do in his
otherwise cogent criticisms of Althuser's reflectionist theory of
representation, either that what is represented, in the sense of the
source-of-the-represented, has no existence or that the relationship
between this source-of-the-represented and the representation is
entirely arbitrary.[27] The means of representation may exist distinct
from the source-of-the-represented – they may have their 'relative
autonomy' – but, if the complex process of constitution of the
representation neither allows us to identify the content of the
representation and the source-of-the-represented nor to compare
the representation and this source, no more does it lead us to the
view that the represented has no existence beyond the process
which represents it'.[28] This is too reminiscent of the formalism of
those painters and critics who, recognising that the painting had a
mode of existence distinct from that which it represented, deduced
that the painting was entirely autonomous and that the presence of
'external' references was an intrusion of alien and inessential ele-
ments. There is no simple correspondence between classes at the
economic level and classes as social forces constituted on the

political and ideological planes. But neither is the connection accidental and arbitrary. What relates them is a process of representation, properly understood, in which a representation of the one is produced at the other distinct and 'relatively autonomous' levels. Perhaps I am straying too far. The point to which I want to return and lend real emphasis is that when we deal with photography as ideology we are not dealing with something 'outside' reality: a looking-glass world related to the real world by laws of reflection and reversal. According to Althusser: 'An ideology always exists in an apparatus, and its practice, or practices. This existence is material.'[29] 'Therefore,' as Pierre Macherey has argued, 'to study the ideology of a society is not to analyse the system of ideas, thoughts and representations (the "history of ideas" approach). It is to study the material operation of ideological apparatuses – to which correspond a certain number of specific practices.'[30]

III

If you wished to find these two prints (Figure 5.1 and 5.2), you would discover them, filed and indexed, in the US Library of Congress. The story of how they came there is itself an encapsulated history of US government departments between 1935 and 1943. If this initial and important fact seems surprising, then remember that Matthew Brady's civil war negatives were stored in the vaults of the US Signal Corps; William Henry Jackson's plates of the Far West were kept in the Bureau of Reclamation; and great collections of photographs of the unbridled exploitation of the timber lands and of the condition of agriculture before the First World War languished in the files of the Forest Service and the Extension Service respectively. The representation of this material in 'coffee-table books' is a recent phenomenon. Both the photographers responsible for these images were employed by the Historical Section of the Farm Security Administration (FSA): a Federal government department of the USA set up in 1935 as part of the 'New Deal' administration to lend support to its programme by documenting the effects of the 'Depression' on the land and the agricultural labour force. The Historical Section was directed from a government office in Washington D.C. by Roy Stryker and served to supply pictures to New Dealers in various departments, to reports and exhibits, to newspapers and the flourishing photographically illustrated magazines. But it was also open to individuals, as a story from

Stryker shows. Some months after a picture (see Figure 5.3) by Walker Evans was issued ('Bethlehem, Pennsylvania'), a woman came into Stryker's office and asked for a copy:

We gave it to her and when I asked her what she wanted it for, she said, 'I want to give it to my brother who's a steel executive. I want to write on it, " *Your* cemeteries, *your* streets, *your* buildings, *your* steel mills. But *our* souls, God damn you." '[31]

In some senses, the photographers Jack Delano and Russell Lee were only co-authors of the pictures, for Stryker, whose original conception it was to go beyond his narrow brief and begin to accumulate 'a pictorial encyclopedia of American agriculture',[32] issued regular and detailed shooting scripts to all his photographers. It was Stryker who was the first to see the contact sheets. It was he, too, who categorised, filed and selected the work the photographers sent in and who is said to have 'killed', by punching holes in the negatives, 100,000 of the 270,000 pictures taken at a cost of nearly one million dollars in the eight years of the Department's existence. The total 'world view' of the FSA file was, therefore, predominantly Stryker's. Of these two photographers, Russell Lee, who took the picture of the FSA clients, had a particularly close relationship with Stryker. Stryker has said: 'When his photographs would come in, I always felt that Russell was saying, "Now here is a fellow who is having a hard time but with a little help he's going to be all right." And that's what gave me courage.'[33]

 In a shooting script issued to all FSA photographers in 1936, we find Stryker suggesting as subjects: 'Relationship between density of population and income of such things as: pressed clothes; polished shoes and so on.' And more particularly: 'The wall decorations in homes as an index to the different income groups and their reactions.'[34] A year after the later picture was taken, under pressure from Departmental and Congressional criticism in the period following Pearl Harbour, Stryker was calling for: 'Pictures of men, women and children who appear as if they really believed in the US. Get people with a little spirit. Too many in our file now paint the US as an old person's home and that just about everyone is too old to work and too malnourished to care much what happens.' He goes on to ask for: 'More contented-looking old couples – woman sewing, man reading.'[35] Clearly, we must have as our aim the analysis of the specific discourse of the scripts and the correspondences of this written discourse with that of the individual photo-

Figure 5.3 Walker Evans, *Bethlehem, Pennsylvania,* 1935

graphs and, more important still, the whole range of filed and captioned images. As Stryker has written: 'The total volume, and it's a staggering volume, has a richness and distinction that simply cannot be drawn from the individual pictures themselves.'[36] We shall want to relate this to Stryker's individual and idiosyncratic character whose ideological framework belonged to that 'lost America' of small rural towns, prior to the effects of urbanisation consequent on the massive expansion of industry in the post-war era and the accelerated industrialisation of agriculture. For Stryker, the picture files exactly represented life as he had known it and wished it to be.

Then, too, there is the question of direct Federal and Congressional interference in the Department which, by 1941, was beginning to succumb to the effects of financial and staffing cut-backs, bureaucratic interference, and the general Congressional assault on the Farm Security Administration. More than this, the specific economic and political processes which created the need for the Historical Section, presented it with its subject-matter and the transmutations it underwent, and fed on its products, suffered significant and far-reaching changes in the period of the build up to war and after. These changes ultimately determined a general transition in American social life: a transition which not only governed changes in the patterns of patronage and the function of intellectuals having a direct bearing on the practice of photography, but also involved, at the most general level, changes in the mode of social perception. As I have argued elsewhere, we are not concerned with political and economic events alone, but with

> one of those moments of transformation which render the roots of social experience socially visible or invisible. We are concerned with a set of circumstances in which the 'logics', by means of which social reality can be signified, collapse inwardly and are usurped by new logics of social perception which become established within public discourse and receive expression inside the hegemonic institutions. What we must explain is the formation and disintegration of socially structured 'ways of seeing' and the specific genres of image-making in which they are realised.[37]

IV

Earlier, I spoke of the 'binding quality' of photographs and said

that, rather than look to the supposedly intrinsic nature of the photographic process, we must account for this by an analysis of the operation of certain privileged apparatuses within the given social formation. I also said that I wished to consider the question of *truth*, which concerns not only the truth function of photographs and what Sontag has called 'the usually shady commerce between art and truth',[38] but also the specific premium put on 'truth' in realist works. Here, we can see that our analyses converge and coincide.

The French philosopher and historian Michel Foucault has argued that there is a constant articulation of power on knowledge and knowledge on power. The exercise of power itself creates and causes to emerge new objects of knowledge and accumulates new bodies of information: 'The exercise of power is perpetually creating knowledge and, conversely, knowledge constantly induces effects of power.'[39] The truth of this knowledge, therefore, is neither outside power nor deprived of power. It is, rather, the product of a multiplicity of constraints, which, in turn, induce the regular effects of power. It is not a question of the struggle for 'truth' but, rather, of a struggle around the status of truth and the economic and political role which it plays. What defines and creates 'truth' in any society is a system of more or less ordered procedures for the production, regulation, distribution and circulation of statements. Through these procedures 'truth' is bound in a circular relation to systems of power which produce and sustain it, and to the effects of power which it induces and which, in turn, redirect it. It is this *dialectical* relation which constitutes what Foucault calls 'a regime of truth':

Each society has its regime of truth, its 'general politics' of truth: that is, the types of discourse it harbours and causes to function as true; the mechanisms and instances which enable one to distinguish true from false statements, the way in which each is sanctioned; the techniques and procedures which are valorised for obtaining truth; the status of those who are charged with saying what counts as true. In societies like ours the 'political economy' of truth is characterised by five historically important traits: 'truth' is centred on the form of scientific discourse and the institutions which produce it; it is subject to a constant economic and political incitation (the demand for truth, as much for economic production as for political power); it is the object, under diverse forms, of an immense diffusion and consumption

(it circulates in apparatuses of education and information whose extent is relatively wide within the social body, notwithstanding certain strict limitations); it is produced and transmitted under the control, dominant if not exclusive, of a few great political and economic apparatuses (university, army, writing, media ...); lastly, it is the stake of a whole political debate and social confrontation ('ideological' struggles).[40]

This brings Foucault to the view that the problem is not one of changing people's 'consciousness' but the political, economic and institutional regime of the production of truth – or, at least, of showing that it is possible to construct a new politics of truth. This does not mean emancipating truth from every system of power; such an emancipation could never be attained because truth itself is already power. In politics what must be our aim is to detach the power of truth from the specific forms of hegemony in the economic, social and cultural domains within which is operates at the present time. For the historian, however, the problem is to *reinsert* the forms of knowledge under examination within the specific regime of truth and the regulating institutions of the social formation which produced them as 'true'. It would, of course, take much detailed and lengthy work to situate the photographs of the Farm Security Administration in this way and this is something I cannot undertake here. However, the general importance of the concepts to their proper analysis must be evident.

 The 'truth' of these individual photographs may be said to be a function of several intersecting discourses: that of government departments, that of journalism, more especially documentarism, and that of aesthetics, for example: each of them at a determinate stage of historical development; each of them incited and sustained by highly evolved social institutions. The photographs, as I have already pointed out, also participate in the wider 'truth' of the file itself, as a composite picture of rural America in the late 1930s and early 1940s, conceived apparently by one man, but called into being, administered and employed by specific government agencies. (These agencies, being subject to historical mutation, could equally withdraw their validation: towards the end of the life of the Historical Department there was strong pressure from the government to destroy the entire file, negatives included. It was not until the early 1960s that the photographs were reevaluated and submit-

deserving no better fate; and that he *saw* the real men of the future where, for the time being, they were alone to be found – that I consider one of the greatest triumphs of Realism.[50]

For Engels, therefore, the elements of realism were located in the existing social formation and its constituent forces, rather than in the author's allegiances, whether progressive or reactionary. The author was not, however, a mere passive reflector of social conditions. In perhaps his most important single theoretical formulation on the subject, Engels wrote: 'Realism, to my mind, implies, besides truth of detail, the truthful reproduction of typical characters under typical circumstances.'[51] This has, at least, two important consequences. First, it requires of the author an *active intervention* in creating a hierarchy of social phenomena founded on an understanding of the *dialectical totality* of history. Second, it entails that realism, as Brecht has also argued, is not to be derived from particular existing works of art but is, in Stefan Morawski's words, to be judged by 'the expression of a cognitive equivalent: specifically, the dominant and typical traits of socially conflicted life in a particular place and time. *Typicality* is thus a key consideration'.[52] This 'typicality' must be grounded in the specific, individual character of the historical moment. There can be no single transhistorical model.

It might also be said at this point that Engel's account demonstrates that Roman Jakobson's characterisation of realism as connected to a 'metonymic' bias in the use of a signifying system is not adequate.[53] While 'truth of detail' implies an inclination to synechdoche – a defining feature of the metonymic pole – this, Engels says, is not enough. This alone would constitute *naturalism*. The importance of the 'typical' in realism implies, on the one hand, a disposition to select the part which stands for the whole but, on the other hand, an ability to identify similarity and to substitute, that is, a *metaphoric* tendency. Therefore, realism in Engels's terms must be defined not as a metonymic bias in opposition to the dominance of metaphor in Romanticism and Symbolism but, rather as a fusion and active equilibrium of metaphoric and metonymic poles.

The problem of 'typicality' in Realism and the precise level within the work at which it may be said to operate was taken up by Lenin in a series of articles on Tolstoy, published between 1908 and 1911. In 'Lev Tolstoy as the Mirror of the Russian Revolution', Lenin uses

the phrase 'most sober realism'[54] to refer to *specific elements* in Tolstoy's work:

> Merciless criticism of capitalist exploitation, exposure of government outrages, the farcical courts and the state administration, and unmasking of the profound contradictions between the growth of wealth and achievements of civilisation and the growth of poverty, degradation and misery among the working masses.[55]

These *elements*, however, stand in contradiction to other elements:

> 'Tolstoy's point of view was that of the patriarchal, naive peasant, whose psychology Tolstoy introduced into his criticism and his doctrine. Tolstoy mirrored their sentiments so faithfully that he imported their naïveté into his own doctrine, their alienation from political life, their mysticism – their desire to keep aloof from the world, 'non-resistance to evil', their impotent imprecations against capitalism and the 'power of money'.[56]

Tolstoy's resolution of these *opposed elements* into an aesthetic whole cannot be taken as a solution to their deep-lying contradictions, which remain the central conflict within his writings. As Pierre Macheray has said of literary works in general, Tolstoy's novels 'appear "healthy", almost perfect, so that all one can do is to accept them and admire them. But in fact their reality does not accord with their self-presentation'.[57] On the contrary, one must see them as 'something which doesn't work very well'.[58] Thus Lenin saw that 'The very thing that Tolstoy did not succeed in finding, or rather could not find, either in the philosophical foundations of his world outlook or in his social-political doctrine, is a synthesis.'[59] It was going beyond this point, however, that Lenin made his most innovatory contribution to the Marxist theory of realism. He argued it is specifically *this contradiction of elements* which 'mirrors' or 'expresses' the contradictory conditions of Russian life in Tolstoy's period:

> the contradiction in Tolstoy's views are indeed a mirror of those contradictory conditions in which the peasantry had to play their historical part in our revolution.[60]

The contradictions in Tolstoy's views are not contradictions inherent in his personal views alone, but are a reflection of the extremely complex, contradictory conditions, social influences

and historical traditions which determined the psychology of various classes and various sectors of Russian society in the *post*-Reform, but *pre*-revolutionary era.[61]

Tolstoy is original, because the *sum total* of his views, *taken as a whole*, happens to express the specific features of our revolution as a peasant bourgeois revolution.[62]

Reflection takes place, therefore, at a *structural* level in which '*all* the distinguishing features of Tolstoy's work'[63] correspond to the transitional nature of the epoch. Reflection is a function precisely of what Lenin calls Tolstoy's 'deviations from integrality'.[64] It is this lack of *integrality* which reflects or embodies the contradictions inherent in the peasant-bourgeois revolution and it can only be explained by reinserting the works within the historical and economic conditions in which these contradictions were real. The possibility of such an explanation in turn becomes real only through a process of change involving two kinds of displacement. In the first place, there is an historical shift: 1905 marked

the end of an epoch that could give rise to Tolstoy's teachings and in which they were inevitable, not as something individual, not as a caprice or fad, but as the ideology of the conditions of life under which millions and millions actually found themselves for a certain period of time.[65]

In the second place, it is a change of class perspective which reveals the lack of 'integrality' in the ideological object:

That is why a correct appraisal of Tolstoy can be made only from the viewpoint of the class which has proved, by its political role and its struggle during the first denouement of these contradictions, at a time of revolution, that it is destined to be the leader in the struggle for the people's liberty and for the emancipation of the masses from exploitation.[66]

That is, more specifically, the correct appraisal can be made 'only from the viewpoint of the Social-Democratic proletariat.[67]

Tolstoy's novels endure, not as models to be imitated, but because they 'embodied in amazingly bold relief the specific historical features of the entire first Russian revolution, its strength and its weakness'.[68] Yet, for all this:

The Russian people will secure their emancipation only when they realize that it is not from Tolstoy they must learn to win a better life but from the class the significance of which Tolstoy did not understand, and which alone is capable of destroying the old world which Tolstoy hated. That class is the proletariat.[69]

Here, then, is a classical Marxist view of realism that is expressly *conjunctural* and can have nothing to do with ideas of 'photographical truth' or 'universal and enduring human values'. From the point of view of analysis, it sends us back to the dense and disparate materials of history. From the point of view of production, it directs us to the complex and contradictory conditions of class conflict within society and to the representational levels at which this conflict is ideologically present. If the account leaves untheorised what T. J. Clark has called the 'concrete transactions . . . hidden behind the mechanical image of reflection'[70] – if it is unable to specify the representational processes of conversion and relation which are themselves 'historically formed and historically altered'[71] – then neither does it lay down prescriptions for form, style or 'human content'.

This must offer little comfort to those who would revive what they take to be the documentary realism of Abbott, Evans and the rest. Although mass unemployment and deep-rooted economic crisis are with us again, few of the requisite determinations are present in our own conjuncture. The variously inflected documentary realism of the FSA photo-file was born of a complex of events and conditions which ranged from the technical and aesthetic to the economic, political and social. Photography, at this time, was emerging fast as a major tool of mass communications. Flash units and small-format cameras were becoming more generally available. Rotogravure was dying and the first big picture magazines which would take its place were already being roughed out for a public unused to such lavish use of photographic imagery. New forms and techniques were being evolved to keep pace with the possibilities of the new equipment and outlets and to create new needs. A whole new territory of themes and contents was added to the range of legitimated subjects. The 'documentary' was constituted as a distinct genre and category: 'In a year or so,' Stryker remarks, 'and with a suddenness matched only by the introduction of television twelve years later, picture-taking became a national industry.'[72] And all this took place in a

'Depression' which characterised not only an economic condition but also a national mood. Yet, set against this, was the genuine exhilaration of the 'New Deal' Administration in Washington, engendering what Stryker described as 'a feeling that things were being mended, that great wrongs were being corrected, that there were no problems so big they wouldn't yield to the application of good sense and hard work'.[73]

Whether 'wrongs' were corrected may be open to doubt but, at this lowest point, a new economic upsurge was being prepared which would transform again the structure of American society. Already, the subjects of the documentary record were the source of reverie and nostalgia. As Stryker said of a picture (see Figure 5.4) of a small town railroad by Walker Evans ('Edwards, Mississippi'):

> The empty station platform, the station thermometer, the idle baggage carts, the quiet stores, the people talking together, and beyond them, the weather beaten houses where they lived, all this reminded me of the town where I had grown up. I would look at pictures like that and long for a time when the world was safer and more peaceful. I'd think back to the days before radio and television when all there was to do was to go down to the tracks and watch the flyer go through.[74]

We cannot be innocent of the values which inhere in the 'realism' of these photographs. We cannot afford to neglect an analysis of the apparatuses at work in the bringing to light of all this 'documentary' material and in its recirculation. We may follow Stryker's gaze: up the dry dirt path between the tracks, past the carts and talking men, past the stores whose names we cannot see and the silent houses of timber and stone. We may live the space of the picture, its 'reality', its ideological field. But as the picture draws us in, we are drawn into its orbit, into the gravitational field of its 'realism'. There, it holds us by the force of 'the Past' as successfully as it once exerted the force of 'the Present'. If the majority of photographs raise barriers to their close inspection, making protracted analysis seem 'excessive', then these photographs invite a closer and closer view. The further one penetrates, the more one is rewarded by the minutiae of detail suspended in the seemingly transparent emulsion. We seem to experience a loss of our own reality; a flow of light from the picture to us and from ourselves into the picture. Like Stryker, we are

Figure 5.4 Walker Evans, *Edwards, Mississippi*, 1936

invited to dream in the ideological space of the photograph. It is now that we should remember 'dreams really have a meaning and are far from being the expression of a fragmentary activity of the brain, as the authorities have claimed. When the work of interpretation has been completed, we perceive that a dream is a fulfilment of a wish.'[75]

Chapter 6

Looking at Photographs

Victor Burgin

It is almost as unusual to pass a day without seeing a photograph as it is to miss seeing writing. In one institutional context or another – the press, family snapshots, billboards, etc. – photographs permeate the environment, facilitating the formation/reflection/inflection of what we 'take for granted'. The daily instrumentality of photography is clear enough, to sell, inform, record, delight. Clear, but only to the point at which photographic representations lose themselves in the ordinary world they help to construct. Recent theory follows photography beyond where it has effaced its operations in the 'nothing-to-explain'.

It has previously been most usual (we may blame the inertia of our educational institutions for this) to view photography in the light of 'art' – a source of illumination which consigns to shadow the greater part of our day-to-day experience of photographs. What has been most often described is a particular nuancing of 'art history' brought about by the invention of the camera, a story cast within the familiar confines of a succession of 'masters', 'masterworks' and 'movements' – a *partial* account which leaves the social fact of photography largely untouched.

Photography, sharing the static image with *painting*, the camera with *film*, tends to be placed 'between' these two mediums, but it is encountered in a fundamentally different way from either of them.

For the majority, paintings and films are only seen as the result of a voluntary act which quite clearly entails an expenditure of time and/or money. Although photographs may be shown in art galleries and sold in book form, most photographs are not seen by deliberate choice, they have no special space or time allotted to them, they are *apparently* (an important qualification) provided free of charge – photographs offer themselves *gratuitously*; whereas paintings and films readily present themselves to critical attention as objects, photographs are received rather as an environment. As a free and familiar coinage of meaning, largely unremarked and untheorised by those amongst whom it circulates, photography shares an attribute of language. However, although it has long been common to speak, loosely, of the 'language of photography', it was not until the 1960s that any systematic investigation of forms of communication outside of natural language was conducted from the standpoint of linguistic science; such early 'semiotic' studies, and their aftermath, have radically reorientated the theory of photography.

Semiotics, or semiology, is the study of signs, with the object of identifying the systematic regularities from which meanings are construed. In the early phase of 'structuralist' semiology (Roland Barthes's *Elements of Semiology* first appeared in France in 1964)[1] close attention was paid to the analogy between 'natural' language (the phenomenon of speech and writing) and visual 'languages'. In this period, work dealt with the codes of analogy by which photographs denote objects in the world, the codes of connotation through which denotation serves a secondary system of meanings, and the 'rhetorical' codes of juxtaposition of elements within a photograph and between different but adjacent photographs.[2] Work in semiotics showed that there is no 'language' of photography, no single signifying system (as opposed to technical apparatus) upon which all photographs depend (in the sense in which all texts in English ultimately depend upon the English language); there is, rather, a heterogeneous complex of codes upon which photography may draw. Each photograph signifies on the basis of a plurality of these codes, the number and type of which varies from one image to another. Some of these are (at least to first analysis) peculiar to photography (e.g. the various codes built around 'focus' and 'blur'), others are clearly not (e.g. the 'kinesic' codes of bodily gesture). Further, importantly, it was shown that the putatively autonomous 'language of photography' is never free from the

determinations of language itself. We rarely see a photograph *in use* which does not have a caption or a title, it is more usual to encounter photographs attached to long texts, or with copy superimposed over them. Even a photograph which has no actual writing on or around it is traversed by language when it is 'read' by a viewer (for example, an image which is predominantly dark in tone carries all the weight of signification that darkness has been given in social use; many of its interpretants will therefore be linguistic, as when we speak metaphorically of an unhappy person being 'gloomy').

The intelligibility of the photograph is no simple thing; photographs are *texts* inscribed in terms of what we may call 'photographic discourse', but this discourse, like any other, engages discourses beyond itself, the 'photographic text', like any other, is the site of a complex 'intertextuality', an overlapping series of previous texts 'taken for granted' at a particular cultural and historical conjuncture. These prior texts, those *presupposed* by the photograph, are autonomous; they serve a role in the actual text but do not appear in it, they are latent to the manifest text and may only be read across it 'symptomatically' (in effect, like the dream in Freud's description, photographic imagery is typically *laconic* – an effect refined and exploited in advertising). Treating the photograph as an object-text, 'classic' semiotics showed that the notion of the 'purely visual' *image* is nothing but an Edenic fiction. Further to this, however, whatever specificity might be attributed to photography at the level of the 'image' is inextricably caught up within the specificity of the social acts which intend that image and its meanings: news-photographs help transform the raw continuum of historical flux into the product 'news', domestic snapshots characteristically serve to legitimate the institution of the family, and so on. For any photographic practice, given materials (historical flux, existential experience of family life, etc.) are transformed into an identifiable type of product by men and women using a particular technical method and working within particular social institutions. The significant 'structures' which early semiotics found in photography are not spontaneously self-generated, they originate in determinate modes of human organisation. The question of meaning therefore is constantly to be referred to the social and psychic formations of the author/reader, formations existentially simultaneous and coextensive but theorised in separate discourses; of these, Marxism and psychoanalysis have most informed semiotics in its moves to grasp

the determinations of history and the subject in the production of meaning.

In its structuralist phase, semiotics viewed the text as the objective site of more or less determinate meanings produced on the basis of what significant systems were empirically identifiable as operative 'within' the text. Very crudely characterised, it assumed a coded message and authors/readers who knew how to encode and decode such messages while remaining, so to speak, 'outside' the codes – using them, or not, much as they might pick up and put down a convenient tool. This account was seen to fall seriously short in respect of this fact: as much as we speak language, so language 'speaks' us. All meaning, across all social institutions – legal systems, morality, art, religion, the family, etc. – is articulated within a network of *differences*, the play of presence and absence of conventional significant features which linguistics has demonstrated to be a founding attribute of language. Social practices are structured *like* a language, from infancy, 'growing up' is a growing *into* a complex of significant social practices including, and founded upon, language itself. This general symbolic order is the site of the determinations through which the tiny human animal becomes a social human being, a 'self' positioned in a network of relations to 'others'. The structure of the symbolic order channels and moulds the social and psychic formation of the individual subject, and it is in this sense that we may say that language, in the broad sense of symbolic order, speaks *us*. The subject inscribed in the symbolic order is the product of a channelling of predominantly sexual basic drives within a shifting complex of heterogeneous cultural systems (work, the family, etc.): that is to say, a complex interaction of a *plurality* of subjectivities presupposed by each of these systems. This subject, therefore, is not the fixed, innate, entity assumed in classic semiotics but is itself a function of textual operations, an unending process of *becoming* – such a version of the subject, in the same movement in which it rejects any absolute discontinuity between speaker and codes, also evicts the familiar figure of the *artist* as autonomous *ego*, transcending his or her own history and unconscious.

However, to reject the 'transcendental' subject is not to suggest that either the subject or the institutions within which it is formed are caught in a simple mechanistic determinism; the institution of photography, while a product of the symbolic order, also *contributes*

to this order. Some earlier writings in semiology, particularly those of Barthes, set out to uncover the language-like organisation of the dominant myths which command the meanings of photographed appearances in our society. More recently, theory has moved to consider not only the structure of appropriation to ideology of that which is 'uttered' in photographs but also to examine the ideological implications inscribed within the *performance* of the utterance. This enquiry directs attention to the object/subject constructed within the technical apparatus itself.[3] The signifying system of photography, like that of classical painting, at once depicts a scene *and the gaze of the spectator*, an object *and a viewing subject*. The two-dimensional analogical signs of photography are formed within an apparatus which is essentially that of the *camera obscura* of the Renaissance. (The *camera obscura* with which Niépce made the first photograph in 1826 directed the image formed by the lens via a mirror on to a ground-glass screen – precisely in the manner of the modern single-lense reflex camera.) Whatever the object depicted, the manner of its depiction accords with laws of geometric projection which imply a unique 'point-of-view'. It is the position of point-of-view, occupied in fact by the camera, which is bestowed upon the spectator. To the point-of-view, the system of representation adds the *frame* (an inheritance which may be traced through easel painting, via mural painting, to its origin in the convention of post and lintel architectural construction); through the agency of the frame the world is organised into a coherence which it actually lacks, into a parade of tableaux, a succession of 'decisive moments'.

The structure of representation – point-of-view and frame – is intimately implicated in the reproduction of ideology (the 'frame of mind' of our 'points-of-view'). More than any other textual system, the photograph presents itself as 'an offer you can't refuse'. The characteristics of the photographic apparatus position the subject in such a way that the object photographed serves to conceal the textuality of the photograph itself – substituting passive receptivity for active (critical) *reading*. When confronted with puzzle photographs of the 'What is it?' variety (usually, familiar objects shot from unfamiliar angles) we are made aware of having to select from sets of possible alternatives, of having to supply information the image itself does not contain. Once we have discovered what the depicted object *is*, however, the photograph is instantly transformed for us – no longer a confusing conglomerate of light and

dark tones, of uncertain edges and ambivalent volumes, it now
shows a 'thing' which we invest with a full identity, a *being*. With
most photographs we see, this decoding and *investiture* takes place
instantaneously, unselfconsciously, 'naturally'; but it does take
place – the wholeness, coherence, identity, which we attribute to the
depicted scene is a projection, a refusal of an impoverished reality in
favour of an imaginary plenitude. The imaginary object here,
however, is not 'imaginary' in the usual sense of the word, it is *seen*,
it has projected an image. An analogous imaginary investiture of
the real constitutes an early and important moment in the construc-
tion of the self, that of the 'mirror stage' in the formation of the
human being, described by Jaques Lacan:[4] between its sixth and
eighteenth month, the infant, which experiences its body as frag-
mented, uncentred, projects its potential unity, in the form of an
ideal self, upon other bodies and upon its own reflection in a mirror;
at this stage the child does not distinguish between itself and others,
it *is* the other (separation will come later through the knowledge of
sexual *difference*, opening up the world of language, the symbolic
order); the idea of a unified body necessary to the concept of
self-identity has been formed, but only through a rejection of reality
(rejection of incoherence, of separation).

 Two points in respect of the mirror-stage of child development
have been of particular interest to recent semiotic theory: first, the
observed correlation between the formation of identity and the
formation of *images* (at this age the infant's powers of vision
outstrip its capacity for physical co-ordination), which led Lacan to
speak of the 'imaginary' function in the construction of subjectivity;
second, the fact that the child's recognition of itself in the 'imaginary
order', in terms of a reassuring coherence, is a *misrecognition* (what
the eye can see for its-*self* here is precisely that which is not the
case). Within the context of such considerations the 'look' itself has
recently become an object of theoretical attention. To take an
example – *General Wavell watches his gardener at work* (Figure
6.1), made by James Jarché in 1941; it is easy enough today to read
the immediate connotations of paternalistic imperialism inscribed
in this 35-year-old picture and anchored by the caption (the general
watches *his* gardener). A first analysis of the object-text would
unpack the connotational oppositions constructing the ideological
message. For example, primarily and obviously, *Western/Eastern*,
the latter term of this opposition englobing the marks of a radical

'otherness'; or again, the placing of the two men within the implied opposition *capital/labour*. Nevertheless, even in the presence of such obviousness another obviousness asserts itself – the very 'natural' casualness of the scene presented to us disarms such analysis, which it characterises as an *excessive* response. But excess production is generally on the side of ideology, and it is precisely in its apparent ingenuousness that the ideological power of photography is rooted – our conviction that we are free to choose what we make of a photograph hides the complicity to which we are recruited in the very act of *looking*. Following recent work in film theory,[5] and adopting its terminology, we may identify four basic types of look in the photograph: the look of the camera as it photographs the 'pro-photographic' event; the look of the viewer as he or she looks at the photograph; the 'intra-diegetic' looks exchanged between people (actors) depicted in the photograph (and/or looks from actors towards objects); and the look the actor may direct to the camera.

In the reading implied by the title to Jarché's photograph, the general looks at the gardener, who receives this look with his own gaze cast submissively to the ground. In an additional reading, the general's look may be interpreted as directed at the camera, that is to say, to the viewing subject (representation identifies the camera's look with that of the subject's point-of-view). This full frontal gaze, a posture almost invariably adopted before the camera by those who are not professional models, is a gaze commonly received when we look at ourselves in a mirror, we are invited to return it in a gaze invested with narcissistic identification (the dominant alternative to such identification *vis-à-vis* photographic imagery is voyeurism). The general's look returns our own in direct line, the look of the gardener intersects this line. Face hidden in shadow (labour here is literally featureless) the gardener *cuts off* the general (our own power and authority in imaginary identification) from the viewing subject; the sense of this movement is amplified via the image of the mower – instrument of amputation – which condenses references to scythe and, through its position (still photographs are texts built upon *coincidences*), penis (the correlates: white fear of black sexuality/fear of castration). Even as we turn back (as we invariably must) from such as excess of reading to the literal 'content' of this picture we encounter the same figure: the worker 'comes between' the general and the peace of his garden, the black man literally

Figure 6.1 James Jarché, *General Wavell watches his gardener at work,* 1941

disturbs. Such overlaying determinations, which can be only sketch-
ily indicated here, act in concert with the empirically identifiable
connotators of the object-text to show the gardener as out-of-place,
a threat, an intruder in what presumably is his own land – material
considerations thus go beyond the empirical in the overdetermina-
tion of ideology.

The effect of representation (the recruitment of the subject in the
production of ideological meaning) requires that the stage of the
represented (that of the photograph as object-text) meet the stage
of the representing (that of the viewing subject) in a 'seamless join'.
Such an integration is achieved within the system of Jarché's picture
where the inscribed ideology is read from a subject position of
founding centrality; in the photograph *Hillcrest, New York*, by Lee
Friedlander (1970) (see Figure 6.2) this position itself is under
threat. The attack comes from two main sources: first, the
vanishing-point perspective system which recruits the subject in
order to complete itself has here been partially subverted through
ambiguous figure/ground relationships – it is only with some con-
scious effort that what is seen in this photograph may be organised
in terms of a coherent and singular site/(sight); second, the device of
the mirror central to the picture here generates a fundamental
ambivalence. A bisected head and shoulders rises from bottom-
centre frame; the system of representation has accustomed us to
identifying our own point-of-view with the look of the camera, and
therefore a full-frontal mirror reflection with the self; here, how-
ever, there is no evidence (such as the reflection of the camera) to
confirm whether we are looking at the reflection of the photo-
grapher or at that of some other person – the quartered figure has
unresolved '(imaginary) self'/'other' status. In Friedlander's pic-
ture, the conjunction of technical photographic apparatus and raw
phenomenological flux has almost failed to guarantee the subjective
effect of the camera – a coherence founded in the unifying gaze of a
unified, punctual, subject. Almost, but not quite – the picture (and
therefore the subject) remains 'well composed' (in common with
Jarché's picture, albeit differently from it). We know very well what
'good' composition is – art schools know how to teach it – but not
why it is; 'scientific' accounts of pictorial composition tend merely
to reiterate *what* it is under a variety of differing descriptions (e.g.,
those of Gestalt psychology). Consideration of our *looking* at
photographs may help illuminate this question, and return us to the

Figure 6.2 Lee Friedlander, *Hillcrest, New York*, 1970

topic of our characteristic use of photographs, with which we began.

To look at a photograph beyond a certain period of time is to court a frustration; the image which on first looking gave pleasure has by degrees become a veil behind which we now desire to see. It is not an arbitrary fact that photographs are deployed so that we do not look at them for long; we use them in such a manner that we may play with the coming and going of our *command* of the scene/(seen) (an official of a national art museum who followed visitors with a stop-watch found that an average of ten seconds was devoted by an individual to any single painting – about the average shot-length in classic Hollywood cinema). To remain long with a single image is to risk the loss of our imaginary command of the look, to relinguish it to that absent other to whom it belongs by right – the camera. The image then no longer receives *our* look, reassuring us of our founding centrality, it rather, as it were, avoids our gaze, confirming its allegiance to the other. As alienation intrudes into our captation by the image we can, by averting our gaze or turning a page, reinvest our looking with authority. (The 'drive to master' is a component of scopophilia, sexually based pleasure in looking.)

The awkwardness which accompanies the over-long contemplation of a photograph arises from a consciousness of the monocular perspective system of representation as a systematic deception. The lens arranges all information according to laws of projection which place the subject as geometric point of origin of the scene in an imaginary relationship with real space, but facts intrude to deconstruct the initial response: the eye/(I) cannot move within the depicted space (which offers itself precisely to such movement), it can only move *across* it to the points where it encounters the frame. The subject's inevitable recognition of the *rule* of the frame may, however, be postponed by a variety of strategies which include 'compositional' devices for moving the eye from the framing edge. 'Good composition' may therefore be no more or less than a set of devices for prolonging our imaginary command of the point-of-view, our *self*-assertion, a device for retarding recognition of the autonomy of the frame, and the authority of the *other* it signifies. 'Composition' (and indeed the interminable discourse *about* composition – formalist criticism) is therefore a means of prolonging the imaginary force, the real power to please, of the photograph, and it may be in this that it has survived so long, within a variety of rationalisations, as a criterion of value in visual art generally. Some

recent theory[6] has privileged film as the *culmination* of work on a 'wish-fulfilling machine', a project for which photography, in this view, constitutes only a historical moment; the darkness of the cinema has been evinced as a condition for an artificial 'regression' of the spectator; film has been compared with hypnosis. It is likely, however, that the apparatus which desire has constructed for itself incorporates *all* those aspects of contemporary Western society for which the Situationists chose the name *spectacle*: aspects forming an integrated specular regime, engaged in a mutual exchange of energies, not strung out in mutual isolation along some historicist progress; desire needs no material darkness in which to stage its imaginary satisfactions; day-dreams, too, can have the potency of hypnotic suggestion.

Precisely because of its real role in constructing the imaginary, the misrecognitions necessary to ideology, it is most important that photography be recovered from its own appropriation to this order. Counter to the nineteenth-century aesthetics which still dominate most teaching of photography, and most writings on photography, work in semiotics has shown that a photograph is not to be reduced to 'pure form', nor 'window on the world', nor is it a gangway to the presence of an author. A fact of primary social importance is that the photograph is a *place of work*, a structured and structuring space within which the reader deploys, and is deployed by, what codes he or she is familiar with in order to *make sense*. Photography is one signifying system among others in society which produces the ideological subject in the same movement in which they 'communicate' their ostensible 'contents'. It is therefore important that photography theory take account of the production of this subject as the complex totality of its determinations are nuanced and constrained in their passage through and across photographs.

Chapter 7

Making Strange: The Shattered Mirror

Simon Watney

In 1935 the English artist Paul Nash took a number of photographs of the local Dorset landscape around Swanage, where he was then living. One of these shows a flight of three stone or concrete steps in the middle of an otherwise unextraordinary field. A clump of brambles behind the steps enables one to roughly gauge their size – perhaps two feet high and five feet long. At the same time, their scale is monumental, in the centre of the image and viewed from a slight angle. Why should Nash, a painter of international reputation, who was also extensively familiar with contemporary European photography, choose to record this particular scene?

A year later he wrote in *Country Life* that 'the landscapes I have in mind belong to the world that lies visibly about us. They are unseen merely because they are unperceived'.[1] There is also at least one description of Nash at work at this time 'flat on his belly . . . taking from the earthworm angle . . . a peculiar foreshortened photograph of some up-ended half-finished fence posts'[2]

In this chapter I wish to explore some of the conditions which influenced both the choice of subject-matter and the actual 'look' of much photography in the 1920s and 1930s. I shall argue that there is a substantial unity of photo-aesthetic values behind the work of Nash and many of the photographers he most admired, including Man Ray, Moholy-Nagy, and André Kertesz. Throughout this

period there existed a coherent, though locally flexible, model of photographic practice from the Soviet Union to France and the USA, which cannot adequately be explained within the generic stylistic categories of traditional 'Art History', for this position derived from a wide range of suppositions concerning the determinant and determining relationships between seeing, representing and knowing, which in turn denied the validity of any crude distinction between aesthetics and politics. Its earliest and most cogent theorisation occurred in Russia before the First World War, where it was closely related to the concept of ostranenie, or *making strange*.

Ostranenie

Paul Nash's stated desire to materialise hitherto 'unseen landscapes' with his camera presupposes a notion of flawed perceptual capacity which he, as a photographer, might correct. In the 1890s Oscar Wilde had written of 'beauty . . . dimmed to us by the mist of familiarity'.[3] Indeed, the notion that the mind has somehow to be protected against the stultifying effects of habit was a commonplace of Romantic thought: 'The only habit your child should be allowed to contract', wrote Rousseau in *Emile*, 'is that of having no habits.' And in his *Essai Sur La Peinture* of 1776 Diderot wrote, in response to the banal and archaic conventions of beauty which shaped so much contemporary art, that 'the arts of imitation need something wild, primitive, striking. . . . First of all move me, surprise me . . . make me tremble, weep, shudder, outrage me; delight my eyes afterwards if you can.'[4] But Romanticism could only understand the tendency of all symbolic systems to ossify in relation to the power and values which they symbolise, in terms of a putative distinction between an art which is based upon conventions and one which is convention-free. It was this latter vision of an art which might bypass the codes of class and nationalism, embodied in classical culture since the Renaissance, which informed the work of so many Romantic artists and writers. Thus, in the tradition of Rousseau's thought, *all* culture was seen in the image of a prison, as a series of constraints and limitations. The Romantics therefore struck out against habit in a libertarian sense, just as they struck out against a fixity of genres in painting, and that hierarchical view of the world which they reflected. At one extreme this could lead to an attack on language itself, understood as the very model of the process by

which thought and communication were supposedly betrayed and deformed by 'conventions'.

Romantic culture could only posit an opposition between the past, viewed as a sclerotic barrier to meaning, and some kind of spontaneously free self-expression, sanctioned by a pre-Saussurean view of language and representation, which expressly rejected any further analysis of the nature of signifying practices. It was also the tendency of this position to treat all matters of 'thought' and perception in an extremely socially abstracted fashion. In this respect Romanticism directed its various attentions to an ideal, monolithic and supposedly universal human audience. This was a direct consequence of equating knowledge with seeing, such that deficiencies or variations of belief could only be explained in terms of deficiencies or variations at the level of sight itself. The problematic metaphor of the 'eye' persists in modern theories of ideology.

One of the most familiar versions of this metaphor occurs widely throughout the nineteenth century and was a stock in trade of aestheticism. Like Wordsworth and Goethe before them, Monet, Cézanne, Pissarro and Van Gogh all described the idea of a pure undifferentiated childhood vision 'corrupted' by subsequent experience, often equated with 'conventions'. All these artists wrote of a common dream of losing their adult sight in order to have the pristine vision of childhood miraculously restored. Gauguin carried this fantasy/proposition to the limit of its tacit social implications. It was not simply the eye which was corrupt, it was European culture itself, European vision. Hence his atavistic quest for an art and a society remote in time or distance from that of his own period and society. Romanticism tended either to look backwards to a series of imaginary Golden Ages, or away to exotic and equally imaginary Arcadias.

In *The German Ideology* Marx gives us a more frankly political version of the same parable. Here he explores the ways in which the 'common sense' of particular groups in society is constructed, arguing that it is always the task of any ruling class to establish its own beliefs and values as if they were 'eternal law'.[5] Marx's own problem was how to re-think our ideas concerning human nature, how to picture consciousness as an 'ensemble of social relations' rather than as an ahistorically given 'essence', and how to relate this picture to the rest of material life. One of his earlier solutions to this

problem involved the concept of 'false consciousness', a concept which was instantly recognisable within the structures of Romantic thought. Capitalism is seen to create conditions which cloud or mystify our awareness of ourselves and our relations to the world in such a way that we cannot correctly perceive our objective conditions of inequality and exploitation, which are misunderstood as if they were 'natural', and therefore immutable.

If this led to a radically new emphasis on the ways in which culture legitimates particular forms of society, and may in turn be used to disclose and 'de-mystify' them, it also tended to preserve the older emphasis on a socially abstracted notion of perception. These two broad tendencies in late nineteenth-century thought – the aesthetic ideal of pure versus corrupt vision and the Marxist picture of true consciousness versus false consciousness – worked together to provide a powerful matrix for ideas concerning the ways in which representations of the world may shape consciousness and, perhaps, change it.

It was in pre-revolutionary Russia, however, that the old Romantic dream of a new culture for a new society, a new convention-free language for a new and completely unconventional kind of human subject, was partially realised. Russian Futurism was not a tendency, or a school, or a unitary movement. Rather, it was a broad, shifting series of alliances between a large number of transient *avant-gardes*, all of which were aligned around a dynamic yet coherent set of ideas, terms and practices. The various debates concerning the original moment of Russian Futurism only point to the futility of approaching this subject with the methodology of positivist Art History, and betray a basic misunderstanding of its objectives and its nature. Like the Surrealist movement, with which it had much in common, Russian Futurism derived from a theory of language which was closely connected to a model of history. This was most clearly exemplified by the poet Khlebnikov's attempts to construct a new Russian language, a phonetic *tabula rasa* which would be the precondition for the emergence of 'budetlyane', the Man of the Future, the new Russian.

Russian Futurism found its momentum along the precise line of its poetics. Yet unlike Dada or Italian Futurism this involved a poetics which was deeply committed to revolutionary politics. Hence the objections of the Russian writer Sergey Tretyakov and others to Marinetti's arbitrary phonetic dislocations which, they

argued, merely pulled language apart into meaningless sounds, unable to reconstruct a new language as was felt to be required for the regeneration of Russian society. This was the significance of Mayakovsky's view of culture as the 'third revolution'. Art was not simply to reflect life: it was to be reactive within and upon it.

Russian Futurism developed a number of strategies to signify its intended break with the language and institutions of bourgeois society. These included the cutting up and juxtaposition of words and images, and the creation of any number of local dialects to release the spirit of 'budetlyane', like Ariel from the tree. The year 1913 was the period of street art, mixed media experiments, and any amount of artistic innovation, so reminiscent of Andre Breton's 'Prosecution of the Real' some two decades later in France. As Viktor Shklovsky wrote retrospectively in 1940, 'in the art of that period painting and literature had not yet separated. . . . The poet tests the world and turns it upside down; he leaves for the street, for the square, which he so stubbornly calls a "tambourine".'[6] It is important to stress that the Russian Futurists felt no discontinuity between their publicity stunts, street theatre, life-styles, books, paintings, films and their politics. Indeed, one might well understand Russian Futurism as a sustained and joyous attack on all rigid and narrow definitions of the scope of the political. Hence the poet Kruchenykh's critique of the Italian Futurists' 'endless ra-ta-ta-ta', which is compared mockingly with the Symbolist playwrite Maeterlink, whom, Kruchenykh claimed, thought that 'the door repeated a hundred times equals Revelation!'[7]

The point of all this experimentation was not, however, privatised: this was not simply another early Modernist *avant-garde* mistaking the museums and art galleries for the heart of capitalism. The roles of such institutions were not overlooked. Neither were they overemphasised. At the heart of all this activity lay a passionate and clearly motivated desire to lay the ground for a new kind of consciousness. To this end was dedicated an army of writers and artists, whose activities ranged from Mayakovsky's performance art to Khlebnikov's science-fiction visions of a completely new universe. There emerged here a consensus of opinion on the subject of 'Zaum', a term which referred to the idea of an anti-propositional language derived from Russian phonetics, 'trans-rational', aspiring to the condition of a universal art, which would emerge, as Khlebnikov put it, 'organically, not artificially like Esperanto'.[8] Closely

connected to the concept of Zaum was that of 'Sdvig', a parallel theory which covered the possibilities of linguistic and pictorial associations, as exemplified by many of Malevich's paintings around 1913–14.[9]

Thus Shklovsky could write in 1914 that, while 'the old art has already died, the new has yet to be born; we have lost awareness of the world, we are like a violinist who has ceased to feel the bow and the strings. . . . Only the creation of new forms of art can restore to man the sensation of the world.'[10] In Shklovsky's eyes, the Russian language was as good as dead; only images were still alive. He had, after all, begun his career as a sculptor. Hence the need for this new kind of language (not unlike Ezra Pound's interpretation of 'Chinese, in which all meaning was supposedly analogical or 'ideogrammic',[11] one which might restore some vital link between people which, it was believed, had become eroded. In this theory of language it is words themselves which are seen to have been damaged as symbolic currency, as if worn out through use: 'The ancient diamonds of words recover their former brilliance,' he writes, 'the creation of a new "tight" language is necessary, directed at seeing and not at recognition', concluding that 'it is not the theoreticians but artists who will travel these paths ahead of all others.'[12] In other words Futuristy – the practices of Russian Futurism – is understood to be effective at the level of perception itself, viewed as the prime conditioner of knowledge. In place of mechanical 'recognition', the Men of The Future will *see*. The writers of a manifesto entitled *Sadok Sudei* in 1913 described how they have begun 'to attach meanings to words according to their graphic and phonic characteristics'. This desire to somehow stabilise language, to force it back into some imagined relations with actual things, is entirely characteristic of Russian Futurism, as was the ease with which theories concerning words could be applied to images.

In some ways Shklovsky held a position which has certain parallels with contemporary European aesthetics, for example Roger Fry's attacks on the 'customary' aspects of Naturalism in his Preface to the *Catalogue of the Second Post Impressionist Exhibition*, held in London in 1912, where he advanced the notion that painters such as Picasso and Matisse 'aim not at illusion, but at reality'.[13] By 1914 this had become a fundamental tenet of early Modernist criticism, and it is interesting to note how the Russian Futurists countered the

elitism of their European contemporaries, who argued that the capacity to see, as opposed to 'mere' recognition, was the innate gift of a naturally privileged minority, with a constant stress on the socially functional role of art in society. Europeans such as Fry, and Apollinaire in Paris, distinguished between different kinds of se- eing, but only on the basis of a belief in some transcendant domain of aesthetic value which was believed to be blocked by ordinary vision. This hardly mattered very much if the capacity to go beyond 'ordinary vision' was innate! None the less, European Modernism was felt to possess some kind of educational and beneficial effect on its audience, if only in its encouragement of 'disinterested vision' required to perceive the metaphysical dimension of 'pure form'.[14] In much the same way that Russian painters understood Cubism as an attack on conventional Realism, in terms of Zaum and Sdvig theories of associational meaning, so Russian critics tended to direct Western aesthetics into questions of the larger social significance of representational systems.

In a poem written in 1913, Kruchenykh described these 'who fell under the wet curtains covering the windows [who] got lost midst the traces of the fugitives [then] taken to a strange home where it was familiar'.[15] This kind of juxtapositioning of the strange and the familiar was central to the strategies which were developed from Zaum and Sdvig aesthetics. All involved the notion of disorienta- tion in one form or another, since Russian Futurism was dedicated to surprising or shocking its public out of its habitualised view of the world, out of its history. Habit was understood very much as Samuel Beckett described it in 1931 as 'a compromise effected between the individual and his environment . . . the guarantee of a dull inviola- bility . . . the ballast that chains the dog to his vomit'.[16] Quite how and why the Futurists themselves had broken with habit is never made clear. Shklovsky, for one, was content to describe the process by which perceptions become habitualised, become no more than mechanical reflections of a seemingly given reality. 'We see the object as though it were enveloped in a sack. We know what it is by its configuration, but we see only its silhouette.'[17] Habitualisation is understood by Shklovsky as an effect of dulled perceptions, percep- tions which have been clouded by routine, by culture. His analysis is thus very much more concerned with the ideological dimensions of everyday life than with the machinery of class, sexuality or modes of production. Hence the remedy he envisaged lay within the tradi- tional territory, and discourse, of art:

Art exists to help us to recover the sensation of life, to make the stone *stony*. The end of art is to give a sensation of the object as seen, not as recognised. The technique of art is to make things 'unfamiliar', to make forms obscure, so as to increase the difficulty and the duration of perception. The act of perception in art is an end in itself and must be prolonged. In art, it is our experience of the process of construction that counts, not the finished product.[18]

It was in this manner that late nineteenth-century aesthetics were recuperated and redirected in directions which neither European nor Russian symbolists could have imagined. The distinction between seeing and 'mere' recognition, which was central within Post-Impressionist and early Modernist aesthetics was turned away from a metaphysical impulse towards the analysis of innate aesthetic forms, and out towards the complex relations between artist and public, and the values which are there negotiated.

In Shklovsky's theorisation, 'ostranenie', or the strategies for *making strange*, is still firmly rooted in an aesthetic dimension, which was to be strongly reinforced by the whole body of Formalist literary criticism. At the same time, however, the weighting placed upon the social nature of perception, its socially learned features and consequences, threatened the tranquility of any attempt to posit an absolute distinction between artistic and quotidian modes of perception and representation. For all its clear debts to Cézanne and the Cubists, Shklovsky's ideas were immediately applicable to a wider range of social practices, in particular film and, of course, photography. The notion of restoring our vision to some kind of Edenic purity was particularly relevant to the photographic media, which Shklovsky himself, together with his friends Mayakovsky and Tretyakov were extensively involved with, particularly after the emergence of the Constructivist movement in 1917, itself a response to the Aestheticism of Russian Futurism in the light of the Revolution. Yet the theory of *making strange* remained central to subsequent developments in Soviet art. In this respect it would be wrong to imagine any kind of absolute rupture in the period from around 1910 onwards. As Tretyakov pointed out in 1923, Russian Futurism had always been a socio-aesthetic tendency, and, referring to a notorious manifesto produced by Kruchenykh, Mayakovsky and others in 1912'[19] pointed out that 'a slap in the face for aesthetic taste was only one moment in a general slap in the face for a daily

routine frozen into its forms'.[20] He goes on to explain that the Russian Futurists were not simply producing yet another system of closed aesthetic dogmatism but 'setting the human psyche as a whole into commotion, spurring on this psyche to the maximum possible degree of creative elasticity, to a break with all canons and with any belief in absolute values'. Art could thus be redefined as a particular mode of production rather than as a fetishised duplication of bourgeois values, seen to be placed, as Art, beyond all question. This was the position held by the Productivists, a group formed in the early 1920s by Mayakovsky, Shklovsky, Tretyakov and a number of artists and photographers including Alexander Rodchenko. Their unofficial mouthpiece was the journal *Lef*, founded in 1923.[21]

In the first issue of *Lef*, Tretyakov argued that without the 1917 Revolution Russian Futurism 'would never have taken its forging of the human personality further than anarchistic sorties against isolated individuals'. Production art pursued the agitational aspects of Futurism in the direction of the material reorganisation of the human psyche, the creation of *budetlyane*. To do this it pursued the strategies of 'aesthetic interruption' pioneered by Khlebnikov and others.

The poet's task now 'is to make the living concretely necessary language of his time', a task which 'may seem Utopian, for it means: art for all – not as a product for consumption, but as a productive capacity'.[22] Here the old Romantic dream of a universal language was finally to be realised in political terms, through a wholesale onslaught against the customary which was implicit in the concept of defamiliarisation. This required a cultural struggle for the 'determinate structure of experiences, feelings, and the character of human action . . . the fixed forms of daily routines'. Production art set out to sabotage 'the structure of feelings and actions that have become automatised on a socio-economic basis by their repetition, that have become habit and possess tremendous tenacity . . . the internalised daily routine which so strongly hinders people from taking on the tasks dictated by the change in the relations of production'. Tret'jakov goes on to describe the ways in which everyday life creates needs which are fetishistic, unconnected to the usefulness of their objects, needs which ultimately enslave. Art, like religion, is rejected as 'a lie'.[23]

At this point *making strange* becomes completely identified with

revolutionary struggle, a theory of culture which was implacably hostile to the hegemonic values of capitalist society, particularly as invested in traditional aesthetics. It has, in other words, been rethought in Marxist terms. Unfortunately, Tretyakov stumbles into moralism here, bewailing the fact that people cannot even seem to walk down the street in a 'rational' way without bumping into one another! The Romantic libertarian origins of the term have been taken over by a new monolithic theory of universally 'correct' practice and, by extension, of 'correct' human nature, which was every bit as inflexible as the bourgeois dogmatism which 'ostranenie' had set out to question. Far from being an agent of free productive capacity the Man of the Future emerges from these pages as the unthinking 'good citizen' desired by every totalitarian regime.

In 1926 Osip Brik, a founder member of both the *Opoyaz*[24] and *Lef* groups, described the situation of Russian photography in terms which were equally applicable to that in Europe and the USA. Photographers are criticised for imitating the appearance of oil paintings in order to attain the social status which attached to the concept of the artist. As a typical productivist Brik rejected the whole philosophy of art to which photographers were aspiring: 'by battling against the aesthetic distortion of nature the photographer acquires his right to social recognition, and not by painfully and uselessly striving to imitate models alien to photography'.[25] Brik argued that 'the best fighters against painterly aestheticism are former painters', and he singled out Rodchenko for special attention.

Rodchenko himself described the limitations of Pictorialism, arguing that, for example, 'the photograph of a newly constructed factory should not be the photograph of the building' and advocates repeated experimentation in the shooting of stills from a variety of angles'.[26] Under Brik's influence Rodchenko sought to establish a programme of specific photographic laws which might release the spectator from his or her preconceptions. Hence his concern with the 'quality of the angle' in photography in his attempt to formulate 'a new aesthetic that can express with photographs the passion and the pathos of our new socialist reality'.[27] If, as he argued, painting was dying away, then the real struggle lay within photography itself, against Pictorialist uses of the medium, and that powerful belief that photographs simply reflect a given reality. This was directly in line

with Tretyakov's concern with the 'tenacious' nature of 'automat-ised' consciousness, and the ways in which this is reinforced by the photographic media. The same argument was also widely held in relation to contemporary film practice.[28] Photography was not merely to chronicle the new age. New forms of representation had to be found which could call into question the ways in which we view the world, on the grounds that issues of subject-matter should not be abstracted from those of formal signification. Hence his various strategies for producing 'difficult' images which delay the usually spontaneous act of recognition. His point was 'to show the world from all points of view and to teach the ability to see it from all sides'.[29] (See, for example, Figure 7.1.)

It is important, however, to distinguish between Rodchenko's photomontages and the rest of his photographic practice, just as it is important to distinguish between the aesthetics of photomontage as a whole and those of *making strange*. His 1923 montage illustra-tions to Mayakovsky's poem *About This* are in fact closely allied to the text in a fairly traditional way. At the same time, the fragmented appearance of the individual illustrations reveal Rodchenko's stylistic debt to contemporary German Dada photomontages, of which Mayakovsky and Brik had first-hand experience.[30] The shock power of images which have been constructed from several differ-ent photographic sources was undoubtedly comprehensible within the framework of Russian Futurist thought. But photomontage had to travel to the Soviet Union in order to take on the ideology of *making strange* which Heartfield, among others, borrowed from the *Lef*-group members in the course of the 1920s. In other words, the propagandist origins of photomontage may have assumed the gen-eral theoretical position implied by *making strange* over the course of a decade or so. But photomontage did not exhaust the pos-sibilities of that general position. The eventual extension of the concept of photomontage, from a specific technique of cutting up photographs to an overall theory of photography, as described by Heartfield, is unthinkable without the input of Russian thought and practice.[31] As early as 1915 Rodchenko had described his desire to show familiar objects in unfamiliar ways, through such Swiftian devices as extreme close-ups, and so on. Such ideas only came to inform the practice of photomontage in Germany through the agency of the *Lef* group. The theory of *making strange* was thus a crucial element in the transition from Dada's comic vision of a world

Figure 7.1 Alexander Rodchenko, *The Driver*, 1933

which is as incomprehensible as it is savage to an analytical Marxist outlook.

Photomontage thus became one of many techniques by which 'a photographer who wishes to grasp the social significance of a phenomenon will seek for methods to underline the essential feature, thus correcting the objectivity of the camera, which regards with indifference the just and the unjust'.[32] As late as 1936 Tretyakov did not see *making strange* as a challenge to the ideology of objectivity itself.

None the less, the theory of 'ostranenie' continued to make its impact felt throughout the 1920s and 1930s in Germany. This is nowhere more clear than in Walter Benjamin's celebrated description of Brecht's claim that 'less than at any time does a simple reproduction of reality tell us anything about reality. Reality proper has slipped into the functional. The reification of human relationships, the factory let's say, no longer reveals those relationships. Therefore something has actually to be constructed, something artificial, something set up.'[33] This is precisely the reasoning behind Rodchenko's serial photographs from the late 1920s in which the entire sequence of an event is shown in a series of related images. The hidden production process of the very newspaper which one is holding in one's hands is shown in one such example.[34] Rodchenko's commercial photography was firmly based on the conviction that photography should not be complicit with the tendency to reproduce objects – people, 'The News', furniture, architecture – as if they had somehow brought themselves into existence without human agency or interest.

The theory of *making strange* provided Brecht with the raw material from which he was to develop all his various strategies towards that 'knowledge achieved through doubt' of which he wrote in *Galileo*.[35] The entire problematic of complex seeing should properly be viewed in this context.[36] After Tretyakov was 'purged' in 1937 Brecht must have felt a great responsibility to his former friend. In 1939 he wrote that 'the most hackneyed and everyday incidents are stripped of their monotony when represented as quite special. The audience is no longer taking refuge in history from the present day: the present day becomes history.'[37] His words sustain a discourse and a range of practices which would have been perfectly familiar to Khlebnikov and Mayakovsky some thirty years earlier. In Germany in the 1930s this discourse could be used towards

socialist realist ends to create a 'proletarian eye' which might
become aware of 'the worker's world which is invisible to the
bourgeoisie, and unfortunately to most proletarians also'.[38] It could
also validate the broader position held by Franz Roh, that 'man in
the jog-trot of conventional life generally conceives but a conven-
tional impression, and rarely actually experiences the object'.[39] But
at this point the theory of defamiliarisation has been appropriated
in such a way that its political implications have been all but
dissolved away. Roh's polemic is dedicated against the local Pic-
torialist tradition exemplified by A. Renger-Patzsch's 1928 antho-
logy *The World is Beautiful*. Roh's own reply was the *Photo-Eye*
anthology of 1928, of which he wrote 'our book does not only mean
to say "the world is beautiful", but also: the world is exciting, cruel,
and weird'.[40]

The *Photo-Eye* collection begins with a picture of a corset shop in
Paris taken by Eugene Atget at the beginning of the century. A
severely traditional French shop-window is seen, filled with head-
less and inhumanly corseted dummies, while another dummy hangs
outside. In 1931 Walter Benjamin wrote that Atget 'cleanses' the
atmosphere of traditional portrait photography, showing the envi-
rons of Paris emptied of people, thus setting the scene for a
surrealist school of photography which might explore 'a salutory
estrangement between man and his surroundings'.[41] Most of the
Photo-Eye anthology is taken up by photographs which ostensibly
explore the aesthetics of defamiliarisation, from aerial landscapes,
X-rays of a woman's handbag and flowers, negative prints, medical
photos, and so on. What should be noted, however, is that while
Roh held a theory of perception which contrasted 'conventional'
views of the world to 'actual experience', this was not connected to
any larger view of the social roles of photography. *Making strange*
had become annexed as a style, a 'look' to photographs which was
resolutely 'modern' but at the same time innocent of any theory of
ideology.

In this respect the Hungarian photographer Moholy-Nagy rep-
resented a powerful strand in European photography, directing his
position from a Constructivist rather than Productivist model
which, with its semi-mystical emphasis on materials,[42] laid a heavy
stress on the physical inadequacies of the human eye (see Figure
7.2, for example). *Making strange* thus passed into the territory of a
more rigorously science-orientated theory of knowledge which

regarded technology as a direct extension of 'natural' vision, in a manner which looks back to Vertov and Rodchenko as well as forward to the technological determinism of Marshal McLuhan in the 1960s. While photographers like Roh and Moholy-Nagy adapted *making strange* to the imperatives of European Modernism, Walter Benjamin argued that *all* photography, constructivist or otherwise, which failed to explore the relationships between images and written language 'must remain arrested in the approximate'.[43] What Benjamin sought was a photographic practice which would not 'paralyse the associative mechanisms of the beholder', a practice which would effectively transform photography into a form of literature, spontaneous experience into contemplatable texts.[44] It was along these lines that the socio-political imperatives of the Shklovsky/Tretyakov formulation of ostranenie came increasingly to inform the photomontage tendency in German photography, with its careful emphasis on the relations between image and language in the context of a specific communist orientation. As Stanley Mitchell has pointed out, it was in this way that Benjamin 'came to regard montage, i.e. the ability to capture the infinite, sudden or subterranean connections of dissimilars, as the major constitutive principle of the artistic imagination in the age of technology'.[45] From this point of view the single print could be seen as innately reactionary, regardless of camera angle or whatever defamiliarising strategy might be employed. This was always a problem in Modernist thought, with its casual rejection of 'Naturalism', as if all mimetic arts carried the same values over and above their site and function.

It was only in the Surrealist movement that Benjamin found a viable equivalent to the theory of montage. This was because he recognised that Surrealism was first and foremost a theory of language, and a theory intimately connected to a dynamic commitment to social change, to revolution. For Surrealism had taken up the grenades of Romanticism, the metaphors of madness and sleep and passion, and had redirected them into the very heart of Modernist aestheticism. Yet photography enjoyed but a tenuous place in the firmament of surrealist practice. Benjamin himself was well aware of 'the inadequate, undialectical conception of the nature of intoxication', the 'fanatical stress on the mysterious side of the mysterious', which led so many of the surrealists to perceive 'the everyday as inpenetrable, the inpenetrable as everyday'.[46] Hence

Figure 7.2 Laszlo Moholy Nagy, *Paris drain*, 1929

Benjamin's ultimate dismissal of an aesthetics of surprise which he saw to be 'enmeshed in a number of pernicious Romantic prejudices'.[47]

Mainstream European photography had gradually accommo- dated the strategies of defamiliarisation into a style, a new Pictorial- ism, consisting largely of subject-matter and camera techniques which were merely unfamiliar to the preconceptions of a narrow bourgeois public which included most of the photographers them- selves. *Making strange* dissolved into the general Modernist need for constant stylistic innovation, seen as an end in itself. It became aestheticised. Surrealism, however, remained far more closely con- cerned with the idea of dramatic perceptual disorientation, linked to the struggle to release some essential and universal 'surreality' supposedly repressed by bourgeois society. It was this sense of social motivation which marked them off most decisively from their European contemporaries, and which in retrospect seems so much like the early generation of Russian Futurists, with whom they shared the central metaphor of the artist as a poet who is above all a seer. In this respect Surrealism involved a particular attitude to- wards sight, an interrogation of the actual process of seeing which was not conceived simply as a passive or neutral receiving mechan- ism but as an exchange between subject and object. In this respect, as in so many others, they were much influenced by Freud. Hence their recuperation of the Romantic figure of the artist as the bearer of universal truths, truths that could only be revealed through their ceaseless attacks upon what André Breton described as 'the mad beast of convention'.[48] It was in these terms that Breton and his friends discovered and admired the work of Atget, who seemed to reveal a city of Paris which admirably fitted in with their vision of an art which would place the spectator out of his depth – out of his habitualised consciousness.

Yet photography proved by and large to be resistant to the surrealist imagination, and Man Ray's photographs have far more to do with a Modernist aesthetic derived from Cubist painting than with Surrealism. His surrealist photos, like those of Brandt, Brassai, Kertesz and others, are little more than illustrations (often very literal) of the current iconography of surrealist taste at any particu- lar time, ranging from mannequins and cotton-reels, to scissors or classical sculpture. For the surrealists anything could be made replete with significance by the straightforward practice of remov-

ing it from familiar surroundings and recontextualising it. This was the task of most surrealist photography. Only occasionally, as in Boiffard's monstrous enlargements of toes and finger-tips (see Figure 7.3, for example), did the photographers find their own means to parallel the poet's objectives, to create a photography of the marvellous on a par with the overall programme of systematic mental disturbance. In the majority of cases the long-term influence of Surrealism meant little more than the creation of an extended sense of the picturesque, which tended all too often to descend into mere whimsy, as in Kertesz's and Brandt's 'distortions'.

Divorced from their original commitment to a radical political programme, the strategies of Surrealism could all too easily appear as little more than a taste for the bizarre in bourgeois terms, a taste which only served ultimately to reinforce the expectations and sense of normality which they momentarily upset. This was particularly the case in the English-speaking world, where the most important texts of Breton and his friends have remained largely inaccessible, leaving a generalised idea of Surrealism in the likeness of Dali and Magritte, in both of whose work the means of surrealist shock and *dépaysement* are totally separated from the movement's avowed ends.

In the mid-1930s Man Ray's studio assistant, Berenice Abbott, took back to the USA a large number of Atget's glass negatives, and thus the seeds of a surrealist-influenced photographic practice which has dominated American photography ever since. Her photographs of New York show us the city completely reconstructed within the canons of surrealist taste, drained of Surrealism's values. New York is *made strange*, but it is made strange by being totally aestheticised. There is no question here of a practice which employs 'unusual' angles, or 'mysterious' subjects in order to reveal any of the social contradictions with which every large city abounds, the invisible 'workers' world'. On the contrary, the metaphor of human beings seen as mannequins, reduced to the mechanical life of automata by the demands of a brutal social system, becomes merely an aesthetic taste, an iconographic theme for the art historians to ponder. It does not require an especially strong sense of irony to appreciate the way in which a range of photographic techniques, which had been expressly developed to reveal the conditions of alienated life and consciousness, became

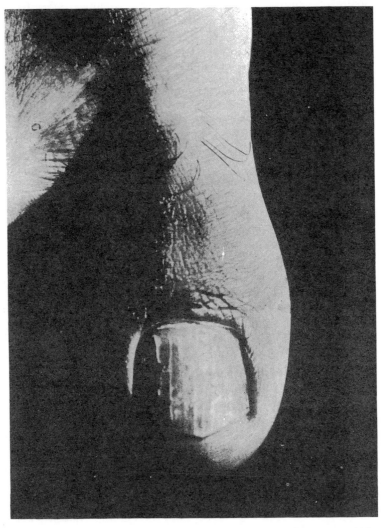

Figure 7.3 J. A. Boiffard, *Big toe, male subject, thirty years old*

themselves objects for alienated aesthetic contemplation, a shattered mirror which obediently continued to reflect the world *as it is not.*

Conclusion

In all its manifestations the aesthetics of *making strange* were dependent upon a picture of consciousness which was steeped in the values of Romanticism. Its hostility to the customary, to all fixed forms of habit and taste, derived from a conviction that our beliefs about ourselves and the world are somehow intimately related to the physical act of seeing. It took as its *sine qua non* a series of dualistic oppositions – reality/illusion, consciousness/unconsciousness, freedom/oppression – which were summed up in the grand metaphor of Vision. According to this picture, it was widely assumed that any idea, in the form of an image or a word, may be temporarily removed from the currency of life in order to be cleaned up, like an old penny, and placed back in circulation. A closely related assumption held that the organs of perception themselves, understood as the all-conditioning portals of knowledge, may similarly be cleansed of the mystifying and misleading accretions which result from our experience of a corrupt and corrupting world. Within this picture belief is seen to consist of discrete units, ideas, 'habits', which may thus be dealt with individually. The thinking self which needs such ideas and habits remained largely untheorised, and was viewed in terms of a traditional notion of some universal human nature. Hence its immediately seductive appeal as a theory of political intervention. For here was the blue-print for revolutionary social change which took no account of the mutual impingements of class, race, sexuality, or consciousness. In this respect the entire theory of *making strange* can be seen to have been rooted in a fundamentally bourgeois abstraction of 'thought' from the rest of material life, with a strongly idealist emphasis on the determining primacy of ideas. This was the measure of the dependency of *making strange* upon a singularly mechanical and reductive concept of 'ideology', or those beliefs about the world which are learned as if they are unquestionable facts of nature.

At its simplest, *making strange* sought to draw attention to socioeconomic contradictions which lay outside the accepted range

of artistic subject-matter. As such it lay in the general tradition of Realist aesthetics. It transcended that tradition, however, by raising the issue of the Realist tendency to abstract issues of subject-matter from those of formal signification, thus opening up one route towards contemporary semiotic analysis. Ultimately, however, the theory of defamiliarisation itself possessed a powerful ideology, a set of tacit assumptions about the relations between art and society. It implied above all that social contradictions could be made immediately and universally accessible to the eye, simply by means of visual surprise. It completely failed to grasp, however, that our preconceptions, our ideology, are primarily determined by widely varying social and historical experience. One cannot defamiliarise that which is not in the first place familiar. The familiar is neither uniform nor heterogeneous. It is not therefore surprising that in practice the devices of 'ostranenie' tended to become reified, to become seen as intrinsically 'correct', at which point they slid into mannerism. They became vulnerable both to that Modernist aestheticism which values the innovative purely in stylistic terms for its own sake, and also to the totalitarian elements within the Romantic tradition which would seek to iron out all human differences, in the name of Art, the Proletariat, Truth or whatever. Thus *making strange* ceased to respond to the demands of specific historical situations, and collapsed into stylisation. In the latter context it gave rise to the rhetorical 'class-eye' style of much official Soviet photography since the 1930s. In the former context it provided the grounding for a whole generation of European and American photographers whose reputations were made on the basis of their 'uniquely eccentric' or alternatively 'uniquely insightful' views of the world. Modern photo-aesthetic dogma concerning the semi-magical 'seeing eye' of such photographers as Kertesz and his one time pupil, Cartier Bresson, remain firmly within this larger historical trajectory. The notion that the camera can be forced to disclose some otherwise invisible bedrock of reality is central to this ideology, and it continues to dominate the discourse of contemporary photography, an unacknowledged yet specifically constructed taste, understood to be the essence of the medium.

Thus, when Paul Nash wrote of his desire to create previously 'unseen landscapes' and trained his camera on those seductively blank steps, he was in all probability responding to the quality which Walter Benjamin found in Atget's photographs, a taste for anony-

mous subjects which were at once familiar and yet unfamiliar, since they had not previously been seen as fitting objects for photography. His practice may thus be seen to be closely related, via his knowledge of the work of both Moholy-Nagy and Man Ray, to that general 'surrealist takeover of modern [photographic] sensibility'[49] which Susan Sontag has described, and which continues to inform the work of photographers as ostensibly disparate in outlook as Diane Arbus and Lee Friedlander. Arbus's crude social paradoxes, and Friedlander's elegant spatial paradoxes, exemplify a broad sense of the visually 'interesting' which did not, however, simply emerge fully grown from the attics of Surrealism. It is also directly related to the socio-political ferment of Russian Futurist aesthetics. This would undoubtedly have surprised Paul Nash nearly half a century ago. We do not, however, learn anything from that surprise, only from our understanding of the objective historical conditions which surprise acknowledges. This is what the theory and practice of *making strange* could not recognise.

This is because the entire theory of defamiliarisation rested upon an unquestioned acceptance of the fallacy which assumes that photographs objectively reflect a given, adequate and fully comprehensible world of appearances. Regarding photographs as propositions, the theorists and practitioners of *making strange* were unable to see that meaning is not constituted in discrete units, but is rather an infinite dialectic between systematically constructed images and historical subjects and institutions. In *Gulliver's Travels* one may read of the sages of Balnibarbi, who sought to establish a universal system of communication without recourse to signs. They were eventually all but crushed beneath the weight of objects which they were obliged to carry with them in order to converse. Swift tells the sages of the kingdom of Tribnia, where objects themselves are used as signs: 'a close-stool to signify a privy-council; a flock of geese, a Senate; a lame dog, an invader; and so on'.[50] Language is reinvented. In much the same way as the sages, *making strange* attempted to subvert all barriers of socio-political disagreement which were understood to result from particular conventions of representation. Yet such barriers are not merely the product of faulty communications. At the very moment when the value-bearing conventions of one class culture were being energetically dismantled and replaced by those of another, the theorists of 'ostranenie' were beguiled by the ancient notion of pure un-

mediated experience, and a vision of some neutral transparent medium by which it might be universally broadcast. We only betray the spirit of enquiring optimism which accompanied their tasks if we remain content to fetishise a particular set of photographic devices which continue to sustain the tenacious myth that photography possesses a single, universally effective revelatory essence. We should not waste time searching for that absolute strategic key, since there is no secret lock to open. We can safely abandon the Romantic quest for some perfect photographic mirror to reality, since it is clear that its pieces are scattered through all our various lives.

Chapter 8

Photography, Phantasy, Function[1]

Victor Burgin

I

Some of the later numbers of *Novy Lef* carry an exchange between
Rodchenko and Kushner, the origin of which was an attack on
Rodchenko in *Sovetskoe Foto*;[2] what is at issue is, quite literally, a
point-of-view. In 1928 Rodchenko had written:

> In photography there are old points-of-view, the point of view of
> a person who stands on the earth and looks straight ahead, or, as I
> call it, the 'navel photo', with the camera resting on the stomach. I
> am fighting against this point-of-view and will carry on fighting
> for photography from all positions other than the 'navel position',
> so long as they remain unrecognised. The most interesting angles
> at present are those from 'top to bottom' and 'from bottom to top'
> and there is much work to be done in this field.[3]

Kushner comments:

> Perhaps it is my personal lack of photographic knowledge, but I
> cannot find any convincing arguments for fixing the angle at a
> definite 90 degrees, on a vertical plane. The need to fight against
> the 'navel photo' can never explain why you give preference to
> the vertical direction in photography and reject all other possible
> perspective foreshortenings.[4]

Rodchenko replies:

> If you take the history of art, you will find that paintings, with few
> exceptions, are painted either from the navel position or from
> eye-level. It may appear that certain primitive pictures and icons[5]
> employ a bird's-eye viewpoint, but this is only an impression.
> There is simply a raising of the horizon so that as many figures as
> are required may be got into the picture . . . they are placed one
> on top of the other, as it were, and not one behind the other as in
> realist painting. The same is true of Chinese painting. . . . [He
> concludes] The antedeluvian laws of visual thinking have confer-
> red on photography a lower stage of painting, etching or engrav-
> ing with their *reactionary perspectives.* . . . We do not see what we
> look at. We do not see the wonderful perspective foreshortenings
> and inclines of the objects. We, who have learned to see what we
> are used to seeing and what is indoctrinated into us, should reveal
> the world. *We should revolutionise our visual perception.*[6]

As criticism of Rodchenko continues, his response becomes more
politically detailed. He writes:

> Several comrades from *Lef* warn us about experimentation and
> formalism in photography, judging not the 'how' but the 'what' to
> be the most important. . . . Comrades should note that a fetishism
> of facts is not only useless but detrimental to photography. . . .
> The revolution does not consist in photographing workers' lead-
> ers instead of generals while using the same photographic techni-
> que as under the old regime, or under the influence of Western
> art. The photographic revolution consists in the strong and
> unhoped for effect of the 'how' quality of the photographic
> fact. . . . A worker photographed like Christ, a woman worker
> photographed like the Virgin Mary, is no revolution . . . we must
> find a new aesthetic . . . to represent the facts of socialism in terms
> of photography.[7]

Kushner replies:

> Comrades of *Novy Lef* have requested that I answer the warning
> of A. Rodchenko published in No. 11 of this magazine. . . . I do
> not understand anything about Rodchenko's confused aesthetic
> philosophy. . . . But it is quite clear to me that Rodchenko is
> wrong to claim that the revolution does not consist in photo-

graphing workers' leaders instead of making portraits of [Csarist] generals. This is *precisely* where the revolution lies. . . . There could not have been any leaders before the revolution, inevitably there must have been just generals. It is unthinkable that there are any generals after the revolution, but leaders are essential and do exist. . . . According to every revolutionary-proletarian photographer the essence of the past revolution is based on this change.[8]

In the same, final, issue of *Novy Lef*, the editors of the magazine intervene:

The editors see a basic fault in both Rodchenko's warning as well as Kushner's answer. Both ignore a functional approach to photography. For the functionalist there exists a why, a wherefore, as well as what and how. That is what makes a work into a 'cause', i.e. an instrument of purposeful effect. . . . Rodchenko interests himself only in the aesthetic function and reduces the whole task into a re-education of taste according to some new basic principles. . . . Kushner's mistake is the opposite – for him the whole problem lies in representing new facts. For him it is immaterial how these facts are shown. Rodchenko states that photographing the leaders of the revolution in the same or in a similar way to the generals does not mean making a revolution: a photographic revolution of course. Kushner replies: precisely in the fact that, before, it was a general and now it is a leader – just this shows the essentials of the Revolution. But photography is not only to record but to enlighten. The form of recording is sufficient to externalise a leader; if however he is represented as a Red General, his character and social role is turned around and falsified. Either *the old, authoritarian, fetishistic psychology* is thus quite mechanically transferred to the leader of the workers or it appears like a malicious parody. In either case an anti-revolutionary result is obtained.

The editors' comments received no known response. There were to be no further issues of *Novy Lef*; with its demise the field of photographic criticism was left to *Sovetskoe Foto*. In 1931 *Sovetskoe Foto* changed its name to *Proletarskoe Foto*; never well-disposed towards the artistic left in photography, it now moved into a position of unremitting hostility, having become in effect the unoffi-

cial organ of ROPF (Russian Society for the Proletarian Photojour-
nalist). In its initial manifesto of 1931, in *Proletarskoe Foto* No. 2,
the newly formed ROPF took up the theme of the necessity for
unity in the photographic sector (the CPSU itself, in this period of
the first Five-Year Plan, was increasingly coming to view the
sectarianism of the artists' organisations as impeding the construc-
tion of socialism); ROPF accompanied its call for unity with the
announcement of the initiation of a 'bitter struggle' against the
leftists of the *Oktyabr* group, to which Rodchenko belonged.

The *Novy Lef* exchange between Rodchenko and Kushner antici-
pated the essential details of the more general disagreement be-
tween the *Oktyabr* photography section and ROPF: the former
committed to the development of new 'specifically photographic'
formal structures, uncontaminated by 'bourgeois culture'; the latter
seeing the need for swift and effective communication which
everyone could easily understand. Neither the theories of the one
nor the other were specifically post-revolutionary: ROPF revived a
Proletkult notion of 'emotional infection' which may in turn be
traced to Tolstoy – this they allied to an assumed unproblematical
photographic realism; Rodchenko's notion of a 'revolution in per-
ception' would seem to be derived from early Futurist practice, and
more specifically from Shklovsky's early work. Shklovskian themes
are faithfully echoed in the writings of fellow *Oktyabr* photographer
Volkov-Lannit (cited in Sartorti and Rogge):

> the history of the appearance of outstanding works of art is
> mainly a history of break-throughs in perspective and habitual
> composition schemes . . . that is, *a history of the disruption of the
> automatism of visual perception* . . . the manifestation of visual
> impressions is achieved through the use of 'new viewpoints' – *the
> unusual process of alienation* (my emphases).

To Shklovsky, art is a set of 'techniques' for upsetting routine
perceptions of the world. In left photography theory this notion
collapses in upon a single such 'device': prioritisation of the un-
familiar viewpoint.

Contemporary workers' commentaries on published work by
Oktyabr photographers[9] criticise the photographs precisely for their
deviation from established norms of the visually 'correct'. A tilted
frame (see Figure 8.1) brings the complaint, from a moulder in a
clay-works: 'Why does L. Smirnov photograph the tennis player as

if he were climbing a hill?'; a low viewpoint (see Figure 8.2)
prompts a potash worker to ask: 'How often do we see teacups that
are bigger than a human head?' *Proletarskoe Foto* describes Lang-
man's photograph 'Ahead with *1040*' (see Figure 8.3):

> A huge cornfield without fences and with a combine harvester as
> small as a flea. We see the strength of nature over the human
> intellect and the human will which is expressed through control
> over the machine. The *Oktyabrists* do not like the human who
> leads the machine.

By contrast, a photograph by ROPF member, A. Sajchet, 'He
Controls Four Workbenches' (see Figure 8.4), elicits this comment
from a locksmith: 'In this photograph everything is clear – no
explanation is required. It is clear and sharp, one can recognise
every screw and cog-wheel on the work bench.' Again, Sajchet's
photograph 'Kindergarten on the Collective farm *New Life*' (see
Figure 8.5), is described by ROPF colleague S. Friedland:

> From the variety and multiplicity of collective life the author has
> taken two elements: (1) The children's cribs, and (2) the collec-
> tive women farmers going to work. The generalisation of the two
> subjects, although different, is closely linked internally – the
> women go to work and their children remain in reliable hands –
> and has a convincing effect.

Sajchet's photographs are indeed a model of expository clarity (it is
to be remembered that such photographs were being published in a
context of widespread illiteracy); elsewhere ROPF practice con-
sisted most predominantly of conventionally 'straight', or equally
conventionally 'artistic', depictions of the 'shock worker' as socialist
hero (see Figure 8.6) – anticipating the principles of Socialist
Realism outlined by Zhdanov at the first congress of the Union of
Soviet Writers in 1934.

Clearly, the *Oktyabr* fraction photography programme was stark-
ly irrelevant to the urgent propaganda needs of the first Five-Year
Plan. In a statement of intent of 1930, the photographic section of
Oktyabr had rejected alike, 'the practice of *AKhRR*, their demurely
smiling pretty little faces, smoking chimneys, and the *Kvass*-sodden
patriotism of workers uniformly shown with sickle and hammer', as
well as 'the bourgeois concept of "new form" and "Leftist photo-
graphy", which came to us from the West . . . the aesthetics of

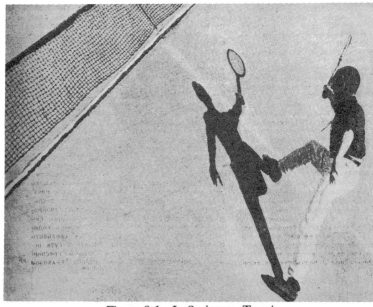

Figure 8.1 L. Smirnov, *Tennis*

Figure 8.2 E. Langman, *Youth Commune at 'dynamo' factory*

Figure 8.3 E. Langman, *Ahead with '1040'*

Figure 8.4 A. Sajchet, *He controls four work-benches*

Figure 8.5 A. Sajchet, *Kindergarten on the collective farm 'New Life'*

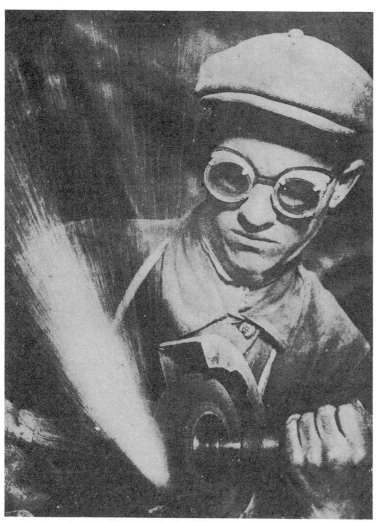

Figure 8.6 N. Maximov, *Shock worker at the factory 'Hammer and Sickle'*

Mancel and Moholy-Nagy's abstract "Leftist" photography', as-
serting that photography supersedes 'the obsolete techniques of old
spatial arts'. Rodchenko was nevertheless expelled from *Oktyabr*
following the scandal caused by the publication of his 'deforming'
portrait of a Pioneer, 'for propagating a taste alien to the pro-
letariat', and, 'for trying to divert proletarian art to the road of
Western-style advertising, formalism, and aesthetics'; in 1931 the
remaining members of the photography section of *Oktyabr* applied
to be accepted into RAPKH (Russian Association of Proletarian
Artists), confessing in their petition: '*Oktyabr* has abandoned the
social struggle to strengthen the position of Productivist art and
seeks to replace it by an abstract theoretics, and leave the artists
without support and guidance in their practical work.'[10] In 1936
Rodchenko himself was dutifully to write, in *Sovetskoe Foto* (its
original title now reinstated):

> I wish to refute utterly the giving of first place to formal decisions
> and second place to ideological decisions; and at the same time to
> search unceasingly new riches of photographic language – that,
> with its help, I might create works on a high political and artistic
> level, works in which the language of photography serves Social-
> ist Realism to the full.[11]

The debates were now ended. The theoretical issues they had
raised, however, remained unresolved. Only months after the
editors of *Novy Lef* had warned against the return of 'the old
authoritarian, fetishistic psychology', Stalin's first full-page portrait
had appeared in *Pravda*. Rodchenko had condemned 'reactionary
perspective'; to assess the validity of the 'leftist' initiative in photo-
graphy in its own terms we must begin by considering the claimed
connection, in photography, between psychology and point-of-
view.

II

Spatial metaphors abound in the everyday discourse of politics:
'perspective', 'position', 'line', and so on. For Rodchenko, however,
it is *not* a metaphor to speak of 'reactionary perspective', nor do the
leftists' detractors differ from them in this: for example, what
Proletarskoe Foto objects to in Langman's image of a combine-
harvester dwarfed by a wheat-stalk is an error of 'proportion' in
which the political is inseparable from the scalar. The complaint

against Langman may be seen as arising from a reading which has its roots in that convention of Russian icon painting (and of Western 'primitive' traditions) according to which the relative importance of depicted figures is expressed in terms of their relative sizes; the claims of the leftists, however, more particularly concern that which they hold to be *unprecedented* in visual art: the *look* given by the camera.

In its essential details the representational system of photography is identical with that of classical painting: both depend (the former directly, the latter indirectly) upon the *camera obscura*. Projecting light reflected from a three-dimensional solid on to a plane surface, the *camera obscura* produces an image conforming to geometric laws of the propagation of light – an image seemingly sanctioned by nature itself, indifferent to the subjective dimensions of human affairs. In recent years, however, contestation of the supposed neutrality of the camera has been pursued to the *point* of that very subjectivity which the apparatus itself constructs. In advance of any other mediation whatsoever, whatever the object depicted the manner of its depiction in the camera implies a unique point-of-view; it is this position, occupied in fact by the camera, which the photograph bestows upon the individual looking at the photograph. The perspectival system of representation represents, before all else, a *look*.

Freud first identifies a psychological investment in looking ('scopophilia', as an independent drive) in the 1905 'Three Essays on the Theory of Sexuality',[12] where he refers to the voyeuristic activities of children. Elsewhere in his publications of that same year he emphasises: 'The libido for looking . . . is present in everyone in two forms, active and passive . . . one form or the other predominates.'[13] In their 'polymorphus perversity' children adopt active and passive roles in easy alternation: exhibitionism and voyeurism are bound in a form of *exchange*. The social world of adults, however, is ordered according to a sort of 'division of labour' in which the determinant look is that of men, and in which it is women who predominantly are looked at. Lacan's readings of Freud identify a double-inscription of psychic life in the look: the essentially auto-erotic, Narcissistic, moment of the mirror-phase – the moment of identification of and with the self; and the look which is a component of the externally directed sexual drive to objectify the *other*. These aspects of the look may be conflated; Freud remarks that the scopophilic instinct is at base auto-erotic: 'it has

indeed an object, but that object is the subject's own body'; Lacan's extended discussion of the look emphatically returns to this theme of the look as guarantor of imaginary self-coherence (a coherence threatened by the look which comes from the other).[14]

We may therefore endorse the basic premise of the *Oktyabr* leftists' programme for photography: looking is not indifferent. There can never be any question of 'just looking': vision is structured in such a way that the look always-already includes a history of the subject. However, this is to endorse the *Oktyabr* premise so completely as to overwhelm the argument based on it: that the ideology of the subject may be *overthrown* by a 'revolution in perception — for it can now no longer be a question of the *ideology* of the subject, a body of ideas the subject 'owns', and may abandon; it is now rather a question of that very ideology of the *subject* which informs the previous formulation. Such a punctual subject of ideology may not be overthrown by the camera as that subject is inscribed in the very functioning of the instrument itself and in the very history of the act of looking. But at what risk? How secure is the coherence of the subject of photographs?

What is now at issue is the work of fixing those images which become reality for a subject, in the same movement offering the subject positions from which the images will be experienced as its own: understanding that this 'it' is only constituted *as* subject through the agency of such movement, that there is no subject prior to its construction across the field of representations.[15] Following recent discussions we may take the concept of *suture* to be centrally concerned with this imbrication of the subject within a discourse. Suture operates within all forms of discourse as a movement of construction/incorporation of the subject *in* the discourse in question: a set of effects in which the subject recognises the discourse as its own. From its origins in psychoanalytic theory, the concept has of necessity undergone a number of vicissitudes in the process of its incorporation in other fields. Perhaps its most prominent formulation is that *vis-à-vis* film, derived from Oudart and Dyan, which may be most simply expressed as follows: the appropriation of the subject into the imaginary field of the film through the agency of an identification of the spectator's look with that of a fictional character, this in turn being effected through such specific techniques as point-of-view and shot/reverse-shot cutting. Heath criticises this formulation as being, in itself, insufficiently sensitive to the variety

and complexity of suturing moments in films. We may nevertheless take our departure from the Oudart/Dyan position in interrogating the movement of suture in the field of photography, a necessary interrogation in that, as Heath has put it, 'No discourse without suture . . . but, equally no suture which is not from the beginning specifically defined within a particular system which gives it form.'[16]

The primary suturing instance of the discourse of still photography takes the form of an identification of the subject with the camera position. As already observed, the look from this position will shift between the poles of voyeurism and narcissism: in the former instance subjecting the other-as-object to an inquisitive and controlling surveillance in which seeing is dissociated from being-seen; and in the latter effecting a dual identification with both the camera *and* the individual depicted. Identification here is rarely the simple matter of like 'identifying with' like implied in an everyday use of the term; it is more often a matter of the *selective* incorporation of attributes of what may be a radically 'other' individual, by analogy with the mode of formation of the Super-Ego. Such selectivity may achieve that conflation of voyeurism and narcissism for which Freud allows. For example, the image of the woman 'surprised' in the act of masturbation is ubiquitous in pornography; if such an image is in turn used as an aid to male masturbation, the imaged woman, certainly, becomes the object of an inquisitive and sadistic voyeurism, but she may also simultaneously become the locus of a narcissistic identification in which the man's enjoyment of his own body becomes conflated in phantasy with the previously quite distinct *jouissance* of the woman. As it is a matter of phantasy and therefore of the participation of the primary processes, the 'contradiction' between identification and objectification is unacknowledged. We might further note that identification need not be with any overt depicted 'content' whatsoever: if we bear in mind the *gestalt* orientation of the mirror-phase – its emphasis on surface and boundary – we can admit that a narcissistic investment may be made in respect of the very specular brilliance of the tightly delineated photographic surface itself; certainly, appreciation of the superficial beauty of the 'fine print' is a centrepiece of photographic connoisseurship: 'Art photography . . . can be something you actually want to hold in your hand and actually press close to you. You want to hold it near to your face or body because there's some subconscious reaction with it.'[17] Such fascination with the 'glossy' may recall the

celebrated *glanz* fetishised by one of Freud's patients,[18] and indeed, the photographic look is ineluctably implicated in the structure of fetishism.

The photograph, like the fetish, is the result of a look which has, instantaneously and forever, isolated, 'frozen', a fragment of the spatio-temporal continuum. In Freud's account of fetishism something serves in place of the penis with which the shocked male infant would 'complete' the woman; the function of the fetish is to deny the very perception it commemorates, a logical absurdity which betrays the operation of the primary processes. This structure of 'disavowal' is not confined to cases of fetishism proper, it is so widespread as to be almost inaccessible to critical attention. Mannoni observes that disavowal presents itself ubiquitously in the analytic situation, in the typical formula: 'I know very well, but nevertheless.' For Mannoni it is 'as if the *Verleugnung* of the maternal phallus sketched the first model of all repudiations of reality, and constituted the origin of all those beliefs which survive their contradiction in experience'.[19] Although, to Freud, the persistence of belief in the female penis is not confined to the male it seems that the consequence of pathological fetishism *is*– suggesting that perhaps the relation of the male look to photographs may be much closer to fetishism proper than is that of the female. To observe a structural homology between the look at the photograph and the look of the fetishist is not to claim, excessively, that all those who find themselves captivated by an image are therefore (clinically) fetishists. What is being remarked is that photographic representation accomplishes that separation of knowledge from belief which is characteristic of fetishism. It is this pervasive structure of disavowal which links fetishism to the image and to phantasy. The motive of the disavowal is to maintain the imaginary unity of the subject *at the cost of (fetishism)/in the face of (phantasy)* the subject's actual splitting; witness a woman's report of her thoughts while watching Oshima's film *In the Realm of the Senses*: 'I had to violate (*violer*) myself a little to endure the sight. I was there, curled up in my seat, very aroused. I would really have liked to have gone that far, I dream of extreme experiences, but at the same time I know very well that I'm not capable of them.'[20] Disavowal in respect of photographs shifts polarity to accommodate the nature of the obstruction to desire on the one hand, 'I know that the (pleasurable) reality offered in this photograph is only an illusion, but nevertheless'; on the other hand, 'I know that this (unpleasurable)

reality exists/existed, but nevertheless *here* there is only the beauty of the print.'

The (fetishistic) *fascination* with the photograph may be nuanced by implied imaginary relations with the viewed such as inferiority/superiority, culpability/moral distance, and so on – these being conveyed by the framing, angle-of-view, focal-length of lense, etc. However, the imaginary relation may not be held for long. To look at a photograph beyond a certain period of time is to become frustrated: the image which on first looking gave pleasure by degrees becomes a veil behind which we now desire to see. To remain too long with a single image is to lose the imaginary command of the look, to relinquish it to that absent other to whom it belongs by right: the camera. The image now no longer receives *our* look, reassuring us of our founding centrality, it rather, as it were, avoids our gaze. In still photography one image does not succeed another in the manner of the cinema. As alienation intrudes into our captation by the still image we can only regain the imaginary, and reinvest our looking with authority, by averting our gaze, redirecting it to another image elsewhere. It is therefore not an arbitrary fact that photographs are deployed so that we need not look at them for long, and so that, almost invariably, another photograph is always already in position to receive the displaced look.

The subject's recognition of the absent other causes a 'tear' in its imaginary relationship with the visual field. In the cinema such devices as the reverse shot close up this rent in the imaginary. The still has no reverse shot (I am of course talking about the single image) but it does have, as I have observed, forms of identification, fetishistic fascination, multiplication/repetition, and 'good composition',[21] all of which exert suturing effects. In addition, and most importantly, it has the ever-present caption, and other forms of linguistic expression which traverse, surround and support the image. Unpleasure is thus further averted by recourse to *writing*, which reinvests the subject with an authority stripped from it by the absent other, for whereas, as Metz has observed, 'one of the characteristics of the world is that it is uttered by no one',[22] there is never any question but that the verbal address emanates from a subject and for a subject, i.e. it *recognises* the subject. As alienation intrudes to evacuate the subject from the visual register, the subject can 'take place' again in the caption, and when it expires there it can find itself returned again to the image (what other purpose is served by those texts – short, pathetic – which invariably accompany

'pin-up' photographs in newspapers and magazines?).

We rarely see a photograph *in use* which is not accompanied by writing: in newspapers the image is in most cases subordinate to the text; in advertising and illustrated magazines there tends to be a more or less equal distribution of text and images; in art and amateur photography the image predominates, though a caption or title is generally added. But the influence of language goes beyond the fact of the physical presence of writing as a *deliberate* addition to the image. Even the uncaptioned photograph, framed and isolated on a gallery wall, is invaded by language when it is looked at: in memory, in association, snatches of words and images continually intermingle and exchange one for the other; what significant elements the subject recognises 'in' the photograph are inescapably supplemented from elsewhere.

III

In a familiar cinematic convention subjective consciousness – reflection, introspection, memory – is rendered as a disembodied 'voice-over' accompanying an otherwise silent image-track. I am not suggesting that such an interior monologue similarly accompanies our looking at photographs, nor do I wish to claim that in the process of looking at a photograph we mentally translate the image in terms of a redundant verbal description. What I 'have in mind' is better expressed in the image of transparent coloured inks which have been poured on to the surface of water in a glass container: as the inks spread and sink their boundaries and relations are in constant alternation, and areas which at one moment are distinct from one another may, at the next, overlap, interpenetrate. Analogies are of course *only* analogies, I simply wish to stress the fluidity of the phenomenon by contrast with the unavoidable rigidity of some of the schematic descriptions which will follow.

It is conventionally held that photography is a 'visual medium' (the contenders in the Soviet photography debate of the 1920s never doubted it). At a strictly physiological level it is quite straightforward what we mean by 'the visual': it is that aspect of our experience which results from light being reflected from objects into our eyes. We do not, however, *see* our retinal images: as is well known, although we see the world as right-way-up, the image on our retina is inverted; we have two slightly discrepant retinal images, but see only one image; we make mental allowances for the

known relative sizes of objects which override the actual relative sizes of their images on our retina; we also make allowances for perspectival effects such as foreshortening, the foundation of the erroneous popular judgement that such effects in photography are 'distortions'; our eyes operate in scanning movements, and the body is itself generally in motion, so that such stable objects as we see are therefore *abstracted* from an on-going phenomenal flux;[23] moreover, attention to such objects 'out there' in the material world is constantly subverted as wilful concentration dissolves into involuntary association; and so on. The detail of these and many other factors as described in the literature of the psychology of perception, cognitive psychology, and related disciplines, is complex; the broad conclusion to be drawn from this work may nevertheless be simply expressed:

> What we see ... is not a pure and simple coding of the light patterns that are focused on the retina. Somewhere between the retina and the visual cortex the inflowing signals are modified to provide information that is already linked to a learned response.... Evidently what reaches the visual cortex is evoked by the external world but is hardly a direct or simple replica of it.[24]

The fact that seeing is no simple matter has of course been acknowledged in visual art for centuries. It is a fact which painting, facing the problem of representing real space in terms of only two dimensions, could not avoid (for its part, sculpture particularly emphasised the imbrication of the visual and the kinaesthetic, the extent to which seeing is a muscular and visceral activity). At times the aims of visual art became effectively *identified* with those of a science of seeing; Berenson complained of the Renaissance preoccupation with problems of perspective: 'Our art has a fatal tendency to become science, and we hardly possess a masterpiece which does not bear the marks of having been a battlefield for divided interests.' Across the modern period, at least in the West, it has been very widely assumed that an empirical science of perception can provide not only a necessary but a sufficient account of the material facts upon which visual art practices are based. Thus, in this present century, and particularly in the field of art education, the psychology of perception has become the most readily accepted art-related 'scientific' discipline, the one in which 'visual artists' most readily identify their own concerns (correspondingly, where philosophical

theories have been used, they have generally had a phenomenologi-cal orientation). Certainly, such studies in the psychology of ap-pearances are necessary, if only to provide a corrective to the naïve idea of purely retinal vision. But if the explanation of seeing is arrested at this point, it serves to support an error of even greater consequence: that ubiquitous belief in 'the visual' as a realm of experience totally separated from, indeed antithetical to, 'the verbal'.

Seeing is not an activity divorced from the rest of consciousness; any account of visual art which is adequate to the facts of our actual experience must allow for the imbrication of the visual with other aspects of thought. In an overview of extant research M. J. Horowitz has presented a tripartite model of the dominant modes of thought in terms of 'enactive', 'image' and 'lexical'.[25] *Enactive* thought is muscular and visceral, is prominent in infancy and childhood, and remains a more or less marked feature of adult thinking. For example: on entering my kitchen I found that I had forgotten the purpose of my visit; no word or image came to mind, but my gesture of picking up something with a fork led me to the implement I was seeking. The enactive may be conjoined with the visual. Albert Einstein reported that, for him, 'The physical entities which seem to serve as elements in thought are certain signs and more or less clear images . . . [elements] of visual and some of muscular type.'[26] The enactive also merges with the verbal: Horowitz supplies the exam-ple of a person who was temporarily unable to find the phrase 'he likes to pin people down', an expression called to mind only after the speaker's manual gesture of pinning something down. We should also note the findings of psychoanalysis concerning the type of neurotic symptom in which a repressed idea finds expression via the enactive realisation of a verbal metaphor: an example from Freud's case histories – Dora's hysterical vomiting at the repressed recollection of Herr K's sexual advances, an idea which 'made her sick'.[27]

Mental *images* are those psychic phenomena which we may assimilate to a sensory order: visual, auditory, tactile, gustatory, olfactory. For the purposes of this chapter, however, I shall use the term 'image' to refer to visual images alone. If I wish to describe, say, an apartment I once lived in, I will base my description on mental images of its rooms and their contents. Such a use of imagery is a familiar part of normal everyday thought. However, not all

imaged thought is so orderly and controlled. We may find ourselves
making connections between things, on the basis of images, which
take us unawares; we may not be conscious of any wilful process by
which one image led to another, the connection seems to be made
gratuitously and instantaneously. The result of such a 'flash' may be
a disturbing idea which we put instantly out of mind, or it may
provide a witticism for which we can happily take credit; or more
commonly it will simply seem inconsequential. At times we may
deliberately seek the psychic routes which bring these unsolicited
interruptions to rational thinking. In the 'day-dream', for example,
the basic scenario and its protagonists are consciously chosen, but
one's thoughts are then abandoned to an only minimally controlled
drift on more or less autonomous currents of associations. The sense
of being in control of our mental imagery is of course most com-
pletely absent in the *dream* itself. Dreams 'come to us' as if from
another place, and the flow of their images obeys no rational logic.
As is well known, Freud's study of dreams led him to identify a
particular sort of 'dream logic' radically different from the logic of
rational thought: the *dream-work*, the (il)logic of the primary
processes of the unconscious. In a certain common misconception
the unconscious is conceived of as a kind of bottomless pit to which
has been consigned all that is dark and mysterious in 'human
nature'. On the contrary, unconscious processes operate 'in broad
daylight'; although they are structurally and qualitatively different
from the processes of rational thought and symbolisation enshrined
in linguistics and philosophical logic, they are nevertheless an
integral part of normal everyday thought processes taken as a
whole. The apparent illogicality which so obviously characterises
the dream invades and suffuses waking discourse in the form of slips
of the tongue, and other involuntary acts, and in jokes. Additional-
ly, and most importantly to this present discussion, the intrusion of
the primary processes into rational thought (secondary processes)
governs the mechanisms of visual association; and it may be useful,
therefore, to give these a summary, *aide-mémoire*, exposition.

Freud identifies four mechanisms in the dream-work: 'condensa-
tion'; 'displacement'; 'considerations of representability'; and 'sec-
onday revision'. In *condensation* a process of 'packing into a smaller
space' has taken place: 'If a dream is written out it may perhaps fill
half a page. The analysis setting out the dream-thoughts underlying
it may occupy six, eight or a dozen times as much space.'[28] It is this

process which provides the general feature of over-determination, by which, for any manifest element, there can be a plurality of latent elements (dream-thoughts). By *displacement* Freud means two related things. First, that process by which individual elements in the manifest dream stand in for èlements of the dream-thoughts by virtue of an association, or chain of associations, which link the two. (Thus displacement is implicated in the work of condensation: displacemens from two or more separate latent elements, along separate associative paths, may eventually reach a point at which the paths meet, forming a condensation at the point of intersection.) The second, related, meaning of the term 'displacement' is that process according to which the manifest dream can have a different 'emotional centre' from the latent thoughts. Something quite trivial may occupy centre-stage in the dream, as it were, to 'receive the emotional spotlight'; what has occurred here is a displacement of feelings and attention from the thing, person or situation which is in reality responsible for the arousal of those feelings. It is thus possible for something as inconsequential as, say, an ice-cube to become in a dream the object of a strong feeling.

Of *considerations of representability*, Freud writes:

> let us suppose that you had undertaken the task of replacing a political leading article in a newspaper by a series of illustrations. . . In so far as the article mentioned people and concrete objects you will replace them easily . . . but your difficulties will begin when you come to the representation of abstract words and of all those parts of speech which indicate relations between thoughts.[29]

In *The Interpretation of Dreams* Freud describes the various ways in which the dream deals, in visual terms, with such logical relations as implication, disjunction, contradiction, etc. We should note a particular role of the verbal in the transition from the abstract to the pictorial: 'bridge words' are those which, in more readily lending themselves to visualisation, provide a means of displacement from the abstract term to its visual representation. Thus, for example, the idea of 'reconciliation' might find visual expression through the intermediary of the expression 'bury the hatchet', which can be more easily transcribed in visual terms. This representational strategy is widely to be found in advertising, which relies extensively on our ability to read images in terms of underlying verbal texts. It

may be appreciated that such readings readily occur 'wild', that is to say, where they were not intended.

Secondary revision is the act of ordering, revising and supplementing the contents of the dream so as to make a more intelligible whole out of it. It comes into play primarily when the dreamer is nearing a waking state and/or recounting the dream, but is nevertheless present at each instant of the dream. Freud has some doubts as to whether this process should properly be considered to belong to the dream-work itself (in an article of 1922 he definitely excludes it). However, it is not important to our purposes here that this be decided; we should note that secondary revision is a process of dramatisation, of narrativisation.

Returning to Horowitz's schema of types of mental representation, *lexical* thought is 'thinking in words'. It should be stressed, however, that this is not simply a matter of the silent mental rehearsal of a potentially actualised speech. Lev Vygotsky has identified an *inner speech* fundamentally different in its nature from externally directed communicative speech. Inner speech 'appears disconnected and incomplete . . . shows a tendency towards an altogether specific form of abbreviation: namely, omitting the subject of a sentence and all words connected with it, while preserving the predicate'.[30] Inner speech in the adult develops out of the 'egocentric speech' (Piaget) of the small child. We should remark that Freud describes the primary processes as preceding the secondary processes in the mental development of the individual; they are pre-verbal in origin and thus prefer to handle images rather than words; where words *are* handled they are treated as far as possible like images. Thus, when Vygotsky observes that, in inner speech, 'A single word is so saturated with sense that many words would be required to explain it in external speech',[31] we may be confident that the reference is to that same centrally important aspect of the primary processes that we encounter in Freud's work as 'condensation'. Freud notes that, in dreams, words and phrases are just meaningful elements among others, accorded no more or less status than are images, and their meanings have no necessary relation to the meanings they would carry in waking speech. We here encounter the question of the *nature* of 'enactive', 'image' and 'lexical' presentations in their unconscious transformation. I shall return to this question later.

I prefaced my references to Horowitz's compartmentalised

model of thought by stressing the fluidity of the actual processes it describes. Horowitz himself writes:

> Normal streams of thought will flow simultaneously in many compartments without clear-cut division between modes of representation. Enactions blur into imagery in the form of kinesthetic, somesthetic, and vestibular or visceral images. Image representation blends with words in the form of faint auditory or visual images of worlds. Words and enactive modes merge through images of speaking.[32]

Inescapably, the *sense* of the things we see is constructed across a complex of exchanges between these various registers of representation. Differing perceptual situations will, however, tend to elicit differing configurations and emphases of response: just as sculpture will tend to prioritise the enactive and kinaesthetic suffusion of visual imagery, so photographs predominantly tend to prompt a complex of exchanges between the visual and verbal registers. As I began by observing, the greater part of photographic practice is *de facto* 'scripto-visual'; this fact is nowhere more apparent than in advertising, and it may help here to refer to a particular example.

IV

The particular conjuncture into which this advertisement (shown in Figure 8.7) was launched, in Britain in the early 1960s, included a best-selling novel by Alan Sillitoe, and a popularly successful film based on this novel – directed by Tony Richardson and featuring Tom Courtney – which retained the title of the original text: *The Loneliness of the Long-Distance Runner*. The fact that Tom Courtney was at that time a prominent emerging young 'star' of British theatre and cinema ensured that the institutional spaces of television, and newspapers and magazines, were also penetrated. During the particular months in which this advertisement appeared, therefore, the expression 'the loneliness of the long-distance runner' was transmitted across the apparatuses of publishing, cinema, television and journalism, to become inscribed in what we might call the 'popular pre-conscious' – those ever-shifting contents which we may reasonably suppose can be called to mind by the majority of individuals in a given society at a particular moment in its history; that which is 'common knowledge'. Two attributes are therefore immediately entrained by this content-fragment of the popular

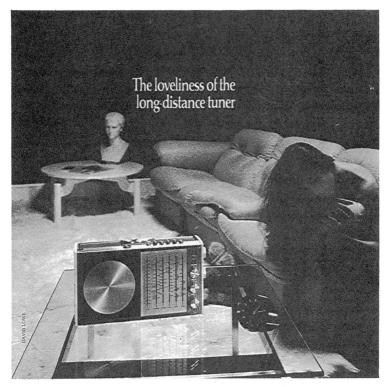

Figure 8.7 Radio advertisement

pre-conscious which serves the advert as *pre-text*: success and contemporaneity; additionally, the visual image across which the fragment is inscribed is clearly open to the implication of the erotic. Ambition, contemporaneity, eroticism, together with the substantial primacy of the visual in their inscription: *the day-dream.*

In his 1908 essay 'Creative Writers and Day-Dreaming' Freud remarks that day-dreams serve one, or both, of two impulses: 'They are either ambitious wishes, which serve to elevate the subject's personality; or they are erotic ones.' To identify these two wishes in all day-dreams is not, of course, to suggest that the manifest contents of such phantasies are themselves stereotyped or unchangeable: 'On the contrary, they fit themselves in to the subject's shifting impressions of life, change with every change in his situation, and receive from every fresh active impression what might be called a "date-mark".'[33] As for thinking in pictures, in his 1923

paper 'The Ego and the Id' Freud remarks that 'in many people this seems to be the favoured method. . . . In some ways, too, it stands nearer to unconscious processes than does thinking in words, and it is unquestionably older than the latter both ontogenetically and phylogenetically.'[34] The child, prior to its acquisition of language, inhabits a mode of thought not adapted to external reality, but rather aimed at creating an imaginary world in which it seeks to gratify its own wishes by means of hallucinatory objects. The day-dream – the conscious phantasy in which the subject constructs an imaginary scenario for the fulfilment of a wish – is one form of survival of such infantile thinking into adult life; however, as the day-dream is situated mainly at the level of the preconscious–conscious system ($Pcs-Cs$), then it is subject to the intermittent binding of its constituent thing-presentations to word-presentations.

In his 1915 paper 'The Unconscious' Freud makes a fundamental distinction between the preconscious–conscious system and the unconscious (Ucs): 'the conscious presentation comprises the presentation of the thing plus the presentation of the word belonging to it, while the unconscious presentation is the presentation of the thing alone.'[35] But what is the nature of this unconscious 'thing'? In reiterating his distinction between $Pcs-Cs$ and Ucs in 'The Ego and the Id' (1923), Freud remarks that the unconscious idea is 'carried out on some material which remains unknown'.[36] Across his various discussions of unconscious formations he nevertheless speaks both *as if* the unconscious works through literal word-play *and* as if it worked through imagery. Leclaire, in his contribution to a much-discussed paper on the unconscious, finds among the most elementary particles of a patient's dream 'the memory of a gesture engraved like an image' (cupped hands) and 'the formula "I'm thirsty"', and comments:

> Inasmuch as we are thus able, through a fragment of analysis, to grasp what the 'ideational representatives' of the drive are, we may say that this gesture and this phrase are included among them. It is they, *image and word,* that will pursue their adventures in Philippe's [the patient] psychic life (my emphasis).[37]

Leclaire remarks that his patient, 'in recounting the memory, imitates the gesture', referring to it as a 'motor-representation'; clearly the 'image' here is on the side of the *enactive.* We should also

note that the 'word' at issue here is not a lexical item in the usual sense, it is a matter rather of phonic *imagery* indistinguishable from sense purely personal to the infant Philippe. Lyotard has spoken of 'word-things', the result of condensation:

> their 'thingness' consists of their 'thickness'; the normal word belongs to a 'transparent' order of language: its meaning is immediate . . . the product of condensation, as the name indicates, is, on the contrary, opaque, dense, it hides its other side, its other sides.[38]

Such condensation is at work in Philippe's discourse where the '*je*' of '*moi-je*' and the ultimate syllable of *plage* compact into the initial sound of '*j'ai soif*'. Condensation here is a product of after-repression, in which elements are attracted into the gravitational field of an ideational representative – '*j'ai soif*' – of the oral drive, this in turn being installed in the primary 'capture of drive energy in the web of the signifier', thus facing on to that literally *unspeakable* 'other side' to which Lyotard alludes. Freud writes:

> repression does not hinder the instinctual representative from continuing to exist in the unconscious, from organising itself further . . . the instinctual representative develops with less interference and more profusely if it is withdrawn by repression from conscious influence. It proliferates in the dark, as it were, and takes on extreme forms of expression.[39]

Thus the ideational representatives will, in Leclaire's phrase, continue to 'pursue their adventures' – to quite particular ends.

The ideational representatives – 'mnemic traces', 'inscriptions', 'signs' – which form the nucleus of the unconscious, ramify and coalesce into specific themes. Laplanche writes:

> As to the ontological status of the unconscious . . . the 'words' that compose it are elements drawn from the realm of the imaginary – notably from visual imagination – but promoted to the dignity of signifiers. The term *imago*, somewhat fallen into disuse, corresponds fairly well, if taken in a broad sense, to these elementary terms of unconscious discourse. . . . The 'sentences' that are found in this discourse are short sequences, most often fragmentary, circular and repetitive. it is these that we discover as *unconscious phantasies.*[40]

Laplanche and Pontalis observe that when Freud speaks of 'unconscious phantasy':

> He seems at times to be referring to a subliminal, preconscious revery into which the subject falls and of which he may or may not become reflexively aware [and they continue]. . . . It is possible to distinguish between several layers at which phantasy is dealt with in Freud's work: conscious, subliminal and unconscious. Freud was principally concerned however *less with establishing such a differentiation than with emphasising the links between these different aspects* (my emphasis).[41]

The actual 'substance' of the contents of the unconscious must, *by definition*, remain unknown. Freud speaks inconsistently on the matter; Lacan commits himself only to the observation that, although they may share identical formal properties, the conscious and unconscious signifiers are otherwise very different. It does seem to be the case, however, that (speaking now as if from the imaginary terrain of the first topography) the 'closer' we approach the unconscious, the less differentiated become the modalities of thought: gesture, image and word become compacted into dense multi-layered and faceted units; and it is as if these, in their turn, were *en route* to destinations of ultimate compression: 'knots' in the tangled associative skeins of the unconscious; *points-de-capiton*[42] in the incessant sliding of sense. It is these which are the ultimate, if mythical, destinations of the bifurcating chains of associations which spread out from the manifest elements of a photograph into the 'intricate network of our world of thought': consciousness, subliminal revery, pre-conscious thought, the unconscious – the way of phantasy; and it is by these same routes that, subject to the transforming vicissitudes of repression, contents may pass 'in the other direction', to *invest* the image, providing the purport of its cathexis.

To return, then, to this particular image. Ambition, eroticism, contemporaneity – the theme of ambition is obviously central to advertising, as is the erotic, which is anyhow latent in *all* acts of looking. In this particular advert, the expression 'The loneliness of the long-distance runner' offers a phantasy identification within a syndrome of success, and with a successful figure – as a certain familiar style of promotional language might have put it: 'Tom Courtney *is* the long-distance runner', ahead of his competitors, the

'leading man' both in the diagesis and in reality. This particular expression at that particular historical conjuncture brings the phantasy satisfaction of the ambitious wish 'up to date'. The conjunction of ambition and eroticism here is achieved, literally, through 'the agency of the letter' – the substitution of a 'v' for an 'n', and a 't' for an 'r', which tacks the manifest verbal text to its pre-text in the pre-conscious. By this device, the verbal fragment faces on to both unconscious contents (in the 'descriptive' sense, i.e. *Ucs–Pcs*) and upon the manifest visual contents of the image.

The text says that the tuner is lovely, what it simultaneously *means* (through the anchorage by which it is related to the constellation of conventional associations around the figure of the woman) is that the woman is lovely; thus the word 'loveliness' acts as a relay in an associative chain linking the radio to the woman – a metonymic movement which facilitates a displacement of libidinal cathexis from the one to the other. The woman is 'lovely', she is also 'lonely': the suppressed term in the pre-text here serves as the material absence which nevertheless anchors the meaning of the woman's posture and, beyond, the entire 'mood' of the picture. Apart from the configuration of the woman's pose, the mood is given most predominantly by the way the scene has been lit; it is the sort of lighting popularly referred to as 'intimate' – a word which also takes a sexual sense. The term 'intimate' here is not reached by totally 'free' association; the association is conventionally determined to the point that we may consider this lighting effect to belong to the complex of 'considerations of representability' in respect of this term. The suppressed term 'lonely', then, in conjunction with the connotations of the lighting, anchors the particular sort of narrative implications of the moment depicted in the image, implications readily linked to the phantasy of seduction, widely encountered across advertising. This scenario is on the side of signification; there is, however, another history inscribed here on the side of *signifiance*.[43]

Along the axis woman/radio we encounter a double oscillation between revelation and concealment. First, the visible marks which dictate the reading 'woman' also suggest the reading 'naked' – there is not a single signifier of clothing. However, from the point-of-view offered by the shot, this additional reading cannot be confirmed; but it nevertheless insists even in the means of concealment: the veil of hair, a time-honoured convention for signifying feminine nudity

without *showing* it (see, for example, conventional pictorial representations of Eve, and the text of 'Lady Godiva'). Second, while the woman's body is hidden, averted, the radio is completely exposed – lit and positioned to offer itself in precisely that 'full-frontal nudity' denied at the other terminal of the relay. (Through the agency of this oscillation, then, driven by voyeurism/exhibitionism, and set in motion by the ambiguity of the woman, the cathexis of the product is further over-determined.)

In spatial terms the axis woman/radio forms the base of a triangle which has as its apex the eye of the subject. Another triangle may be constructed from this same base but whose apex is now to be located at the position of the sculpted bust. If a look were to be directed from this position – a possibility alluded to by the 'head' already present there – it would take in that view of the woman's body which is absent from the subject's visual field but which is nevertheless available to its imaginary field (or, as we might say, absent at one level of 'the imaginary' but available at another). Significantly, the sculptured gaze is in fact averted from the woman, though its frozen fixated field includes the radio.

The elements of the image, resumed in their structuration of the subject of this scene, then, are these: the woman's body, represented as an ambiguity, a mystery, but finally as an *absence*; the radio, unambiguously foregrounded as dominant positive term in both imaginary and symbolic spaces; the look of the spectator from the camera position, a look which swings between woman and radio from its suspension point in the word 'loveliness'; the mirror identification of this look with the stone head in the background, from which position it might solve the riddle posed by the woman, but where instead it becomes literally *petrified*, fixated – the gaze, and knowledge, both averted. There is thus a second level of narrative to be read symptomatically across this particular image, a history of fetishism, related to the 'primal phantasies' – phantasies of seduction, castration, the primal scene, and inter-uterine life – which Freud held to be trans-individual (to the point of suggesting that they are transmitted by heredity). The primal phantasies lie at the unconscious extremity of phantasy life in general. Phantasies may also be pre-conscious and, in the form of the day-dream, conscious; nevertheless all phantasies are rooted in unconscious wishes; they are essentially the *mise-en-scène* of desire as it seeks hallucinatory satisfaction.

This sketch analysis of an advertisement is to indicate how manifest visual and verbal elements engage with one another and with latent registers of phantasy, memory and knowledge, much as cogs engage gear-trains: transmitting, amplifying, transforming, the initial input. Most importantly, such effects are not erased, they become inscribed in memory. As Horowitz writes:

> Perceptions are retained for a short time, in the form of images, which allows continued emotional response and conceptual appraisal. In time, retained images undergo two kinds of transformation: reduction of sensory vividness and *translation of the images into other forms of representation (such as words)* (my emphasis).[44]

It is hear that we encounter a general social effect of photographs. A major part of the political import of photographic signification is its constant confirmation and reduplication of subject-positions for the dominant social order through its imbrication within such dominant discursive formations as, for example, those which concern family life, erotic encounters, competitiveness, and so on. The role of such scenarios in advertising will be readily conceded, as will the role of the verbal in achieving them – writing is physically integrated into nearly all advertisements. But 'art' photographs are not exempt from such determinations of meaning, determinations which are achieved even where actual writing is absent. I shall take my examples, again, from the period of the 1960s.

Throughout the 1960s in the USA, in the setting of the growing escalation of, and protest against, the war in Vietnam, blacks and women organised against their own oppression. In 1965 the Watts riots effectively marked the exhaustion of the predominantly Southern black strategy of non-violent political struggle, and the emergence of the concept of *black power*. In 1967 the Black Panthers went publicly armed and uniformed in Oakland, and carried their weapons into the California State House in Sacramento. In this same year the national women's peace march in Washington marked the effective inauguration of the women's liberation movement. It is surely reasonable to suppose that the knowledge of events such as these suffused the collective *Pcs–Cs* of Americans in the 1960s. Let us now consider some 'art' photography of this period.

The catalogue to a 1976 exhibition of Gary Winogrand's

photographs[45] contains an image in which four women, talking and gesturing among themselves, advance towards the camera down a city street. The group of women, who are of varying degrees of middle age, is the most prominent feature in the right-hand half of the image; equally prominent in the left half of the image, visually just 'touching' the women, is a group of huge plastic bags stuffed full of garbage. This photograph is also printed on the cover of the catalogue; the author of the introduction to the catalogue tells us:

> When four ageing women gossip their way past four ballooning garbage bags, it earns power for the eye that sees them. If that eye laughs and gloats it condemns the women to nothing more than participation in an eternal joke.

Concluding the montage of aphorisms which is Winogrand's own written contribution to the catalogue, Winogrand states: 'I like to think of photographing as a two-way act of respect. Respect for the medium, by letting it do what it does best, describe. And respect for the subject, by describing it as it is.' But, as the women's movement so consistently argued, what the world 'is' depends extensively on how it is *described*: in a culture where the expression 'old bag' is in circulation to describe an ageing woman, that is precisely what she is in perpetual danger of 'being'. Neither the photographer, nor the medium, nor the subject, is basically responsible for the meaning of this photograph, the meaning is produced, in the act of *looking* at the image, by a way of *talking* (it is even likely that this 'purely visual' communication could not have been achieved in any other language but English).

Regardless of how much we may strain to maintain a 'disinterested' aesthetic mode of apprehension, an appreciation of the 'purely visual', when we look at an image it is instantly and irreversibly integrated and collated with the intricate psychic network of our knowledge. It is the component meanings of this network than an image must *re-present*, reactivate and reinforce, there is no choice in this. What flexibility there is comes in the way in which these components are assembled (and even here we may have less freedom than we may like to believe). Such 'sexism' as might be ascribed to this image, or to others, is not 'in' the photograph itself. Such 'isms', *in the sphere of representation*, are a complex of texts, rhetorics, codes, woven into the fabric of the popular pre-conscious. It is these which are the *pre-text* for the 'eternal joke', it is these

which pre-construct the photographer's 'intuitive' response to these fragments of the flux of events in the world, producing his or her recognition that there is something 'there' to photograph. *It is neither theoretically necessary nor desirable to make psychologistic assumptions concerning the intentions of the photographer,* it is the pre-constituted field of discourse which is the substantial 'author' here, photograph and photographer alike are its products; and, in the act of seeing, so is the viewer.

About a quarter of the way into Lee Friedlander's book *Self Portrait*[46] is a photograph captioned 'Madison, Wisconsin, 1966'. In it, the shadow of the photographer's head falls across a framed portrait of a young black person. The portrait is set in an oval aperture cut in a light coloured mount, an oval now tightly contained within the shadow of the head. Placed in this context the oval is made to serve as the schematic outline of a face, the shadows of Friedlander's ears are stuck absurdly one to each side, but the face which looks out from between the ears is black. Item 109 in the catalogue to the Museum of Modern Art exhibition, *New Photography USA,*[47] is an untitled photograph by Gary Winogrand taken in Central Park Zoo in 1967. It shows a young white woman close beside a young black man; each carries a live chimpanzee which is dressed in children's clothing. In everyday social life it is the face which carries the burden of identity; in these terms, to exchange one's face for that of another would be to take the other's place in society. Friedlander's photograph suggests the idea of such an exchange of identities – if I am white, it invites me to imagine what it would be like if I were black. In Winogrand's picture my identity and my social position are secure. We are all familiar with expressions of irrational fear of the 'mixed marriage': from the comparatively anodyne punning of the joke about the girl who married a Pole – and had a wooden baby – the the cliché insults of the committed racist, according to whose rhetoric the union of white and black can give issue to monkeys. In terms of these considerations, therefore, it should be clear that Friedlander's photograph is open to readings couched in terms of social change, to which Winogrand's image is not only closed but hostile. 'It should be clear', but it is empirically obvious that no such *differences* are in practice constructed or sanctioned in the dominant discourse of the art institution within which these photographs are organically located. Friedlander and Winogrand in fact occupy virtually inter-

changeable positions in the established pantheon of photographic *auteurs*, the work of both having been assimilated *equally* to the discourse of art photography. Obviously this discourse itself exercises its own massive determinations on the received sense of art photographs. The discourse in dominance in art photography is, *de facto*, that of 'modernism'; there has, however, been a significant inconsistency in the application of a modernist programme to photography.

V

The first paragraph of John Szarkowski's intr)duction to the catalogue which contains Winogrand's Central Park Zoo picture tells us: 'New pictures derive first of all from old pictures. What an artist brings to his work that is new – special to his own life and his own eyes – is used to challenge and revise his tradition, as he knows it.'[48] There is a vivid similarity in this passage to the style and content of Clement Greenberg's writing, indeed the criteria for evaluating photographs employed throughout Szarkowski's texts corresponds almost identically to the programme for Modernist art laid down by Greenberg. The 1961 essay 'Modernist Painting' is probably Greenberg's most succinct statement of his view of modernism, and may therefore serve here as a convenient check-list.[49] In this essay Greenberg defines Modernism as the tendency of an art practice towards self-reference by means of a foregrounding of: the tradition of the practice; the difference of the practice from other (visual arts) practices: the 'cardinal norms' of the practice; the material substrate, or 'medium', of the practice.

In reference to *tradition* Greenberg states: 'Modernist art continues the past without gap or break, and wherever it may end up it will never cease being intelligible in terms of the past.' (Szarkowski's endorsement of this position is quoted above.) In respect of *difference*, Greenberg writes:

> Each art had to determine through its own operations and works, the effects exclusive to itself. . . . It quickly emerged that the unique and proper area of competence of each art coincided with all that was unique in the nature of its medium.[50]

Szarkowski says, in an interview: 'I think in photography the formalist approach is . . . concerned with trying to explore the intrinsic or prejudicial capacities of the medium as it is understood

at that moment.'[51] Greenberg argues for the destruction of three-dimensional space in painting, 'For flatness alone was unique and exclusive to pictorial art.' He argues for a renewed emphasis on colour, 'in the name of the purely and literally optical ... against optical experience as revised or modified by tactile associations'. Flatness, the 'purely optical', and other such things as 'norms of finish and paint texture', belong to what Greenberg calls '*cardinal norms* of the art of painting'. Szarkowski devotes his catalogue introduction to the 1966 Museum of Modern Art exhibition *The Photographer's Eye*[52] to cataloguing such cardinal norms of photography, which he identifies as: 'The Thing Itself', 'The Detail', 'The Frame', 'Time', and 'Vantage Point'. What is not to be found in Szarkowski's discourse is Greenberg's emphasis on the *medium* defined in terms of material substrate. Greenberg insists on the materiality of the painted surface as a thing in itself in the interests of an anti-illusionism; to make a comparable insistence in respect of photography would be to undermine its founding attribute, that of illusion; we might further note that it might very well evict the camera itself from the scene, returning photography to, literally, *photo-graphy* – drawing with light. This elision, this failure to complete the journey upon which it has embarked (Modernism is *nothing* if not totally internally coherent), marks a contradiction which runs like a fault-line through Szarkowski's discourse: illusion cannot be totally abandoned, but neither can the full consequences of retaining it be accepted.

We should recall that the modernist programme for painting dictated that the art work be a totally autonomous material *object* which made no reference whatsoever to anything beyond its own boundaries: the painted surface itself, its colour, its consistency, its edge, its gesture, was to be the only 'content' of the work. Any form of representation other than self-representation, in Greenberg's words, 'becomes something to be avoided like a plague'. This impetus is in direct line of descent from the desire of Bell and Fry, early in this century, to free art from concerns 'not peculiarly its own'. Bell, writing in 1913, stated: 'To appreciate a work of art we need bring with us nothing but a sense of form ... every other sort of representation is irrelevant'; and he complained of those who 'treat created form as if it were imitated form, a picture as though it were a photograph'.[53] In the same movement in which, in the West, the issue of representation in art became a dead issue, photography became consigned to the far side, the 'wrong' side, of that divide

which Cubism had opened up between the nineteenth century and the modern period. Initiatives to recover photography from this remote shore (in the history of which Stieglitz figures so prominently) were therefore unavoidably directed towards securing 'picture' status for photographs. The general programme of Modernism showed the way: the *art* of photography is achieved *only* through the most scrupulous attention to those effects which are irreducibly derived from, and specific to, the very functioning of the photographic apparatus itself – representation may be the contingent vulgar flesh of photography, but its spirit is 'photographic seeing'. Szarkowski is thus able to judge:

> Winogrand . . . is perhaps the most outrageously thoroughgoing formalist that I know. What he is trying to figure out is what that machine will do by putting it to the most extreme tests under the greatest possible pressure.[54]

However, although content in photographs may be ignored, it will not go away. The fear perhaps is that to *speak* of it would be to back-slide into Naturalism, that it would necessarily be to abandon the gains of the Modernist discourse which has provided art photography in the modern period with its credentials and its programme. On the contrary, it would be to pursue the modernist argument with an increased rigour.

The Modernist programme for a given practice is centred upon that which is irreducibly *specific* to the practice: in a sense, that which remains after eliminating the things it is *not*. The initial definition of this specificity is therefore crucial, as all subsequent modes of action and evaluation will depend upon it. In a 1964 article in the *New York Review of Books* Greenberg himself is in no doubt as to the locus of the specificity of photography.[55] First, it is *not* Modernist painting: 'its triumphs and monuments are historical, anecdotal, reportorial, observational before they are purely pictorial'. But then neither is 'brute information' art. In fact, 'The purely descriptive or informative is almost as great a threat to the art in photography as the purely formal or abstract.' Greenberg concludes:

> The art in photography is literary art before it is anything else. . . .
> The photograph has to tell a story if it is to work as art. And it is in choosing and accosting his story, or subject, that the artist-photographer makes the decisions crucial to his art.

Greenberg, however, offers no suggestion as to how an impression of narrative can be given by a single image. Szarkowski, writing some two years later, can continue to assert that 'photography has never been successful at narrative. It has in fact seldom attempted it.' Photographs, he finds, 'give the sense of the scene, while withholding its narrative meaning'.[56] 'Narrative meaning' here is clearly equated with the sort of factual account of an event which might be sought in a court of law. Obviously, this cannot be derived from a single image alone. But what is this 'sense' which Szarkowski mentions but does not discuss, this 'story' which Greenberg names but cannot explain? Greenberg's equation of 'story' with 'subject' raises more questions than it answers, but they are productive questions – questions raised around the ambivalence of his use of the term 'subject': subject of the photograph (the thing pictured); subject of the story (that which it is 'a tale of'). As I have observed above, we may only resolve this ambivalence through the introduction of a third term – the seeing subject (the individual who *looks*); to introduce *this* subject is, in the same movement, to introduce the social world which constructs, situates and supports it.

To speak of the 'sense' and 'story' of a photograph is to acknowledge that the reality-effect of a photograph is such that it inescapably implicates a world of activity responsible for, and to, the fragments circumscribed by the frame: a world of causes, of 'before and after', of 'if, then . . .', a *narrated* world. The narration of the world that photography achieves is accomplished not in a linear manner but in a repetition of 'vertical' readings, in stillness, in *a*temporality. Freud remarks that time does not exist in the unconscious, the dream is not the illogical narrative it may appear to be (this is the dramatic product of secondary revision), it is a *rebus* which must be examined element by element – from each element will unfold associative chains leading to a coherent network of unconscious thoughts, thoughts which are extensive by comparison with the dream itself (which is 'laconic'). We encounter the everyday environment of photographs as if in a waking dream, a daydream: taken collectively they seem to add up to no particular logical whole; taken individually their literal content is quickly exhausted – but the photograph, too, is laconic, its meaning goes beyond its manifest elements. The significance of the photograph goes beyond its literal signification by way of the routes of the primary processes: to use a filmic analogy, we might say that the individual photograph becomes the point of origin of a series of

psychic 'pans' and 'dissolves', a succession of metonymies and metaphors which transpose the scene of the photograph to the spaces of the 'other scene' of the unconscious,[57] and also, most importantly, the scene of the popular preconscious: the scene of discourse inseparable from *language*.

VI

I began with a debate in photography which is now distant. The terms of the debate, however, have a mythic simplicity which still inspires our current controversies on the left of art and photography in the West; 'form' and 'content' ('how' and 'what') are still the most visible marks in a terrain which, regardless of the number of times it has been ploughed, obstinately retains the following salient features: an aesthetically conservative realism, in which the principal concern is who is to be represented and what they are to be shown as doing; and a leftist formalism, which asserts that what people believe, and thus the way they will behave, can be changed by the very form of the way in which they are represented. These allow a middle ground: an ecumenically pious wish for a synthesis of the former and latter tendencies which will combine their strengths and eradicate their weaknesses. In their intervention in the Rodchenko/Kushner exchange the editors of *Novy Lef* sought not to unite the opposing factions but rather to restructure and realign the very terms of the debate. They proposed a 'functional' approach to photography; in the practical terms of that specific conjuncture we might judge ROPF practice (in effect, Kushner's words in action) to be the very model of the functional in serving the urgent information/exhortation needs of the first Five-Year Plan; in the context of that massive national struggle for production the capitulation of the leftists seems to have been inevitable. However, *Novy Lef*'s editors were as critical of Kushner as of Rodchenko; they imply that the two opposed problematics are not necessarily mutually exclusive but, rather, that they occupy different registers, the possible imbrication of which has to be considered; moreover, they stipulate no particular sphere to which the consideration of 'function' should apply. Their unelaborated comments thus open on to such unresolved problems of recent theory as the articulation of the social subject with the 'subject in the text', and the specificity of political struggles on/for particular institutional ground.

I have observed that to take account of the 'function' of photo-

graphy, in the literal sense of 'the mode of action by which it fulfils its purpose', is unavoidably to face the complexities of the imbrication/transposition/transformation of manifest visual elements within discourses which precede them: discourses of the unconscious; discourses of the popular preconscious; discourses of the specific institutions within which the photographic practice in question is situated. My discussion has been centred upon the institution of art: I have already alluded to some historical difficulties which beset photography in quest of credentials from established 'fine art' – these difficulties were not resolved; rather, the deep-rooted contradictions which caused them maintain the relation of photography to 'art' in a constant state of crisis. While, obviously, we should not underestimate the specific differences between such representational practices as advertising, cinema, journalism, television, etc., neither should we overestimate the degree of discontinuity between them – together they form an integrated specular regime, contributing to a unitary 'popular imaginary'. The progressive incursion of photography into the institutional spaces previously reserved for painting and sculpture has served to upset the conventional disavowal of the relation of art to such other representational practices, if only because photography is central to so many of them. As Peter Wollen has written:

> For photography to be an art involves reformulating notions of art, rejecting both material and formal purism and also the separation of 'art' from 'commerce' as distinct semiotic practices which never interlock. Photography is not an 'art-in-itself' any more than film, but an option within an inter-semiotic and inter-textual 'arena'.[58]

Clearly, the discursive formation which supports the term 'art' outruns any one site; the term is used in respect of a complex of institutions, practices and representations: art museums, art magazines, art schools, painting, photography, sculpture, art history, art theory, art criticism, across to representations of the artist in the popular media: Kirk Douglas's Van Gogh, Anthony Quinn's Gaugin, Charlton Heston's Michaelangelo, and so on. Not the least important determinant in this complex is *art administration*; in an essay on the institutional determinants of photographic imagery Barbara Rosenblum concludes that fine-arts photography 'does not have unlimited capacity to absorb all types of imagery', and that it differs from news and advertising photography in that determinants

upon imagery 'are generated primarily through the distribution systems, rather than through the organisation of production'.[59] Modernist discourse rules the distribution systems of art photography, aided extensively by John Szarkowski's directorship of the Department of Photography at the Museum of Modern Art, New York – the institution which has served as primary power-centre and ideological anchor for the expansion of 'art photography' even prior to, but certainly since, Szarkowski's predecessor Edward Steichen launched *The Family of Man* exhibition there in 1955. *The Family of Man* would appear to have foregrounded 'content', *history*; in fact its seamless totality collapsed in upon a single humanist myth.[60] The lines of today's superficially quite different 'formalism' ultimately converge within the same humanist perspectives.

E. H. Gombrich has traced the lineage of the belief in the ineffable purity of the visual image. Plato puts into the mouth of Socrates a doctrine of two worlds: the world of murky imperfection to which our mortal senses have access; and an 'upper world' of perfection and light. Discursive speech is the tangled and inept medium to which we are condemned in the former, while in the latter all things are communicated visually as a pure and unmediated intelligibility which has no need for words. The idea that there are two quite distinct forms of communication, words and images, and that the latter is the more direct, passed via the Neo-Platonists into the Christian tradition. There was now held to be a divine language of *things*, richer than the language of words; those who apprehend the difficult but divine truths enshrined in things do so in a flash, without the need for words and arguments. As Gombrich observes, such traditions 'are of more than antiquarian interest. They still affect the way we talk and think about the art of our own time.'[61] Foucault has directed our attention to the action of *power* in the truth-effect of 'the way we talk and think' within and across our major institutions: society is *ordered* on the basis of what it holds to be true; truth does not stand outside discourse, waiting to be 'expressed' by it; truth is *produced* by material forms of discourse inscribed in concrete practices. The global 'truth' whose perpetual regeneration is guaranteed across the discursive formation of art is that of the transcendent freedom of the sovereign individual – that 'freedom of the spirit' (a spirituality whose natural realm is that of *light*, pure vision) which we are

guaranteed in exchange for the subjection of the *body* to extant structures of power.

The 'artist' discovers the truth in perplexed appearances on behalf of those unable to see it for themselves. The calling of the 'left' artist is no less elevated, it is that of Foucault's 'universal' left intellectual, who speaks as 'the consciousness/conscience of everyone'.[62] Again, it is a matter of a discourse uttered from one place *on behalf of* those who stand in another – the political is permanently displaced to a perpetual *elsewhere*, as if the actuality of dominance, repression, exploitation, subjection to a specific *order*, did not insinuate itself throughout the very fibre of art traditions and institutions *themselves* (as if 'political' engagement were a *fixture* which can only be played 'away'). There have been two main consequences of this left humanism: on the one hand, the total evacuation of considerations of the political from art production itself – which becomes the receptacle of all that is 'timeless', 'biological', in 'human nature'; on the other, the complete abandonment of the dominant sectors of the art institutions (certainly, a difficult and hostile environment) in favour of a 'popular' art of posters, banners, and murals.[63] To gain the ground conceded by these, the dominant, tendencies it is required that the familiar pronouncement 'everything is political' be taken precisely to the letter, rather than being used, as it is, as a segregationist gesture of laying aside (e.g. 'art is political – it's a bourgeois weapon against the masses'). Thus Foucault writes:

> To say that 'everything is political' is to recognise this omnipresence of relations of force and their immanence to a political field; but it is to set oneself the barely sketched task of unravelling this indefinite tangled skein . . . the problem isn't so much to define a political 'position' (which brings us back to making a move on a pre-constituted chessboard) but to imagine and bring into existence new schemes of politicisation. To the great new techniques of power (which correspond to multinational economies or to bureaucratic States) must be opposed new forms of politicisation.[64]

Without necessarily abandoning those forms which already exist, 'new forms of politicisation' within the institutions of art (and) photography must begin with the recognition that meaning is

perpetually displaced from the *image* to the discursive formations which cross and contain it; that there can be no question of either 'progressive' contents or forms *in themselves*, nor any ideally 'effective' synthesis of the two; that there can be no *genre* of 'political' art (and) photography *given in advance* of the specific historical/institutional/discursive conjuncture; that there can be neither 'art for all' nor 'art for all time'. These and other unrequited spectres of the left art imaginary are to be exorcised; the problem *here* is not to answer the old questions, it is to identify the new ones. It follows that such a politicisation must be 'pan-discursive' with respect to the discursive formation in question. In the register of theory there is still a need for that 'archaeology' which, as Foucault envisaged:

> would not set out to show that the painting is a way of 'meaning' or 'saying' that is peculiar in that it dispenses with words. It would try to show that, at least in one of its dimensions, it is discursive practice that is embodied in techniques and effects.[65]

Moving towards the register of 'practice', Benjamin saw the need for a 'pan-discursivity' as a devolution of established subject positions, in which 'we, as writers, start taking photographs ourselves . . . technical progress is, for the author as producer, the basis of his political progress'.[66]

Select Bibliography

The purpose of this bibliography is to indicate a relatively small number of books and articles in English to which the reader unfamiliar with the general orientations of the foregoing essays may refer. In the case of the very extensive writings of Freud and Marx I have indicated 'entry points' of most immediate proximity to the concerns of the essays in this book. Articles of interest published in the journals *Screen* and *Screen Education* (London) are too numerous to list. Unless otherwise stated, the place of publication is London.

ALTHUSSER, L., 'Ideology and Ideological State Apparatuses: Notes towards an investigation', in *Lenin and Philosophy and other essays*, New Left Books, 1971.

BARTHES, R., *Mythologies*, Paladin, 1973.

BARTHES, R., *Elements of Semiology*, Jonathan Cape, 1976.

BARTHES, R., *Image–Music–Text*, Fontana, 1977.

BENJAMIN, W., 'A Short History of Photography', *Screen*, vol. 13, no 1, Spring 1972.

BENJAMIN, W., 'The Work of Art in the Age of Mechanical Reproduction', in *Illuminations*, Fontana, 1973.

BOURDIEU, P., 'The Aristocracy of Culture' and 'The Production of Belief: Contribution to an Economy of Symbolic Goods', *Media, Culture and Society*, vol. 2, no. 3, July 1980.

BURGIN, V., 'Art, Common-Sense and Photography', *Camerawork*, 3, 1976.

BURGIN, V., 'Modernism in the *work* of Art', *20th Century Studies*, 15–16, Canterbury, 1976.

COWARD, R. and ELLIS, J., *Language and Materialism*, Routledge & Kegan Paul, 1977.

ECO, U., *A Theory of Semiotics*, Indiana University Press, 1976.

ERLICH, V., *Russian Formalism: History, Doctrine*, Mouton, The Hague, 1965.

FOUCAULT, M.,'Las Meninas', in *The Order of Things*, Tavistock, 1970.

FOUCAULT, M., 'What Is an Author?', in *Language, Counter-Memory, Practice*, Blackwell, Oxford, 1977.

FOUCAULT, M., 'The Eye of Power', in *Power/Knowledge*, Harvester, Brighton, 1980.

FREUD, S., *The Standard Edition of the Complete Psychological Works of Sigmund Freud*, 24 vols, Hogarth Press, 1953–74. A useful guide to the above is ROTHGEB, C. L., (ed.) *Abstracts of the Standard Edition of the Complete Psychological Works of Sigmund Freud*, International Universities Press, New York, 1973. Major works from the *Standard Edition* are being reprinted in the Pelican Freud Library; see especially vol. 1, *Introductory Lectures on Psychoanalysis*, 1973; vol. 4, *The Interpretation of Dreams*, 1976 (particularly ch. 6); and vol. 7, *On Sexuality*, 1977 (particularly 'Three Essays on the Theory of Sexuality' and 'Fetishism'). For a superb guide to Freudian concepts, see Laplanche and Pontalis. For an intellectual biography of Freud, see Mannoni.

HALL, S., 'The Social Eye of Picture Post', *Working Papers in Cultural Studies*, vol. 2, Birmingham University, Spring 1972.

HIRST, P. Q., 'Althusser and the Theory of Ideology', *Economy and Society*, vol. 5, no. 4, November 1976.

LAING, D., *The Marxist Theory of Art*, Harvester, Brighton, 1978.

LAPLANCHE, J. and PONTALIS, J.-B., *The Language of Psycho-Analysis*, Hogarth Press, 1973.

MacCABE, C., *Godard: Images, Sounds, Politics*, Macmillan, 1980.

McLELLAN, D., *Marx*, Fontana, 1975.

MANNONI, O., *Freud: The Theory of the Unconscious*, New Left Books, 1971.

MARX, K. and ENGELS, F., *Collected Works*, vol. 5, Lawrence & Wishart, 1976. The most frequently quoted remarks of Marx and Engels on ideology come from ch. I, section 4, of *The German Ideology*, in this volume.

MARX, K., *Capital*, vol. 1, Lawrence & Wishart, 1954. The later notion of 'fetishism', also important to a Marx-derived theory of ideology, is described in ch. I, section 4. (For brief general introductions to Marx's work, see McLellan and Singer.)

MITCHELL, J., *Psychoanalysis and Feminism*, Penguin, Harmondsworth, 1975.

MULVEY, L., 'Visual Pleasure and Narrative Cinema', *Screen*, vol. 16, no. 3, Autumn 1975.

ROSENBLUM, B., *Photographers at Work*, Holmes & Meier, New York, 1978.

SEKULA, A., 'The Instrumental Image: Steichen at War', *Artforum*, vol. 14, no. 4, December 1975.

SINGER, P., *Marx*, Oxford University Press, 1980.

SOCIETY FOR EDUCATION IN FILM AND TELEVISION, *Screen Reader 1: Cinema/Ideology/Politics*, 1977.

SPENCE, J., DENNETT, T. *et al.*, *Photography/Politics: One*, Photography Workshop, 1979.

STURROCK, J. (ed.), *Structuralism and Since*, Oxford University Press, 1979.

TAGG, J., 'Power and Photography', *Screen Education*, no. 36, Autumn 1980.

WALTON, P. and DAVIS, H., *Language, Image and the Media*, Blackwell, Oxford, 1981.

WILLIAMS, R., *Problems in Materialism and Culture*, Verso, 1980.

WILLIAMS, R., *Culture*, Fontana, 1981.

WILLIAMSON, J., *Decoding Advertisements*, Marion Boyars, 1978.

WOLLEN, P., 'The Two Avant-Gardes', *Studio International*, vol. 190, no. 978, November–December 1975.

Notes and References

Chapter 1: Walter Benjamin

1. Address delivered at the Institute for the Study of Fascism, Paris, on 27 April 1934.
2. Benjamin himself (*see Schriften*, Frankfurt, 1955, vol. I, p. 384).
3. Benjamin makes a play on words here with *Schreibender* (one who writes), *Beschreibender* (one who describes) and *Verschreibender* (one who prescribes). (Translator's note.)
4. The following passage, later deleted, originally appeared in the manuscript in place of the next sentence: 'Or, in Trotsky's words: "When enlightened pacifists undertake to abolish War by means of rationalist arguments, they are simply ridiculous. When the armed masses start to take up the arguments of Reason against War, however, this signifies the end of War."'
5. See Benjamin, 'Linke Melancholie' (Left Melancholy), on Erich Kästner's new book of poems, in *Die Gesellschaft*, 8, 1931, vol. I, pp. 182 ff. In quoting from himself, Benjamin has altered the original text.

Chapter 2: Umberto Eco

[The following notes are by Peter Wollen; they accompanied the original publication of Eco's article in *Cinemantics*, 1, 1970.]

1. Eco insists that all signs, including images – i.e. not only verbal signs – are arbitrary and conventional and we therefore have to learn how to interpret them. They are cultural rather than natural. However, he concedes that looking at a photograph of a zebra is closer in some respects to looking at an actual zebra than it is to hearing or reading the word 'zebra'. Nevertheless, Eco insists that what the semiologist must concentrate on is the *differences* between looking at and understanding the image as opposed to the object in the world of action.
2. Eco adopts a thoroughgoing binarism. He believes that the brain works like a digital computer, dissolving everything continuous into a series of discontinuous alternative choices. Perception works rather like a TV scanning mechanism. This brings up the problem of the delicacy of perception. In verbal language there is what Martinet calls a 'safety margin'

between the different phonemes: '*p*' stays quite separate from '*b*' and the intelligibility of language would begin to collapse if there were an indefinite number of slurred half-way sounds. This is not true about visual images, as anybody will know who has looked at a colour atlas. Colours blend into each other and it is extremely difficult to identify one colour as opposed to another. The degree of delicacy varies from individual to individual (for instance, tea-tasting or wine-tasting, which require the same order of skill as colour-matching). What is true about colours is also true about tones, about squirls and squiggles, etc. There is no safety margin. Nevertheless we are able for all practical purposes to tell the time from a clock, however imperceptible the movement of the hánds: we can, in fact, interpret the angle of two lines with sufficient delicacy to catch trains.

3. Eco uses the French version 'syntagm', as opposed to the American (Bloomfieldian) 'syntagma'. The terms describe similar concepts, and differ in as much as the French and American schools differ in their approaches.

4. Eco translates the French *Sème* (as used by Buyssons, Prieto *et al.*) into the Italian 'sema'.

5. Verbal language has two articulations. The first articulation is that of phonemes and, as Hjelmslev showed, this can be established by a simple commutation test. Thus if we change 'pig' into 'big' we get a different meaning; hence, we can identify '*p*' and '*b*' as separate phonemes. The second articulation is that of morphemes. Here too, we can apply a simple commutation test. If we change 'full-speed' into 'half-speed' we also get a different meaning, but at a different level. Similarly, we can change 'full-speed' to 'full-back' and 'half-speed' to 'half-back'. In this way, we identify four separate phonemes: 'full', 'half', 'speed' and 'back'. Verbal language, then, has two articulations. According to Eco, when we begin to study visual images, we find we need to postulate three articulations, three levels at which meaning may be affected. The first articulation is that of 'figures'. By this Eco seems to mean the way in which we can tell one abstract painting from another by detecting variations in colour, the angle of lines, etc., and that these variations are meaningful, that a formal variation of this kind necessarily maps out a corresponding semantic variation. The second articulation is that of 'signs'. Here Eco seems to mean the way in which we recognise a certain line or shape as having an object or class of objects in the outside world, in the world of action, as referent. Thus we recognise an oval with a dot in it as an eye. The third articulation is that of 'semes'. Here Eco means, roughly speaking, the way in which we build up a whole picture from a combination of elements: two eyes+nose+mouth=face. Eco does not discuss whether some kind of commutation test could be applied at each of these levels in order to establish them firmly.

Chapter 3: Victor Burgin

1. Based on lectures given at the Polytechnic of Central London and the Slade School of Fine Art, 1974.

2. Walter Benjamin, 'A Short History of Photography', *Screen*, Spring 1972, p. 24.

3. Walter Benjamin, 'The Work of Art in the Age of Mechanical Reproduction', *Illuminations*, Fontana, 1973, p. 228.

4. Benjamin, 'A Short History of Photography', p. 6.

5. *Diane Arbus*, Aperture monograph, 1972.

6. Stephen Heath, *The Nouveau Roman*, Elek, 1972, p. 189.

7. Roland Barthes, *Mythologies*, Paladin, 1973, p. 109.

8. Ibid, p. 116.

9. Ibid, p. 118.

10. Jean-Marie Benoist, 'The End of Structuralism', *Twentieth Century Studies*, May 1970, p. 31.

11. Roland Barthes, *Elements of Semiology*, Jonathan Cape, 1967, p. 93.

12. Roland Barthes, 'Situation du linguiste', *La Quinzaine litteraire*, 15 May 1966.

13. Barthes, *Elements of Semiology*, p. 12.

14. Ferdinand de Saussure, *Course in General Linguistics*, Fontana, 1974, p. 16.

15. *Elements*, pp. 10–11.

16. *Course*, pp. 13–14.

17. Ibid, p. 14.

18. Ibid, pp. 108–9.

19. Oswald Ducrot and Tzvetan Todorov, *Dictionnaire encylopédique des sciences du langage*, Editions du Seuil, 1972, p. 132.

20. *Elements*, p. 38.

21. Jacques Derrida, *De La Grammatologie*, Editions de Minuit, 1967, p. 21.

22. Ibid, pp. 70–1.

23. Jonathan Culler, *Structuralist Poetics*, Routledge & Kegan Paul, 1975, p. 132.

24. Saussure, *Course*, p. 123.

25. Ibid, p. 123.

26. John Lyons, *Introduction to Theoretical Linguistics*, Cambridge University Press, 1968, pp. 73–4. See here and following for discussion of 'potentiality of occurrence'.

27. Roman Jakobson and Morris Halle, *Fundamentals of Language*, Mouton, 1971. p. 92.

28. *Course*, p. 113.

29. Louis Hjelmslev, *Prolegomena to a Theory of Language*, University of Wisconsin, 1969, pp. 112 ff.

30. Ducrot and Todorov, *Dictionnaire*, p. 41.

31. Louis Hjelmslev, *Language: An Introduction*, University of Wisconsin, 1970, p. 136.

32. Stephen Heath, *Vertige du déplacement*, Fayard, 1974, p. 65.

33. Cf. Barthes, *Mythologies*, pp. 120–1, for remarks on neologism.

34. Roland Barthes, *Système de la Mode*, Editions du Seuil, 1967, p. 7.

35. Umberto Eco, *La Structure Absente*, Mercure de France, 1972, p. 11.

36. Roland Barthes, 'Rhetoric of the Image', *Working Papers in Cultural Studies*, University of Birmingham, Spring 1971, p. 45.

37. Ibid, p. 41.

38. The signs of natural language are described by Saussure as 'unmoti-vated' or 'arbitrary'. The relationship between a word and its referent is entirely conventional, whereas the relationship in a 'motivated' code is only partially conventional. Here there is a greater or lesser degree of resemblance to the referent, as in the schematised car silhouettes in the 'No Overtaking' road sign. Barthes sometimes uses the terms 'digital' and 'analogical' in place, respectively, of arbitrary and motivated.

39. Barthes, 'Rhetoric of the Image', p. 46.

40. Cf. *La Structure Absente*, pp. 201 ff.

41. *Elements*, p. 66.

42. Umberto Eco, 'Articulations of Cinemantic Code', *Cinemantics*, 1 January 1970. (Part One of Eco's article ('Critique of the Image') appears as Chapter 2 of this book.)

43. *Course*, p. 13.

44. Ibid, p. 66.

45. Irwin Panofsky, *Studies in Iconology*, Harper & Row, p. 3.

46. 'Critique of the Image', p. 33.

47. Eco's terminology here is derived from Hjelmslev via Priato (see *Là Structure Absente*, pp. 206ff.) In his later work the terminology changes, 'sign', for example, becoming 'recognition seme' (see 'Introduction to a Semiotics of Iconic Signs', VS, vol. 2, 1972).

48. 'Critique of the Image', p. 36.

49. Eco, 'Introduction to a Semiotics of Iconic Signs', p. 5.

50. 'Critique of the Image', pp. 35–8.

51. Prosodic features are those variations in speech, such as timbre, pitch, duration, which allow us to pronounce the same words with a different emphasis or sense. In some languages certain prosodic features are clearly conventionalised and commutable to the point at which they must be considered to belong to *langue*. In Chinese; for example, a certain phonemic form will take on two totally separate senses according to whether it is uttered in a high or low tone. In regard to European languages, on the other hand, there is still some dispute among linguists as to whether certain such 'marginal' features belong to *langue* or *parole*.

52. Christian Metz, *Language and Cinema*, Mouton, 1974, pp. 276–7.

53. Christian Metz, *Film Language*, Oxford University Press, 1974, p. 26.

54. Lev Kuleshov, *Art of the Cinema*, selections in *Screen*, Winter 1971–2, pp. 115–16.

55. Tzvetan Todorov, 'Language and Literature', in *The Structuralist Controversy*, ed. Macksey and Donato, Johns Hopkins Press, 1972, p. 127.

56. Ibid, p. 129.

57. Tzvetan Todorov, 'Structural Analysis of Narrative', *Novel*, vol. 3, Autumn 1969, p. 73.

58. Barthes, 'Rhetoric of the Image', p. 48.

59. Jean-Louis Swiners, 'Problèmes de photo-journalisme contem-porain', *Techniques graphiques*, nos 57–9, 1965.

60. Ibid, no. 59, p. 290.

61. Jacques Durand, 'Rhétorique et image publicitaire', *Communica-*

tions, vol. 15, 1970, pp. 70–95.

62. Antanaclasis differs from the previously mentioned syllepsis in that its constituent propositions are quite distinct, whereas in syllepsis they 'overlap'.

63. Sigmund Freud, *The Psychopathology of Everyday Life,* Macmillan, 1914.

64. Jacques Lacan, 'The Insistence of the Letter in the Unconscious', in *The Structuralists from Marx to Lévi-Strauss,* ed. de George and de George, Doubleday, 1972, p. 323.

65. Jean-Marie Benoist, 'The End of Structuralism', *Twentieth Century Studies,* vol. 3, May 1970, p. 42.

66. Benjamin, 'A Short History of Photography', p. 25.

67. Metz, *Language and Cinema,* p. 35.

Chapter 4: Allan Sekula

1. Quoted in Richard Rudisill, *Mirror Image: Influence of the Daguerreotype on American Society,* Albuquerque, 1971, p. 57.

2. Ibid, p. 57.

3. Roland Barthes, 'Rhetoric of the Image', *Communications,* vol. 4, 1964, p. 44.

4. *New York Morning Herald,* 30 September 1839, quoted in Robert Taft, *Photography and the American Scene,* New York, 1938, p. 16.

5. *Godey's Lady's Book,* 1849, quoted in Rudisill, *Mirror Image,* p. 209.

6. *Daguerreian Journal,* 15 January 1851, quoted in Rudisill, *Mirror Image,* p. 281.

7. *Mademoiselle de Maupin,* London, 1899, pp. 28–44; originally published in 1834.

8. 'The Death of Art in the 19th Century', in *Realism and Tradition in Art 1848–1900,* ed. Linda Nochlin, Englewood Cliffs, N.J., 1966, pp. 16–18.

9. Jonathan Wayne (ed.), *Art in Paris 1845–1867,* London, 1965, pp. 153–4; originally published in 1869.

10. 'The Unconscious in Art', *Camera Work,* 1911.

11. 'Alfred Stieglitz: Four Happenings', in *Photographers on Photography,* ed. Nathan Lyons, Englewood Cliffs, N.J., 1966, pp. 129–30, my emphasis.

12. 'How I Came to Photograph Clouds', in *Photographers on Photography,* ed. Lyons, p. 170.

13. Eric Johnson, 'The Composer's Vision: Photographs by Ernest Bloch', *Aperture,* no. 16, 1972, p. 3.

14. 'Equivalence: The Perennial Trend', in *Photographers on Photography,* ed. Lyons, p. 170.

15. *Guide to Aesthetics* (trans. Patrick Romanell), New York, 1965, p. 15, originally published in 1913.

16. Ibid, p. 34.

17. *Aesthetic as Science of Expression and General Linguistic* (trans. Douglas Ainslie), New York, 1953, p. 17.

18. 'Photography and the New God', in *Photographers on Photography*, ed. Lyons, p. 143, my emphasis.
19. *Lewis W. Hine and the American Social Conscience*, New York, 1967, p. 29.
20. *What is Art?*, London, 1959, p. 288.
21. Milton Brown, in *Paul Strand: A Retrospective Monograph, The Years 1915–1968*, Millerton, New York, 1971, p. 370.

Chapter 5: John Tagg

1. This chapter is based on a lecture given at the Midland Group Gallery in August 1977. The research for it was carried out with the aid of a Research Fellowship jointly given by the Arts Council of Great Britain and the Polytechnic of Central London.
2. Berenice Abbott, 'From a Talk Given at the Aspen Institute, Conference on Photography, 6 October, 1951' in *New York in the Thirties: The Photographs of Berenice Abbott*, Side Gallery, Newcastle, 1977, p. 23.
3. Ibid.
4. Quoted in Valerie Lloyd, 'Introduction', in *New York in the Thirties*, p. 4.
5. Berenice Abbott, 'Changing New York', in *Art for the Millions: Essays from the 1930s by Artists and Administrators of the WPA Federal Art Project*, ed. Francis V. O'Connor, New York Graphic Society, Boston, 1975, p. 161.
6. Quoted in Lloyd, 'Introduction', p. 160.
7. Abbott, 'Changing New York', p. 160.
8. Max Raphael, *The Demands of Art*, Routledge & Kegan Paul, 1968, pp. 11–12.
9. Cf. Max Raphael, *Theorle des geistigen Schaffens auf marxistischer Grundlage*, Fischer Vorlag, Frankfurt am Main, 1974. What Max Raphael argues in *Proudhon–Marx–Picasso: Trois études sur la sociologie de l'art*, Excelsior, Paris, 1933, is that certain categories and laws are realised in the works of art of all peoples and all times: categories or laws such as symmetry and series, statics and dynamics, the separation and interpenetration of the three dimensions. These categories and laws are realised, however under different configurations and the diversity of these configurations originates, in turn, in the diversity of natural environments against which people must struggle and of the concrete social structures within which this struggle (material production) takes place. What is common to them all cannot be known by abstraction. It involves the entire biological and historical formation of human consciousness whose nature is *relatively* constant, compared with the variable phenomena of social life. But to make this *relative* constancy absolute is to ignore the historical genesis of consciousness and the necessity for its realisation.
10. Abbott, 'Changing New York', p. 160.
11. Quote from the original plan for the photographic sub-project of the WPA/FAP, in Ibid, p. 158.
12. Ibid, p. 161.

13. Alfred H. Barr, 'Is Modern Art Communistic', *New York Times Magazine*, 14 December 1952, pp. 22–3, 28–30. See also, John Tagg, 'American Power and American Painting: The Development of Vanguard Painting in the US 1945', *Praxis*, vol. 1, no. 2, Winter 1976, pp. 59–79.

14. Roland Barthes, 'Rhetoric of the Image' *Working Papers in Cultural Studies*, Spring 1971, pp. 45–6. See also Stuart Hall, 'The Determinations of News-photographs', *Working Papers in Cultural Studies*, Autumn 1972, p. 84.

15. Barthes, 'Rhetoric of the Image', p. 45.

16. 'An interview with Pierre Macherey', ed. and trans. Colin Mercer and Jean Radford, *Red Letters*, Summer 1977, p. 5.

17. Walter Benjamin, 'A Short History of Photography', trans. Stanley Mitchell, *Screen*, vol. 13, no. 1, Spring 1972, p. 7.

18. Hans Hess, 'Art as Social Function', *Marxism Today*, vol. 20, no. 8, August 1976, p. 247.

19. Karl Marx, *Capital: A Critical Analysis of Capitalist Production*, vol. I, trans. Samuel Moore and Edward Aveling, Allen & Unwin, 1938, p. 105.

20. Susan Sontag, 'Photography', *New York Review of Books* 18 October 1973.

21. 'Prison Talk: An Interview with Michel Foucault', *Radical Philosophy*, Spring 1977, p. 10.

22. See John Tagg, 'Marxism and History', *Marxism Today*, vol. 21, no. 6, June 1977.

23. Louis Althusser, 'Ideology and Ideological State Apparatuses, in *Lenin and Philosophy*, New Left Books, 1971, p. 139.

24. 'An Interview with Michel Foucault', p. 11.

25. Althusser, 'Ideology and Ideological State Apparatuses, p. 136.

26. Quinton Hoare and Geoffrey Nowell Smith, Lawrence & Wishart, 1971, p. 238.

27. Paul Q. Hirst, 'Althusser and the Theory of Ideology', *Economy and Society*, vol. 4, no. 5, November 1976, pp. 385–412.

28. Ibid, p. 407.

29. Althusser, 'Ideology and Ideological State Apparatuses', p. 158.

30. 'An Interview with Pierre Macherey', p. 5.

31. Roy Emerson Stryker, 'The FSA Collection of Photographs', in *This Proud Land: America 1935–1943 As Seen by the FSA Photographers* Secker & Warburg, 1973, p. 7.

32. Ibid.

33. Quoted in Nancy Wood, 'Portrait of Stryker', in *This Proud Land*, p. 14.

34. 'Selected Shooting Scripts', in *This Proud Land*, p. 187.

35. 'From R. E. Stryker to Russell Lee, Arthur Rothstein. In particular, FSA 19 February 1942', ibid, p. 188.

36. Stryker, 'The FSA Collection of Photographs', p. 7.

37. See John Tagg, 'The Image of America in Passage', unpublished essay, p. 7.

38. Sontag, 'Photography'.

39. 'An Interview with Michel Foucault', p. 15.

40. Michel Foucault, 'The Political Function of the Intellectual', *Radical Philosophy*, Summer 1977, p. 13.

41. Wood, 'Portrait of Stryker', p. 16.

42. 'Power and Sex: An Interview with Michel Foucault', *Telos*, Summer 1977, p. 157.

43. Ibid.

44. Arthur Rothstein, in *Just Before the War: Urban America from 1935 to 1941 as Seen by the Photographers of the Farm Security Administration*, catalogue to an exhibition at the Newport Harbour Art Museum, October House, New York, 1968, p. 6.

45. T. J. Clark, *Image of the People: Gustav Courbet and the Revolution of 1848*, Thames & Hudson, 1973.

46. Ibid, p. 81.

47. Karl Marx, 'Letter to Nannette Philips, March 24, 1861', in Marx and Engels, *On Literature and Art*, ed. Lee Baxandall and Stefan Morawski, International General, New York, 1974, p. 113.

48. Engels, 'Letter to Minna Kautsky, London, November 26, 1885', in Marx and Engels, *On Literature and Art*, Progress Publishers, Moscow, 1976, p. 88.

49. Engels, 'Letter to Margaret Harkness. Beginning of April 1888 (draft)', in Marx and Engels, *On Literature and Art*, ed. Baxandall and Morawski, p. 116.

50. Ibid, p. 117.

51. Ibid, p. 115.

52. Stefan Morawski, 'Introduction', ibid, p. 31.

53. Cf. Roman Jakobson, 'Two Aspects of Language and Two Types of Aphasic Disturbances', in Roman Jakobson and Morris Halle, *Fundamentals of Language*, Janua Linguarum 1, Mouton, The Hague and Paris, 1971, pp. 67–96.

54. V. I. Lenin, 'Lev Tolstoy as the Mirror of the Russian Revolution', in *Articles on Tolstoy*, Progress Publishers, Moscow, 1971, p. 6.

55. Ibid.

56. 'L. N. Tolstoy and the Modern Labour Movement', ibid, p. 20.

57. 'An Interview with Pierre Macherey', p. 5.

58. Ibid, p. 5.

59. Lenin, 'Heroes of "Reservation"', in *Articles on Tolstoy*, p. 24.

60. Lenin, 'Lev Tolstoy as the Mirror of the Russian Revolution', p. 7.

61. Lenin, 'L. N. Tolstoy', p. 12.

62. Lenin, 'Lev Tolstoy as the Mirror of the Russian Revolution', p. 7 (my emphasis).

63. Lenin, 'Lev Tolstoy and and his Epoch', in *Articles on Tolstoy*, p. 29.

64. Lenin, 'Heroes of "Reservation"', p. 27.

65. Lenin, 'Lev Tolstoy and his Epoch', p. 31.

66. Lenin, 'L. N. Tolstoy', p. 12.

67. Ibid, p. 13.

68. Ibid, p. 11.

69. Lenin, 'Tolstoy and the Proletarian Struggle', in *Articles on Tolstoy*, p. 22.

70. Clark, *Image of the People*, p. 12.

71. Ibid.

72. Stryker, 'The FSA Collection of Photographs', p. 7.

73. Ibid, p. 9.

74. Quoted in Wood, 'Portrait of Stryker', p. 15.

75. Sigmund Freud, *The Interpretation of Dreams*, trans. James Strachey, Penguin, 1976, pp. 198–9.

Chapter 6: Victor Burgin

1. Published in English by Jonathan Cape, 1967.

2. For an overview of this work, in its application to photography, see Victor Burgin, 'Photographic Practice and Art Theory', *Studio International*, July–August 1975 (also Chapter 3 in this book).

3. See Jean-Louis Baudry, 'Ideological Effects of the Basic Cinematographic Apparatus', *Film Quarterly*, Winter 1974–5.

4. Published in English as 'The Mirror-phase as Formative of the Function of the I', *New Left Review*, September–October 1968.

5. Anyone familiar with recent film theory will recognise the extent to which my remarks here are indebted to it. The English language locus of this work is *Screen* magazine (see particularly Laura Mulvey, 'Visual Pleasure and Narrative Cinema', *Screen*, vol. 16, no. 3, Autumn 1975).

6. See particularly Jean-Louis Baudry, 'The Apparatus', *Camera Obscura*, Autumn 1976.

Chapter 7: Simon Watney

1. *Country Life*, vol. LXXXIII, 1938, quoted by Andrew Causey, *Paul Nash's Photographs: Document and Image*, London, Tate Gallery, 1973.

2. Conrad Aiken, quoted by Causey, ibid.

3. Oscar Wilde, *The Critic as Artist*, London, 1891.

4. Diderot, *Essai Sur La Peinture*, 1766, quoted from Anita Brookner, *The Genius of the Future*, Phaidon, 1971.

5. Karl Marx, *The German Ideology*, New World Editions, 1967.

6. Viktor Shklovsky, *Mayakovsky and His Circle*, Pluto Press, 1974.

7. Quoted from Vladimir Markov, *Russian Futurism*, MacGibbon & Kee, 1969.

8. Ibid.

9. See 'An Englishman in Moscow', 'Musical Instrument', 'Woman at Poster Column', in Troels Anderson, *Malevich*, Stedelijk Museum, Amsterdam, 1970.

10. Viktor Shklovsky, *The Resurrection of the Word* (1914), trans. Richard Sherwood, in *Russian Formalism*, Academic Press, Edinburgh, 1972.

11. See Pound and Fenollosa, *The Chinese Written Character as a Medium for Poetry*, 1919.

12. Shklovsky, *The Resurrection of the Word*.

13. Roger Fry, 'The French Post-Impressionists' (1912), in *Vision and Design*, Phoenix Library, 1928.

14. See Fry, *Vision and Design*; and Guillaume Apollinaire, *The Cubist Painters*, Paris, 1913.

15. Quoted from Sue Compton, *Russian Futurist Books*, British Library, 1978.

16. Samuel Beckett, *Proust*, Paris, 1931.

17. Viktor Shklovsky, *Theory of Prose* (1929), quoted in Frederic Jameson, *The Prison-House of Language*, Princeton, 1972.

18. Viktor Shklovsky, on 'Tolstoy's Diaries', quoted in Robert Scholes, *Structuralism in Literature*, Yale, 1974.

19. 'A Slap in the Face of Public Taste' (1912); see Markov, *Russian Futurism*, and Compton, *Russian Futurist Books*.

20. Sergey Tretyakov, 'Where from: Where to?', *Lef*, no. 1, 1923.

21. See Victor Burgin, 'Socialist Formalism', *Studio International*, March–April 1976.

22. Tretyakov, 'Where from: Where to?'.

23. Alexander Rodchenko and Varvara Stepanova, *Productivist Manifesto* (1921), reprinted in *Alexander Rodchenko*, ed. David Elliott, Museum of Modern Art, Oxford, 1979.

24. Osip Brik, 'Photography versus Painting', *Sovetskoe Foto*, no. 2, 1926, reprinted in *Alexander Rodchenko*, ed. Elliott.

25. Ibid.

26. Alexander Rodchenko, 'A Warning', *Novy Lef*, no. 11, 1928, quoted from A. B. Nakov, 'Back to the Material: Rodchenko's Photographic Ideology', *Art Forum*, October 1977.

27. Alexander Rodchenko, 'Reply to Volkov-Lannit and Kuchner', *Novy Lef*, no. 11, 1928, quoted from Nakov, 'Back to the Material: Rodchenko's Photographic Ideology'.

28. See, for example, H. Denkin, 'Linguistic Models in Early Soviet Cinema', *Cinema Journal*, Autumn 1977; and S. Crofts and O. Rose, 'Vertov: Man with a Movie Camera', *Screen*, Spring 1977.

29. Alexander Rodchenko, quoted by Hubertus Gassner, 'Analytic Sequences: Rodchenko's Photographic Method', in *Alexander Rodchenko*, ed. Elliott.

30. Brik, Pasternak, Mayakovsky and Aseev visited Berlin in 1922. The concept of 'Ostranenie was exchanged for the typographical innovations of Dada which so influenced Rodchenko's 1923 photomontages, as well as his lay-out for *Lef* in the same year.

31. See Heartfield's letters to Tretyakov, quoted in Sergey Tretyakov, *John Heartfield: A Monograph*, Moscow, 1936: 'A photograph can, by the addition of an unimportant spot of colour, become a photomontage.' In other words, photomontage became theorised by Heartfield as any practice which interrupts reflexive readings of photographs (quotation cited in *John Heartfield: Photomontages*, ICA, 1969).

32. Tretyakov, *John Heartfield*.

33. Walter Benjamin, *A Short History of Photography* (1931), reprinted in *Germany: The New Photography 1927–33*, ed. David Mellor, Arts

Council of Great Britain, 1978.

34. See *Here Speaks Tass, Alexander Rodchenko: Fotografien 1920–1938*, Wiencind Verlag, Cologne, 1978, p. 35.

35. Bertolt Brecht, *The Life of Galileo*, Eyre Methuen, 1963.

36. See Martin Walsh, 'The Complex Seer: Brecht and the Film', *Sight and Sound*, Autumn 1974.

37. Bertolt Brecht, *The Messingkauf Dialogues*, Eyre Methuen, 1971.

38. Edwin Hoernie, *The Working Man's Eye* (1930), reprinted in *Germany: The New Photography 1927–33*, ed. Mellor.

39. Franz Roh, 'Mechanism and Expression: the Essence and Value of Photography' (1928), in *Photo-Eye*, ed. Franz Roh and Jan Tschichold, Thames & Hudson, 1974.

40. Ibid.

41. Benjamin, *A Short History of Photography*.

42. See L. Moholy-Nagy, *Photography* (1925), reprinted in *Painting, Photography, Film*, Lund Humphries, 1969.

43. Benjamin, *A Short History of Photography*.

44. Ibid.

45. Stanley Mitchell, 'Benjamin and Brecht', *New Left Review*, January–February 1973.

46. Walter Benjamin, 'On Surrealism', *New Left Review*, march–April 1978.

47. Ibid.

48. André Breton, *Surrealism and Painting* (1928), Thames & Hudson, 1971.

49. Susan Sontag, 'Melancholy Objects', in *On Photography*, Allen Lane, 1978.

50. Jonathan Swift, *Gulliver's Travels* (1726).

Chapter 8: Victor Burgin

1. This chapter combines two papers: one given at the Centre Universitaire Américain du Cinéma à Paris in May 1978; the other given at a symposium presented by the Program of European Cultural Studies, Princeton University, February 1979.

2. The complete texts of the Rodchenko/Kushner exchange may be found in Rosalind Sartorti and Henning Rogge, *Sowjetische Fotografie 1928–1932*, Carl Hanser, Munich, 1975. Substantial extracts from this correspondence, together with translations of other writings by Rodchenko, are in Colin Osman (ed.), *Camera International Yearbook 1978*, Gordon Fraser, London. I draw upon both of these sources here.

3. *Novy Lef*, no. 6, 1928.

4. *Novy Lef*, no. 8. This edition of *Novy Lef* was subtitled 'Photo-issue'; its editor was Tretyakov.

5. It is interesting to note, if only in passing, that it has been argued that icon painting was orientated to the point-of-view of an observer imagined to be *within* the picture, 'facing out', in contrast to the Renaissance orientation from outside looking in. See B. A. Uspensky, '"Left" and

"Right" in Icon Painting', *Semiotica*, vol. 13, no. 1, 1975.

6. *Novy Lef*, no. 9.

7. *Novy Lef*, no. 11.

8. *Novy Lef*, no. 12.

9. See contemporary commentaries in Sartorti and Rogge, *Sowjetische Fotografie*, pp. 56 ff.

10. G. Karginov, *Rodchenko*, Thames & Hudson, 1979, p. 258.

11. Osman (ed.), *Creative Camera International Yearbook 1978*, p. 190.

12. S. Freud, 'Three Essays on the Theory of Sexuality', *The Standard Edition of the Complete Psychological Works of Sigmund Freud* (24 vols), London, Hogarth Press, 1953–74, vol. VII.

13. S. Freud, 'Jokes and their Relation to the Unconscious', *Standard Edition*, vol. VIII, p. 98.

14. J. Lacan, *The Four Fundamental Concepts of Psychoanalysis*, Hogarth, 1977, pp. 67 ff.

15. Note Lacan: 'I do not think that one is dealing with the negation of the subject anywhere, at least in the field vaguely defined by this label. One is dealing with the dependency of the subject, which is extremely different; and more specifically, with the return to Freud, of the dependency of the subject *vis-à-vis* something really elementary and which we have attempted to isolate under the term of "signifier"' (Discussion of M. Foucault, 'What is an Author', *Screen*, vol. 20, no. 1, Spring 1979, p. 33).

16. Stephen Heath, 'Notes on Suture', *Screen*, vol. 18, no. 4, Winter 1977–8, p. 69.

17. S. Freud, 'Fetishism', *Standard Edition*, vol. XXI, p. 152.

18. Bill Gaskins, interview in *Camera Work*, no. 5, 1976, p. 3.

19. O. Mannoni, 'Je sais bien, mais quand même', in *Clefs pour l'imaginaire ou l'autre scène*, Editions Seuil, Paris, 1969, p. 12.

20. Marie-Françoise Hans and Gilles Lapouge, *Les femmes, la pornographie, l'érotisme*, Editions Seuil, Paris, p. 245.

21. See 'Looking at Photographs' (Chapter 6) in this book for an account of the suturing effect of 'good composition' (indeed, *all* of those attributes of the still image we tend to identify as 'aesthetic' may be brought within the purview of *suture*).

22. C. Metz, 'Notes towards a Phenomenology of the Narrative', in *Film Language*, Oxford University Press, New York, 1944, p. 20.

23. See James J. Gibson, 'Constancy and Invariance in Perception', in *The Nature and Art of Motion*, ed. Gyorgy Kepes, Studio Vista, 1967.

24. Karl H. Pribram, 'The Neurophysiology of Remembering', *Scientific American*, January 1969.

25. M. J. Horowitz, *Image Formation and Cognition*, Meredith, 1970.

26. In Brewster Ghiselin, *The Creative Process*, Mentor, 1955, quoted in Dan I. Slobin, *Psycholinguistics*, Scott, Foresman, 1974, p. 101.

27. S. Freud, 'Fragment of an Analysis of a Case of Hysteria', *Standard Edition*, vol. VII.

28. S. Freud, *The Interpretation of Dreams*, Standard Edition, vol. IV.

29. S. Freud, *Introductory Lectures on Psycho-Analysis, Standard Editions*, vol. XV, p. 175.

30. Lev Vygotsky, *Thought and Language*, MIT Press, 1977, p. 139.

31. Ibid, p. 148.

32. Horowitz, *Image Formation and Cognition*, p. 77.

33. S. Freud, 'Creative Writers and Day-Dreaming', *Standard Edition*, vol. IX, p. 147.

34. S. Freud, 'The Ego and the Id', *Standard Edition*, vol. XIX, p. 21.

35. S. Freud, 'The Unconscious, *Standard Edition*, vol. XIV, p. 201.

36. S. Freud, 'The Ego and the Id', *Standard Edition*, vol. XIX, p. 20.

37. J. Laplanche and S. Leclaire, 'The Unconscious: A Psychoanalytic Study', *Yale French Studies*, no. 48, 1972, p. 145.

38. J.-F. Lyotard, *Discours, Figure*, Editions Klincksieck, Paris, p. 244.

39. S. Freud, 'Repression', *Standard Edition*, vol. XIV, p. 149.

40. Laplanche and Leclaire, 'The Unconscious', pp. 162–3.

41. J. Laplanche and J.-B. Pontalis, *The Language of Psycho-Analysis*, Hogarth, 1973, p. 316.

42. The image here is Lacan's, but its extension to unconscious, as well as conscious, thought is Laplanche's. Lacan himself has rejected such an implication of *passage* between *Pcs–Cs* and *Ucs* systems, preferring the 'recto – verso' image of 'double-inscription' – correspondence without joining (see Anika Lemaire, *Jacques Lacan*, Routledge & Kegan Paul, 1977, pp. 249–51).

43. There is no radical discontinuity between the primary and the secondary processes: both are ever-present aspects of language. Kristeva has coined the term *signifiance* to indicate the simultaneous presence of these two registers (in her terminology, the 'semiotic' and the 'symbolic') – *signifiance* exceeds the signification which unites signifier and signified along the syntactically ordered route of conscious discourse. (See 'The System and the Speaking Subject', *The Times Literary Supplement*, 12 October 1973.)

44. Horowitz, *Image Formation and Cognition*, p. 78.

45. Gary Winogrand, Grossmont College Gallery, El Cajon, California, 1976.

46. Lee Friedlander, *Self Portrait*, Haywire Press, 1970.

47. John Szarkowski, A. C. Quintavalle and M. Mussini, *New Photography USA*, Universita' Di Parma/Museum of Modern Art, New York, 1971.

48. Ibid, p. 15.

49. C. Greenberg, 'Modernist Painting', *Arts Year Book*, no. 4, 1961.

50. Ibid.

51. Maren Stange, 'Szarkowski at the Modern', in *Photography: Current Perspectives*, Light Impressions, 1978, p. 74.

52. John Szarkowski, *The Photographer's Eye*, Museum of Modern Art, New York, 1966.

53. Clive Bell, *Art*, Capricorn, 1958, p. 29.

54. Stange, 'Szarkowski at the Modern', p. 74.

55. C. Greenberg, 'Four Photographers', *New York Review of Books*, 23 January 1964.

56. Szarkowski, *The Photographer's Eye*.

57. Much of the ideological power of photographs surely derives from

this – we cannot see in the photographic *image* much other than we already know, albeit the knowledge has been repressed or disavowed; it is this fact which must account for the sense of *déjà vu* which many have reported in their experience of photographs (Cf. S. Freud, 'Fausse Reconnaissance (Déjà Raconté) in Psycho-Analytic Treatment', *Standard Edition*, vol. XIII, pp. 201–7).

58. P. Wollen, 'Photography and Aesthetics', *Screen*, vol. 19, no. 4, Winter 1978–9, p. 28.

59. B. Rosenblum, 'Style as Social Process', *American Sociological Review*, vol. 43, 1978, p. 435.

60. See R. Barthes, 'The Great Family of Man', in *Mythologies*, Paladin, 1973, pp. 100 ff.

61. E. H. Gombrich, 'Icones Symbolicae', in *Symbolic Images*, Phaidon, 1972.

62. M. Foucault, 'The Political Function of the Intellectual', *Radical Philosophy*, vol. 17, 1977, p. 12.

63. Thus the easy, because uncontradictory, alternation in such left-leaning periodicals as *Time Out, New Statesman* and *Village Voice* of occasional pieces on 'radical' artists (accompanying photograph 'the artist with his/her work' mandatory) with otherwise unbroken strings of art reviews indistinguishable from those in the 'thoroughly bourgeois' press.

64. M. Foucault, 'Interview with Lucette Finas', in *Michel Foucault – Power, Truth, Strategy*, Feral, Sydney, 1979, p. 72.

65. M. Foucault, *The Archaeology of Knowledge*, Tavistock, 1974, p. 194.

66. W. Benjamin, 'The Author as Producer', in *Understanding Brecht*, *New Left Books*, 1973, p. 95. (Chapter 1 of this book, p. 24.)

Notes on Contributors

Walter Benjamin was a literary critic, analyst of culture, and a friend and early champion of Brecht. He committed suicide in 1940, in occupied France, to avoid being taken by the Gestapo. Current collections of his essays include *Understanding Brecht* and *Illuminations*.

Victor Burgin is Senior Lecturer in the History and Theory of the Visual Arts in the School of Communication, Polytechnic of Central London. His publications include *Work and Commentary*.

Umberto Eco is Professor of Semiotics in the Faculty of Letters and Philosophy, University of Bologna. He is the author of *A Theory of Semiotics*, as well as other works.

Allan Sekula teaches in the Department of Cinema Studies, New York University. He is the author of many essays on photography.

John Tagg is Lecturer in Art History at Leeds University. He is the editor of *Proudhon, Marx, Picasso*, a collection of essays by Max Raphael.

Simon Watney is Lecturer in the History and Theory of the Visual Arts in the School of Communication, Polytechnic of Central London. He is the author of *English Post-Impressionism*.

Index